JAMESTOWN

JAMESTOWN
A HISTORY OF
NARRAGANSETT BAY'S ISLAND TOWN

Rosemary Enright & Sue Maden
with the Jamestown Historical Society

Published by The History Press
Charleston, SC 29403
www.historypress.net

Copyright © 2010 by Rosemary Enright and Sue Maden

All rights reserved

Front cover, top: Jamestown fire station (left) and town hall, circa 1905. *Courtesy of the Jamestown Historical Society.*

Front cover, bottom: "Sheep Crossing," by J.A.S. Monks (page 32). *Courtesy of Richard Hutchinson.*

Back cover, left: Police chief Charles E. Hull (page 105). *Courtesy of the Jamestown Historical Society.*

Back cover, right: Map of Conanicut Island (page 10), *Courtesy of the Jamestown Historical Society.*

First published 2010
Second printing 2010; Third printing 2012

ISBN 9781540224279

Library of Congress Cataloging-in-Publication Data

Enright, Rosemary, 1940-
Jamestown : a history of Narragansett Bay's island town / Rosemary Enright and Sue Maden, with the Jamestown Historical Society.
p. cm.
Includes bibliographical references and index.

1. Jamestown (R.I.)--History. I. Maden, Sue. II. Jamestown Historical Society (Jamestown, R.I.) III. Title.
F89.J3E57 2010
973.2'1--dc22
2010020917

Notice: The information in this book is true and complete to the best of our knowledge. It is offered without guarantee on the part of the authors or The History Press. The authors and The History Press disclaim all liability in connection with the use of this book.

All rights reserved. No part of this book may be reproduced or transmitted in any form whatsoever without prior written permission from the publisher except in the case of brief quotations embodied in critical articles and reviews.

CONTENTS

Preface	7
The Islands of Jamestown	9
Settlement and Purchase	13
Founding a Town	25
The American Revolution	41
Rebuilding Jamestown	51
Resorts and Summer People	71
Growing Pains	85
The Downhill Slide	113
Jamestown and the Military	127
Postwar Adjustments	145
After the Bridges	165
Epilogue	177
Bibliography	179
Index	183
About the Authors	191

PREFACE

Every tale told—and history is a tale—involves a series of choices, a road taken and a road not taken. At the very beginning of this project, we decided on three guidelines to control our choices: 1) emphasize eras and influences not covered thoroughly somewhere else, 2) concentrate on the dynamic flow through key periods of change, and 3) try to see our history through the eyes of people for whom the island was home.

As we constructed our story, we found we had quite a bit to say about the purchase of the island from the Narragansett because new information has come to light in the last few years. Our coverage of the summer people and the military concentrates on the effects on the town. In the post–World War II era, the emphasis is inevitably on growth and expanding our definition of "Jamestowner" to include all those for whom the island is now home.

When possible, we used original material: town records, such as minutes of meetings, land evidence records, and tax records; archives and oral histories from the Jamestown Historical Society collection; and contemporary newspapers. Published works that were consulted are listed in the bibliography.

Many people helped with this project, and we thank them all.

The staff at the Jamestown Philomenian Library was always helpful, and the library's collection of special materials—such as microfilm, genealogical information, local history, and indexes to the *Jamestown*

Preface

Press and local history collection—was invaluable. The *Jamestown Press*, in addition to supporting the Jamestown Historical Society over the years by publishing historical articles and columns from which we have borrowed heavily, encouraged us and gave us access to its publications and photographs. Old Jamestowners, especially Ed Morinho and Donald Richardson, patiently answered our questions about the Jamestown of their childhood. Every department in the town hall—town clerk, tax assessor, building, public works, planning—contributed. Ginny Saunders and Dick Allphin compiled information from newspapers between 1950 and 2009, supporting not only this book but also the efforts of the historical society to create a searchable timeline of Jamestown history. The timeline will keep us busy for some time to come.

The majority of the illustrations are from the Jamestown Historical Society archives. Others were taken for us or loaned to us by Richard Hutchinson, Varoujan Karentz, Joe Logan, Nancy Logan, Sue Maden, Peter Marcus, Jeff McDonough, the Jamestown Philomenian Library, the *Jamestown Press*, the *Providence Journal*, the Rhode Island Bridge and Turnpike Authority, Donald Richardson, the Town of Jamestown, and Andrea von Hohenleiten. A special thank-you goes to Justin Jobin, who digitized maps from the historical society collection.

Our readers were Joyce Allphin, Lisa Bryer, John Enright, Nancy Logan, Jeff McDonough, Heidi Moon, John Murphy, Alice Noble, Ginny Saunders, Walter Schroder, and Harry Wright. They identified errors and infelicities. The errors that still exist are ours, not theirs.

The Jamestown Historical Society board and members of its Collections Committee, as well as our friends and relatives, greeted our absorption in the project with good humor and tolerated our distraction with grace. We thank them for their support.

THE ISLANDS OF JAMESTOWN

Jamestown, Rhode Island, officially encompasses three islands in Narragansett Bay—Conanicut, Dutch, and Gould—plus a number of small islets known collectively as "dumplings." Only Conanicut Island, with one of its East Passage islets, is currently inhabited. When people talk about Jamestown, they usually mean Conanicut. Nevertheless, the history of Jamestown includes the history of its other two islands as well.

Conanicut is the second-largest island in Narragansett Bay. Averaging one mile wide and about nine miles long, it sits just inside the mouth of the bay, dividing the entrance into the East and West Passages. Until 1940, the only way to reach the island was by boat. Bridges now connect the island to Saunderstown on the mainland to the west and to Newport on Aquidneck Island to the east.

The geology and geography of Conanicut Island—itself almost three separate islands—are complex. The northern part is the largest segment, containing about one-half of the acreage of the island. This is also geologically the youngest portion. The underlying bedrock was formed roughly 290 to 325 million years ago. The Great Creek and a wide saltwater marsh create a natural boundary between the North End and the rest of the island. A road skirts the marsh on the east side, and a causeway spans the creek and marsh midway between the East and West Passages.

JAMESTOWN

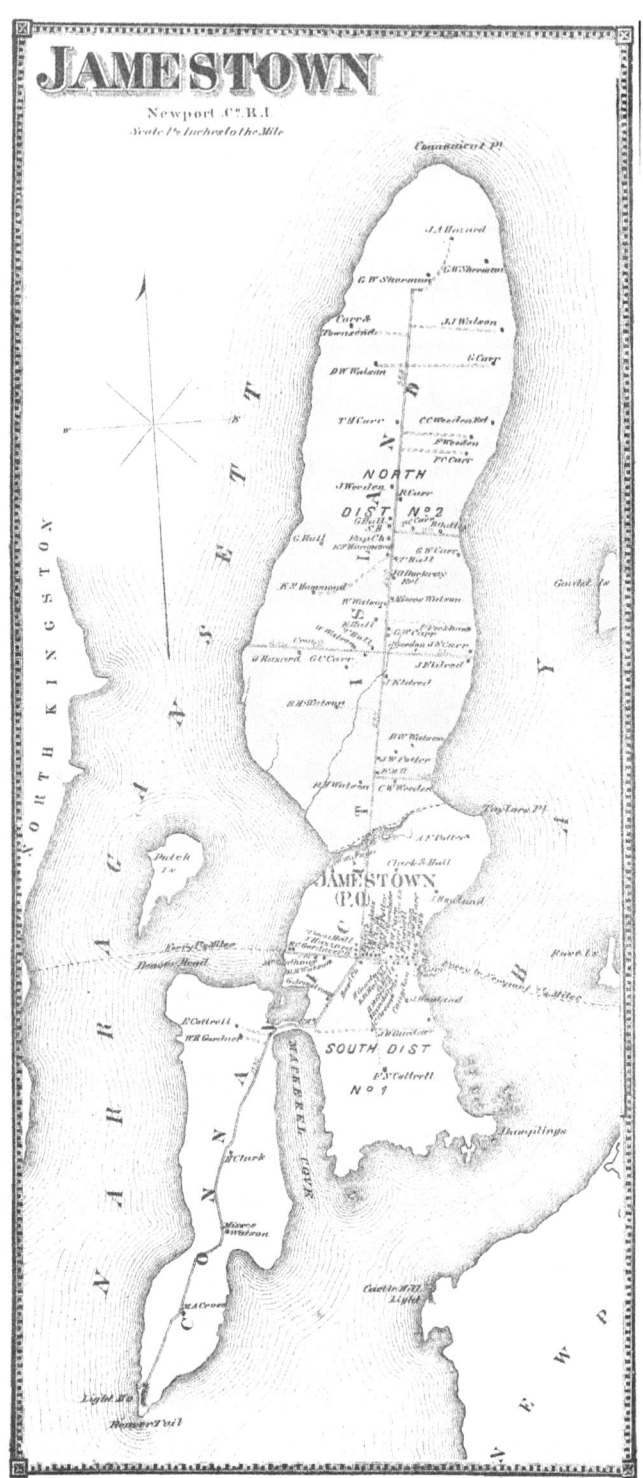

Conanicut Island, with Dutch Island to the west and Gould Island to the east. This map is from *D.G. Beers Atlas of Rhode Island*, 1870. *Courtesy of the Jamestown Historical Society.*

The Islands of Jamestown

South of the Great Creek are the village of Jamestown and a rocky peninsula known as the Dumplings. The Dumplings peninsula and the islets near it in the bay are geologically the oldest part of the island. They were formed more than 570 million years ago, when Conanicut Island was part of a series of volcanic islands off southern Africa.

A narrow beach between Mackerel and Sheffield Coves joins a southern peninsula to the rest of the island. Beavertail, as the peninsula is called because of the shape of its southernmost part, is reachable by only one road—frequently impassable during storms—across the isthmus. Beavertail and the area between the Dumplings and the Great Creek were formed about 425 million years ago.

Dutch Island, in the West Passage, is a teardrop-shaped island of eighty-one acres. It belongs to the State of Rhode Island and can be reached only by small boat. Because of potentially dangerous ruins and past vandalism, access is limited.

Gould Island, in the East Passage, is even smaller—about fifty acres. It is owned jointly by the U.S. Navy, which controls seventeen acres at the

Fern fossil from Mackerel Cove, believed to be about 5 million years old. In 1976, geologists uncovered a fossil 550 million years old at Beavertail. *Courtesy of the Jamestown Historical Society.*

northern end, and the State of Rhode Island. The navy portion is always closed to the public. The state portion is a bird sanctuary and is only accessible by special permit.

Geologically, both islands are related to the northern part of Conanicut Island.

The land around Narragansett Bay was carved into its current shape by glaciers that covered all of Rhode Island until about fifteen thousand years ago. The glaciers flowed slowly south, picking up and dropping rocks, grinding some into small particles, carving deep valleys and, in general, changing the face of the land. As the earth warmed, the glaciers retreated, revealing the recarved surface.

Because much of the earth's water was still in ice form in the more northern glaciers, sea level at that time was about 100 to 150 meters (350 to 400 feet) lower than it is today. What is now the floor of Narragansett Bay was land or a freshwater lake. As the warming continued and more water was released into the oceans, saltwater flooded into the low-lying areas, creating islands out of the higher ground.

Jamestown's unique character was in large part fashioned by its semi-isolation as an island community.

SETTLEMENT AND PURCHASE

Archaeologists speculate that humans arrived in the Narragansett Bay area as long ago as 10,000 BCE, soon after the glaciers receded. These first inhabitants would have lived on what is now the floor of the bay. Time passed, the ice age ended, and saltwater filled the basin. Clues to who these first inhabitants were and what they did were washed away or buried in the bottom of the bay. No artifacts or records of these early Rhode Islanders have been uncovered.

The first residents to leave evidence of their culture arrived about 3000 BCE. Research into these early inhabitants began in 1936. During the fall of that year, men removing loam from a farm on the west side of the island south of the Great Creek dug up some human bones and artifacts. Within the next three months, at least seventeen skeletons were unearthed. Some Jamestowners were appalled by the desecration of what was thought to be a Narragansett burial ground, and the town council decided to buy the land and collect everything that had already been removed. The council asked Catharine Morris Wright to take charge of the material that was recovered.

There matters stood until 1966, when Catharine Wright and her husband, Sydney, asked William Scranton Simmons, a Harvard-trained anthropologist and ethnohistorian, to excavate what became known as the West Ferry site.

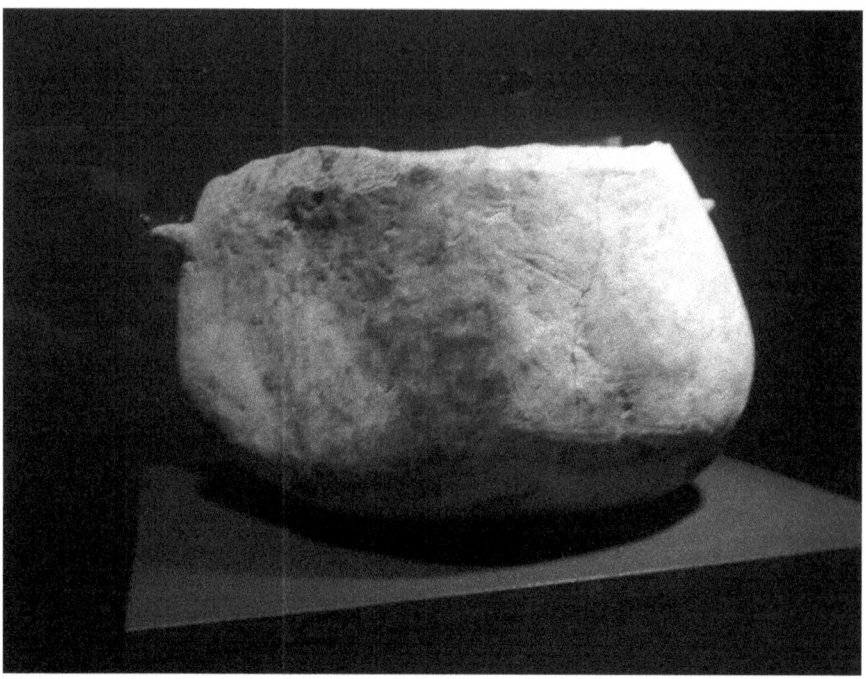

A soapstone pot used on Conanicut Island about thirty-four hundred years ago. This bowl is in the Sydney L. Wright collection at the Jamestown Philomenian Library. *Courtesy of Jamestown Philomenian Library.*

Simmons discovered that two quite different groups had buried their dead in the same area. The earliest artifacts dated from about 3000 BCE. These artifacts show that the first Jamestowners were hunters who knew nothing about agriculture or pottery. Their bowls and kettles were expertly carved from Rhode Island steatite, or soapstone. Stone implements were created by percussion flaking or by the more laborious process of pecking and polishing.

Many of the people buried in the early graves were cremated. Carbon dating of charcoal from the graves suggests that the last hunter-gatherers were buried on Conanicut Island before 1200 BCE. Whether these people were ancestors of later Native American inhabitants is unknown.

Settlement and Purchase

THE NARRAGANSETT

The more recent and more numerous graves discovered at the West Ferry site in the 1960s were Narragansett and date from the early to mid-seventeenth century, about 1620 to 1660. In the years immediately preceding European settlement, the Narragansett controlled most of what is now Rhode Island. They were both hunters and farmers. According to tradition, some Narragansett who lived in South County on the mainland during the colder months made Conanicut Island their summer home.

The number of graves unearthed in the 1960s seemed to indicate that the summer colony numbered about one hundred. More graves—possibly from the fifteenth and sixteenth centuries—were discovered later at a slight distance from the original site, and archaeologists now believe that the village of Jamestown was built in and around the largest Indian burial ground in the northeast.

The bodies in the graves at the West Ferry site are aligned along a northeast–southwest axis, reflecting the Narragansett belief that the spirit goes to the southwest at death. Most are lying on their sides in a semifetal

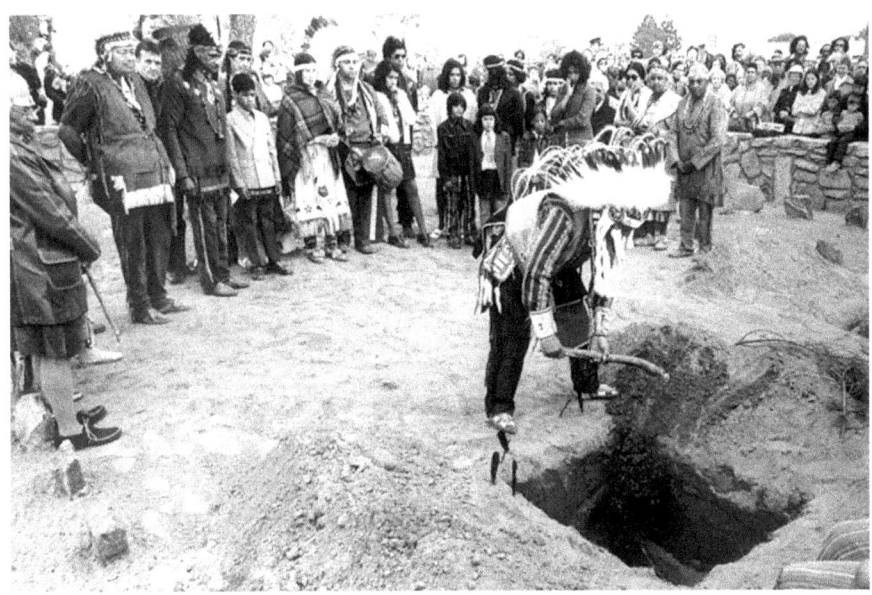

Reburial ritual at the West Ferry archaeological site. In 1973, the Narragansett reburied remains of Native Americans that had been exhumed earlier in the century. *Courtesy of the Jamestown Historical Society.*

position. Many of the graves contain European trade items, such as iron hoes and muskets, for the dead to take to the afterlife.

The Narragansett believe that the spirit remains with the body until all evidence of the body has disappeared. Respect for this belief has prevented further examination of grave sites, and remains exhumed in the 1930s and 1960s were reburied in 1973.

Settlement of Rhode Island by European colonists—at first by religious refugees from Massachusetts—began at Providence in 1636 and quickly spread south along both sides of Narragansett Bay. In 1637, the powerful Narragansett sachems Canonicus and Miantonomi deeded Aquidneck Island to the colonists, who were already moving into the island's northern end at what is now Portsmouth. The agreement included the right to use "the Marsh or grasse upon Quinunigut" to feed their livestock. This is apparently the first written use of the island's name.

The wealth of grass on Conanicut may have resulted from Narragansett horticultural methods. Reportedly, the Narragansett set fire to the woods from time to time to clear land for growing corn, beans, and other crops. As a result, much of Conanicut Island in the early seventeenth century was, unlike nearby Aquidneck Island, largely unforested.

Some of the Portsmouth settlers quickly moved to the southern end of Aquidneck Island to found the new settlement of Newport. Conanicut Island is mentioned again in the record of the first Newport town meeting:

> *It is agreed and ordered, that the Plantation now begun at this Southwest end of the island, shall be called Newport; and that all the landes laying Northward and Eastward from the said Towne towards Pocasset, for the space of five miles, so across from sea to sea with all ye landes Southward and Westward, bounded with the main sea, together with the small Island and the grass of Cunnunnegot, is appointed for the accommodation of ye said Towne.*

The critically important grass on the island was thus assigned as common property for all Newporters.

For the next twenty years, Newporters used the island as a common pasture for their livestock or as a place to gather grass for winterfeed. But since the Narragansett had not transferred ownership of the island to the

Settlement and Purchase

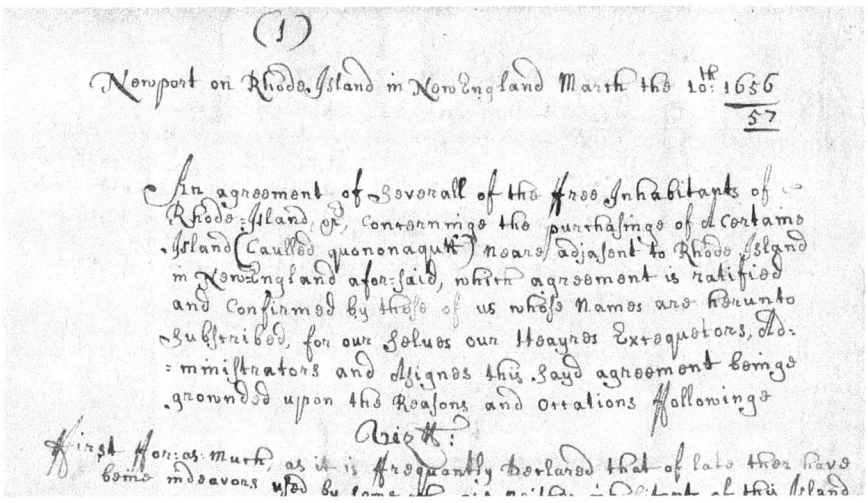

The preamble to the Conanicut Island prepurchase agreement states the reasons for wanting to purchase the island. Twelve numbered articles follow. *Courtesy of the Jamestown Historical Society.*

colonists, the colonists were increasingly concerned that this very useful property might fall to outside speculators. They were particularly concerned about the Dutch, who as early as 1616 had used Dutch Island in the West Passage as a trading post.

Leaders in favor of purchasing both islands tried to persuade the colonial government to negotiate with the Narragansett. When they were unsuccessful, they gathered together a coalition of over one hundred men to purchase the islands as a common venture. In March 1657, the members of the coalition met and agreed to negotiate a "full and firm purchase" of the islands. The prepurchase contract they wrote said that each signer would receive a share of the island proportionate to the amount of the total purchase price he invested. The largest investors purchased 1/20th of the island, which amounted to about 240 acres plus a share in the common areas. The smallest investors each promised 1/900th of the purchase price for about five and a half acres.

That same month, Thomas Gould—who had a 1/111th share of Conanicut and Dutch Islands—independently purchased Aquopimoquk Island in the East Passage from Scuttape, a grandson of Canonicus, and renamed it Gould Island.

The Purchasers

While 106 men are named as participants in the 1657 prepurchase agreement, only 101 of them signed the final document. These men—they were all men, although a widow is mentioned in the records soon after the purchase—had widely different backgrounds and careers. Most lived in Newport, but others came from Portsmouth, Middletown, and the Wickford area. Some were involved in commerce and politics. Some were farmers. Others were craftsmen, such as tailors, carpenters, or blacksmiths. They had different religious beliefs. Typical of the times, almost one-third were unable to write their own names and therefore signed the agreement with an identifying "mark"—often a version of one or more of their initials.

The agreement named sixteen investors to "a perpetual council or committee" and authorized seven of the most prominent council members as trustees to complete the purchase negotiations with the Narragansett and to enforce the contract. The trustees were all political leaders and successful businessmen. They were also among the most heavily invested. Their leaders were Benedict Arnold and William Coddington, the only two purchasers with a $1/20^{th}$ (or 5 percent) interest in the project. The remaining five trustees were chosen from among the fourteen men who each invested $1/40^{th}$ of the total price: William Brenton, who contributed an additional $1/111^{th}$ share; Caleb Carr; John Cranston; John Sanford, the only trustee born in North America; and Richard Smith Sr. of Narragansett.

The other members of the "perpetual Council" were Richard Smith Jr., Richard Tew, Joseph Clarke, John Greene, Richard Knight, James Barker, Mark Lucar, John Roome, and William Baulstone. Together, the council represented over 40 percent of the investment in the islands.

Captain Randall Holden, John Easton, Daniel Gould, John Sailes, and Valentine Whitman, although named in article two as purchasers, did not sign the final agreement

Settlement and Purchase

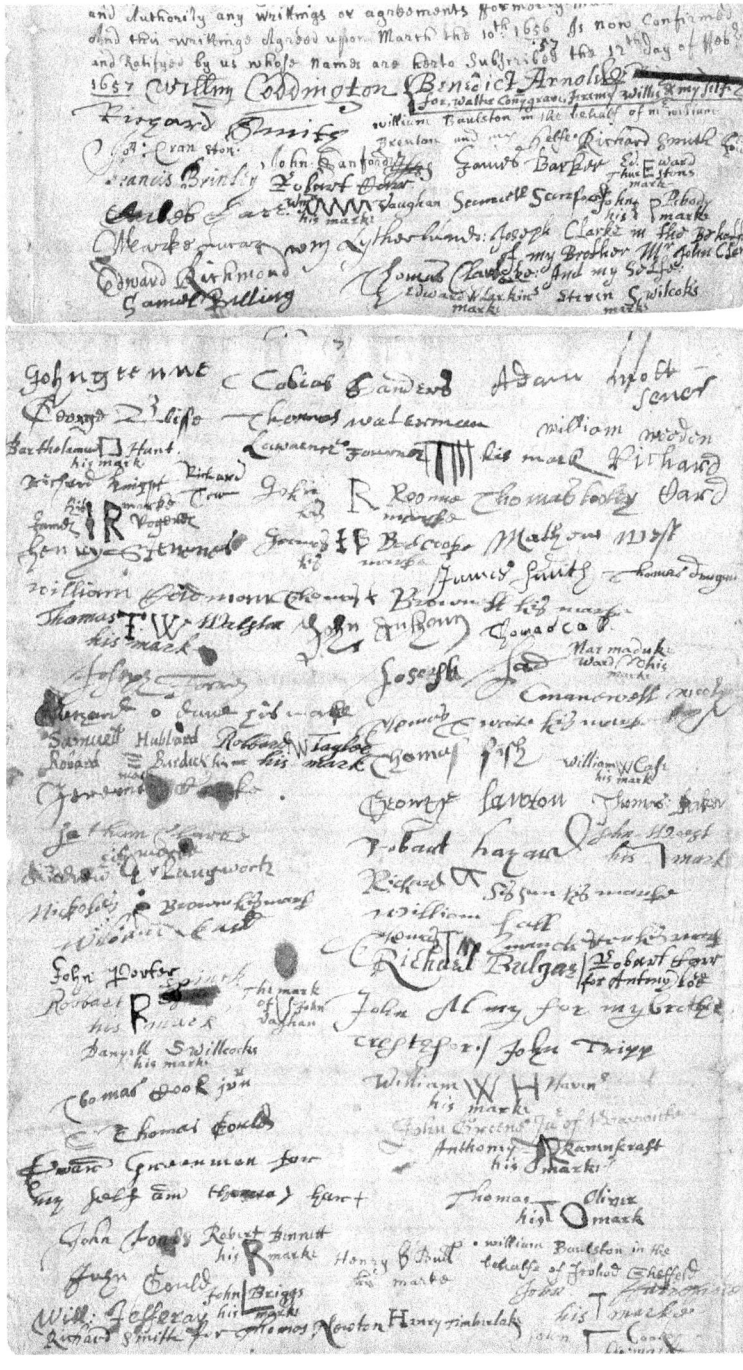

The Conanicut Island prepurchase agreement was signed by 101 men. See the table on the following pages for an alphabetical listing of the names. *Courtesy of the Jamestown Historical Society.*

Jamestown

Signers of the Conanicut Island 1657 Prepurchase Agreement

Signer	Portion	Signer	Portion
Christopher Almy	1/200	William Jefferay	1/200
John Anthony	1/300	Richard Knight	1/67
Benedict Arnold	1/20	Joseph Ladd	1/450
James Babcock†	1/67	Andrew Langworthy†	1/450
Thomas Baker	1/300	Edward Larkin†	1/250
James Barker	1/40	George Lawton	1/200
William Baulstone	1/60	Anthony Low	1/200
Robert Bennett†	1/250	Mark Lucar	1/200
Samuel Billings	1/300	William Lytherland	1/300
George Bliss	1/450	Thomas Manchester†	1/300
William Brenton	1/40	Adam Mott Sr.	1/111
John Briggs†	1/111	Thomas Newton	1/300
Francis Brinley	1/40	Thomas Oliver†	1/900
Nicholas Brown†	1/300	John Peabody†	1/200
Thomas Brownell†	1/67	John Porter	1/111
Richard Bulgar	1/200	Anthony Ravenscraft†	1/900
Henry Bull†	1/111	Edward Richmond	1/300
Robert Burdick†	1/300	James Rogers†	1/40
Richard Card	1/200	John Roome†	1/54
Caleb Carr	1/40	John Sanford	1/40
Robert Carr	1/40	Samuel Sanford	1/150
William Case†	1/300	Tobias Saunders	1/200
Thomas Cass	1/900	Ichabod Sheffield	1/450
Jeremiah Clarke	1/300	Richard Sisson†	1/250
John Clarke	1/54	James Smith	1/40
Joseph Clarke	1/54	Richard Smith Jr.	1/40

Settlement and Purchase

Signer	Portion	Signer	Portion
Latham Clarke	1/300	Richard Smith Sr.	1/40
Thomas Clarke	1/111	Robert Spink	1/300
William Coddington	1/20	Henry Stevens	1/300
William Codman	1/300	Robert Taylor†	1/300
Walter Conigrave	1/60	Joseph Terry	1/200
Thomas Cook Jr.	1/111	Richard Tew	1/54
John Cooke†	1/250	Edward Thurston†	1/200
John Cranston	1/40	Henry Timberlake	1/200
Richard Dune†	1/200	Thomas Tooley	1/250
Thomas Dunger	1/200	John Tripp	1/250
William Earle	1/300	Lawrence Turner†	1/200
John Fairfield†	1/300	John Vaughan†	1/200
Thomas Fish	1/300	William Vaughan†	1/111
John Fones	1/900	Thomas Waite†	1/250
John Gould	1/111	Thomas Walston†	1/200
Thomas Gould	1/111	Marmaduke Ward†	1/450
John Greene	1/40	Thomas Waterman	1/200
John Greene Jr. of Warwick	1/200	William Weeden	1/111
Edward Greenman	1/111	John West†	1/450
William Hall	1/300	Matthew West	1/200
Thomas Hart	1/200	Daniel Wilcox†	1/111
William Havens†	1/200	Stephen Wilcox†	1/200
Robert Hazard	1/300	Jeremy Willis	1/200
Samuel Hubbard	1/300	Emanuel Wooly	1/200
Bartholomew Hunt†	1/450		

† *indicates that the signature was a mark*

The Purchase

Purchase of the islands progressed quickly once the prepurchase agreement among the colonists was settled. Richard Smith Jr. handled the negotiations with the most important of the Narragansett sachems, Cashanaquont. Smith Jr., who is designated as "of Narragansett" in the agreement, lived part of the time in Newport and part of the time at Smith's Castle in Wickford. He spoke the Narragansett language and was highly qualified to act for the consortium.

In April 1657, the trustees contracted with Cashanaquont to pay the equivalent of one hundred pounds sterling in wampum and peage (a form of white wampum) for Conanicut and Dutch Islands. Both the Narragansett and the colonists used wampum as currency at the time, silver and gold being rare in the colonies. Later that year, Cashanaquont and his warriors met with the purchasers in Newport and completed the transaction. In the sales document, Cashanaquont acknowledged receipt of the one hundred pounds and "several gifts of value beforehand received" and did "bargain for, make over, and make lawful sale of all and every part and parcel of the aforenamed Island Quononaqutt." He also agreed to ensure that the colonists' claim would not be disputed by other sachems:

> *And furthermore I the aforenamed Sachem Cashanaquont do hereby own myself obliged to clear and satisfy all ye other Sachems or others pretending, or that shall or may hereafter pretend or lay claim and interest in the premises to the disturbance of the premised purchasers. And moreover I hereby engage, that upon my own proper charge to satisfy them and every of them so claiming. And also in time convenient as shall be required by ye aforenamed purchasers I do engage upon my own proper charges to remove all ye Indian inhabitants, and clear them off from ye foresaid island Quononaqutt, and cause them to leave free and full possession of said Island wholly to ye said Purchasers, without putting ye said purchasers to any further charges, either for the Indians Corn fields or any other labours of the said Island.*

Despite the agreement, some Native Americans and colonists questioned the title to the island, and efforts continued to settle all claims. The Jamestown Land Evidence records contain three other sales documents between the colonists and individual Narragansett sachems.

Settlement and Purchase

In May 1658, a powerful mainland sachem named Quisaquann relinquished his title to Conanicut and Dutch Islands for an unspecified payment in cloth and peage.

In July 1659, Caskotappe and Wequaquanuit deeded their rights in return for £155 sterling in peage. The two sachems, grandsons of Canonicus, had earlier objected to the use of the grasses of the island under the 1636 Aquidneck Island sale, but at this time they agreed "to remove all such persons that live or work on either of said Island."

Finally, in January 1660, Towasibbam accepted five pounds sterling in peage for his interest in the island.

It is difficult to determine if the colonists negotiated fairly with the Narragansett and impossible to know if the sachems understood the concept of "sale" in European terms. The total amount paid for approximately six thousand acres, some of them unusable, was about £300. (Since the material goods given to Cashanaquont and Quisaquann were not specified in the sales agreements, a more precise figure cannot be calculated.) The £100 paid to Cashanaquont was twice what Richard Smith Sr. had paid Roger Williams for his trading post in Wickford thirteen years earlier. That was, however, a different kind of sale, including less land but both a trading post and, presumably, the good will of the people who traded there. According to early records from Providence, by 1678–79, land improved for planting sold at £3 per acre and vacant land not improved, for three shillings per acre. If the land on Conanicut were considered unimproved, the value of the farmland twenty years after the purchase would have been between £720 and £900.

FOUNDING A TOWN

The purchasers immediately hired a surveyor, Joshua Fisher, to survey Conanicut Island and to draw up their plan to divide its six thousand acres. They allocated forty-eight hundred acres to farms. They platted a town with one-acre house lots and reserved an artillery ground, a burial ground, and a prison. They set aside Dutch Island for common pasture.

During the following years, the trustees met to resell forfeited shares and to approve the sale of shares to men outside the consortium. For example, in notes from the meeting of the trustees on June 3, 1658, the 1/111th share originally assigned to Daniel Gould, one of the five who did not sign the agreement, was divided equally among Peleg Sanford, Bartholomew West, Ralph Earll Sr., and John Gould. This reallocation took place before the final survey, and Bartholomew West's name appears on the Fisher map.

The growth of the settlement during the twenty years after the purchase was slow. One of the island's original purchasers, Francis Brinley, was in his early eighties when he wrote in 1715:

> *After* [the survey] *every proprietor settled his lands, some sooner and some later, as to them seemed meet and convenient. The aforesaid John Green mentioned in the draught was the first person to improve his land, and immediately sowed hay seed on his land where about he intended to build a house.*

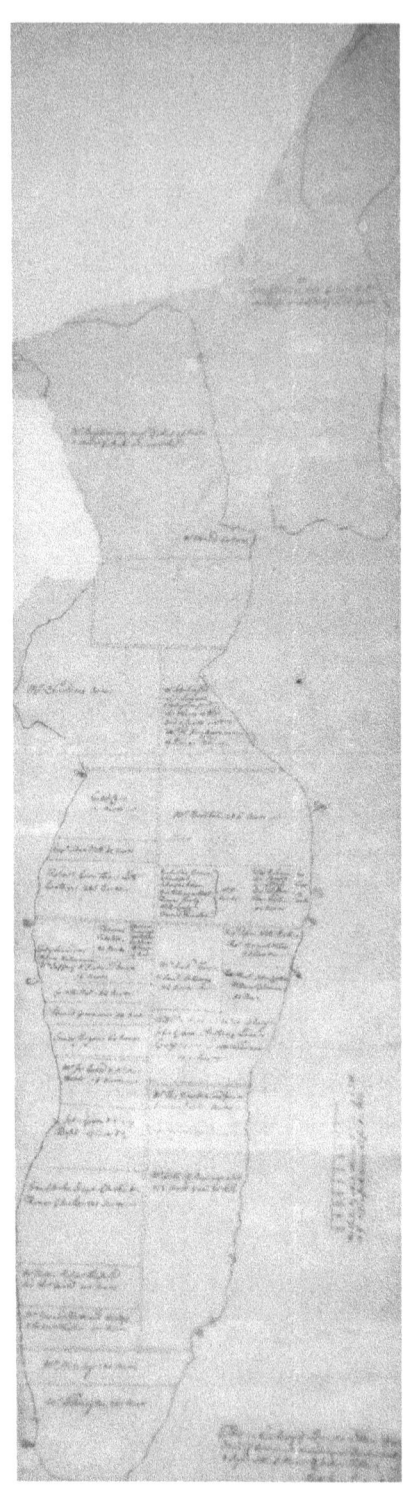

Map of Conanicut Island drawn by the surveyor Joshua Fisher in 1658. The southern tip of the island—Beavertail—is at the top. *Courtesy of the Town of Jamestown.*

Founding a Town

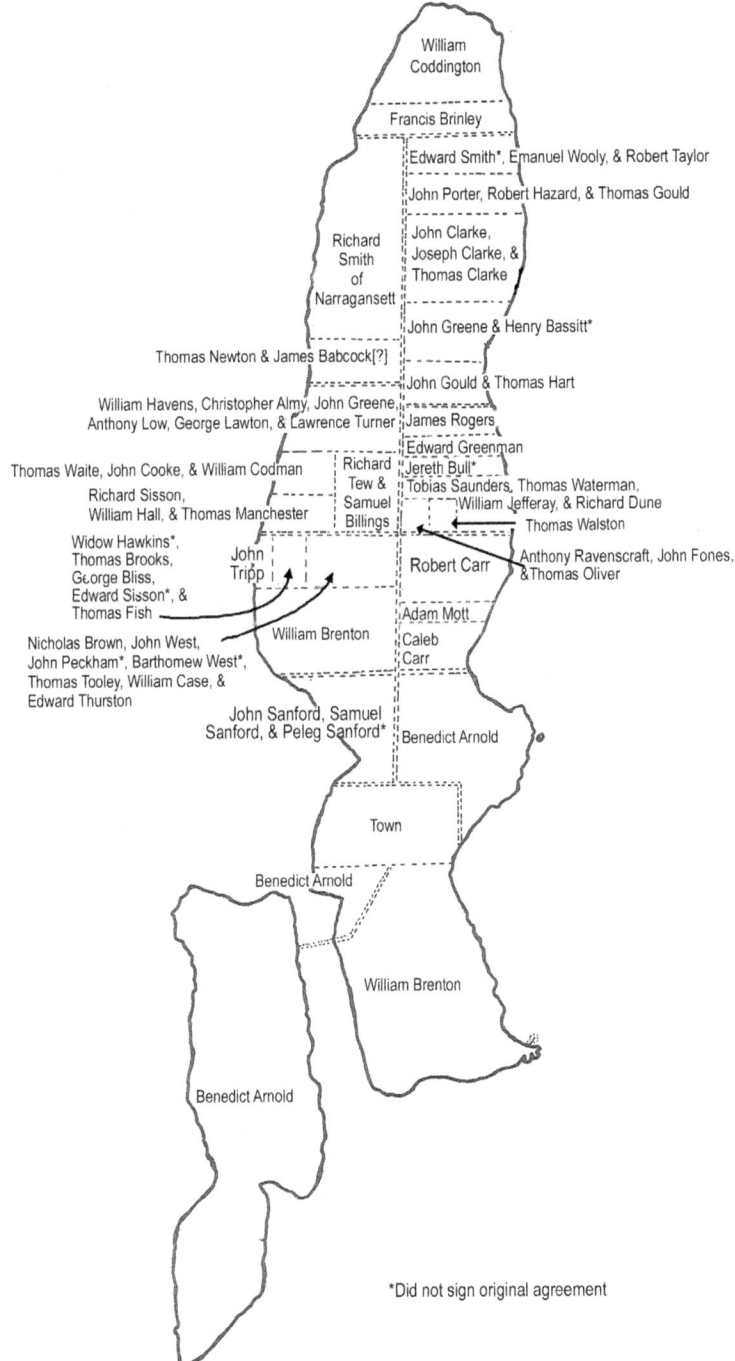

The 1658 map reoriented and with ownership indicated. *Courtesy of the Jamestown Historical Society.*

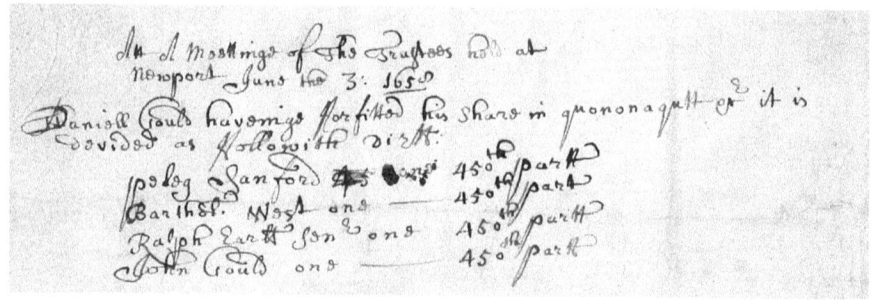

Notes from the June 3, 1658, meeting of the Conanicut Island trustees. At the meeting, the trustees reallocated the 1/111th share originally assigned to Daniel Gould. *Courtesy of the Jamestown Historical Society.*

Many of the original purchasers never moved to Conanicut Island. Some had probably engaged in land speculation and sold their shares almost immediately. The process of selling shares was complicated by the seventh article of the prepurchase agreement, which forbade "the purchasers or any of them to dispose or make any sale of their or any of their proportions of the premised purchase (as mentioned in the second Article) but only to a purchaser or purchasers of the premises," thus limiting possible buyers to members of the consortium. Benedict Arnold and William Brenton quickly bought up available shares and so acquired large tracts of land. At the time of the initial survey, Arnold already owned 1,411 acres instead of the 240 acres that his original one-twentieth share brought him.

A few of the original 101 men seem to have purchased their shares of the island with an eye to providing for their children. One of the purchasers spelled out his intention in the prepurchase agreement itself: "Henry Bull, having promised his son Jereth his share." Others, including the trustee Caleb Carr and his brother Robert, settled their sons on the island and used their interest in Conanicut to further their own financial interests in Newport.

THE CARRS

The Carrs arrived in Newport soon after it was founded, and both men participated actively in the political and commercial life of the town. In

Founding a Town

the prepurchase agreement, each of the Carrs contracted for a one-fortieth share in the island. On the 1658 Fisher map, Caleb's share was 125 acres on the east side of the island, just north of the Great Creek. Robert's portion was 263 acres, also on the east side, north of his brother's property. The two plots were separated by a 40-acre field belonging to Captain Adam Mott Sr. The size of Captain Mott's and Caleb Carr's fields were in accordance with their original shares, but the size of Robert's farm indicated that he had already purchased at least another one-fortieth share.

Over the next forty years, Caleb Carr built on his initial investment.

Transportation to and from Newport was critical to the economic growth of the island. As long as the land was used only for grazing, casual and intermittent communication across the three-mile-wide East Passage was sufficient, although even in the earliest days boats operating between Newport and Jamestown must have carried goods for more than one owner, with or without compensation. As farmers and their families began to populate the island, producing and requiring a wider variety of goods, a more formal ferry service became desirable.

The Carrs already owned a wharf in Newport. Their land on Conanicut Island faced Newport Harbor. By the late 1660s, Caleb Carr seems to have become a recognized common carrier. In January 1670, he was paid four pounds by the colonial government "for several services done by him and his boat to this day."

Caleb Carr was elected governor of the colony in May 1695 and died in a boating accident in December of the same year. His will contains a detailed description of his sons' inheritance, which also provides a partial history of the land purchases Caleb Carr made in Jamestown and a hint of his other activities on the island:

> *I give and bequeath unto my son Nicholas Carr...my farm, being and lying on the island of Conanicut, containing by estimation seven score acres, which I formerly leased unto him for about twenty years...as also that right in the share of Dutch island which belongeth to the said farm. Further... forty acres of land lying on the west side of the highway, over against my brother Robert Carr, his land on the said Conanicut island, as also ten acres of land on the said island which I purchased of John Peckham, Jr., and also twelve acres of land at the head of the forty acres aforesaid, which*

The old Carr Homestead. The house and grounds are still owned by the Carr family.
Courtesy of the Jamestown Historical Society.

twelve acres I purchased or bought of Benedict Arnold. Further, I give and bequeath to son Nicholas Carr...one-fourth of my share of land at Gould island, as also twenty-five feet in length of land from the west end of my ware house now standing upon my wharf here in Newport; the said land to be twenty foot in breadth, that if he see cause he may build upon it, or otherwise improve it. Further...that my said son Nicholas Carr shall have privilege of my wharf here in Newport, for his own occasions.

I give and bequeath unto my son Caleb Carr...the land at Conanicut, which I bought of Jirah Bull, Thomas Waterman and Richard Dunn... with the right in Dutch island belonging unto the said land, and also one quarter, or one-fourth part of my land at Gould Island.

I give and bequeath unto my son Edward Carr...fifty acres and half acre of land at Conanicut, which I bought of Jeremiah Willets, and sixty-five acres of land on said Conanicut island, which I bought of John Greene and Henry Bassett, as also ye right to Dutch island belonging to the said land.

Founding a Town

In the thirty-five years between the 1658 survey and the writing of his will in 1693–94, Caleb more than tripled his holdings on the island. By granting his son Nicholas the land next to his warehouse in Newport and continued access to the pier there, he encouraged the profitable continuance of the ferry service.

INCORPORATION

In 1678, Caleb Carr and Francis Brinley petitioned the Rhode Island General Assembly to incorporate the settlement on Conanicut Island as a town, claiming that the new town had 150 inhabitants. On November 4, 1678, the General Assembly voted "that the said petition is granted; and that the said Quononoqutt shall be a Township, with the like priviledges and libertyes granted to New Shoreham." The new town was called James-Towne, and four days later the assembly assessed the new town twenty-nine pounds toward defraying the colony's debts. No direct evidence exists identifying the "James" for whom the town was named, but it is generally believed to be James, Duke of York, brother to England's reigning monarch Charles II and the future King James II.

The first town meeting was held in April 1679. John Fones was elected moderator and town clerk. Francis Brinley, Caleb Carr Sr., Caleb Carr Jr., and Nicholas Carr constituted the town council. Ebenezer Slocum and Caleb Carr Jr. were chosen as constables as a consequence of Michaell Kally "obstinately refusing to take his engagement to said office." Peter Wells became the town sergeant, and John Fones and Ebenezer Slocum were the deputies of the court. Nicholas and Caleb Carr Jr. took on the task "to be viewers of cattle, sheeps, swine, and horses which may be carried or transport from this Township."

One of the most important orders of business during the early days of the town was the laying out of roads. In his original survey, Joshua Fisher set aside an area along the Indian trail that ran between the East and West Passages for a village; the trail is now called Narragansett Avenue. (Until 1894, it was Ferry Road.) Another east–west road, North Ferry Road, crossed the island near what is now Eldred Avenue.

The artillery green, originally envisioned as the town green, was platted halfway between the East and West Passages on the north side of Ferry Road at what became known as the Four Corners. To the west of the artillery green, North Main Road ran—as it does today—north along the length of the island. Another Indian trail, now Southwest Avenue, led to the narrow beach at Mackerel Cove. No roads passed through the Beavertail area.

Portions of North Main Road were impassible because of the Great Creek and surrounding wetlands, and in 1681, the town council addressed the issue by approaching Joseph Remington "about a highway at the sea side on the east side of the island until such time as the other highway be made passable." The agreement resulted in a road along the east side, skirting Potter's Cove, turning west slightly north of the current Newport Bridge toll plaza, and crossing back to North Main Road along Weeden Lane.

This roundabout way from the village to the North End seemed sufficient for forty years, perhaps because the village did not offer much to the farmers whose lives centered on their farms. Finally, in 1722, the town voted to build a bridge over the Great Creek. Three years later, in June 1725, the General

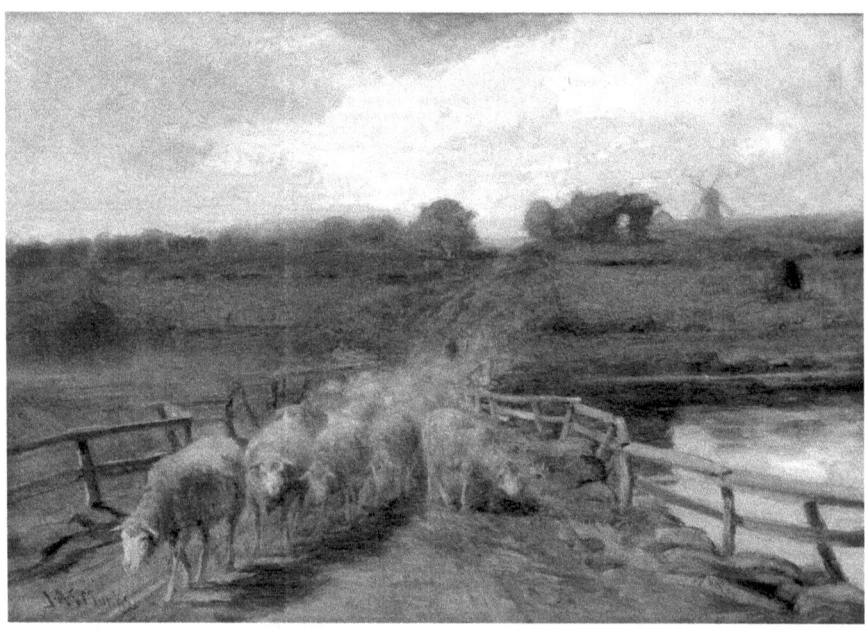

Sheep on the North Main Road Bridge across the Great Creek and saltwater marsh. This painting is by John Austin Sands Monks. *Courtesy of Richard Hutchinson.*

Founding a Town

Assembly voted "that there be 10 pounds out of the general treasury allowed to Jamestown toward the building of a bridge on their island." The bridge and the connecting highways were completed in 1729.

With the bridge, a traveler could cross the creek and marsh, but gates across the road often impeded further travel. As early as 1681, the town sold and leased sections of roads to farmers, who were allowed to fence them in with their own property with the proviso that they leave "bars or gates for people to pass with horse and cart." For this privilege in 1707, the farmers paid "10 shillings a year into the town treasurer for every such highway so fenced," providing an important source of revenue for the town. Multiple barred gates interrupted traffic on the only road down Beavertail into the early twentieth century.

Access to the shores on the east and west sides of the island was a different issue. Most farms had been laid out to run from North Main Road to the water. Reaching the shore usually required crossing private land. An

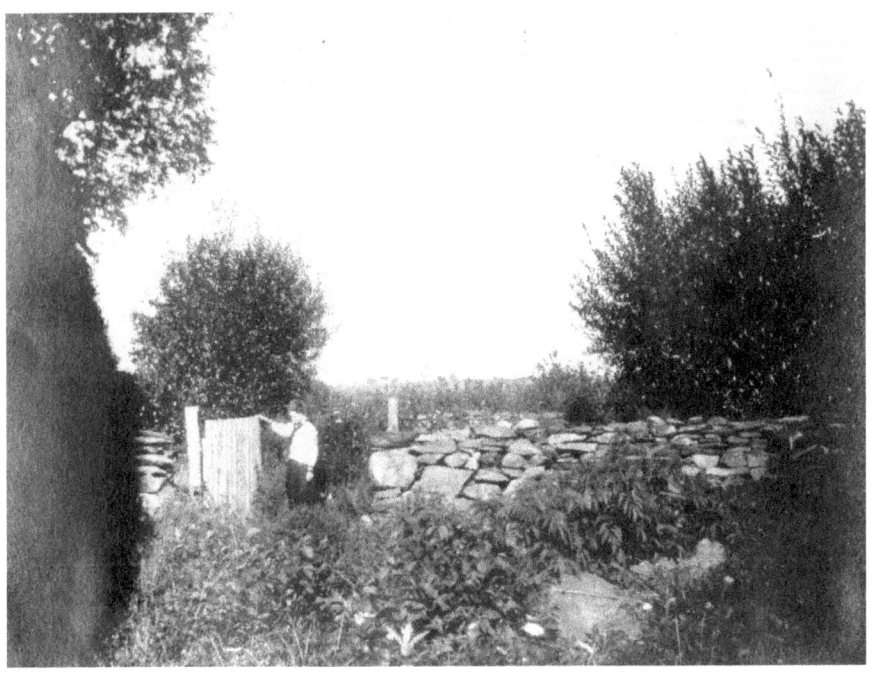

Town pound on North Main Road. During the colonial period, farm animals found loose were held at the pound until the owner could retrieve them. *Courtesy of the Jamestown Historical Society.*

altercation about such public access occasioned a letter in 1771 from David Chesebrough, the agent for an absentee owner, to his employer:

> *A very unhappy affair…between your tenant Pearce and Martin as they were mending highways of which Martin was the overseer which ended in Martin's breaking Pearce's head &c…The people in general are on Martin's side and are determind to have a highway run thro' your farm in order to fetch sand to mend the bridge on the highway south of your farm which they say is a priviledge they have had for this 40 years which it seems Pearce opposed and occasiond his broken head.*

The determination to ignore the owner's property rights in this particular case might have been politically motivated since the absentee owner was Thomas Hutchinson, a Tory and the last civilian governor of Massachusetts under British rule.

Farm animals in the roadways were also a problem. In 1698, the town council declared "that no hog or hogs, nor pig nor pigs shall be keep in the highways without a yoke on them" and voted to build a pound to hold animals seized under the ordinance. In 1717, the council further prohibited the pasturing of cattle, including sheep and horses, in the highway and established fines for violation.

Strategic Importance

Economically during this era, Jamestown was an agricultural adjunct to the thriving city of Newport. Agricultural products from Conanicut Island were shipped to Newport for consumption and transshipment to distant ports.

Newport—along with Boston, New York, Philadelphia, and Charleston—was one of the major ports on the East Coast. It had a deep, protected harbor. Unlike Boston, hidden behind the hook of Cape Cod, it had quick access to the open ocean and the shipping lanes that led to the southern colonies, the West Indies, and Africa. In 1708, Governor Cranston reported that 103 oceangoing vessels had been built in the colony in the previous ten years, and by 1740, Rhode Island's merchant fleet—the majority of it home-

Founding a Town

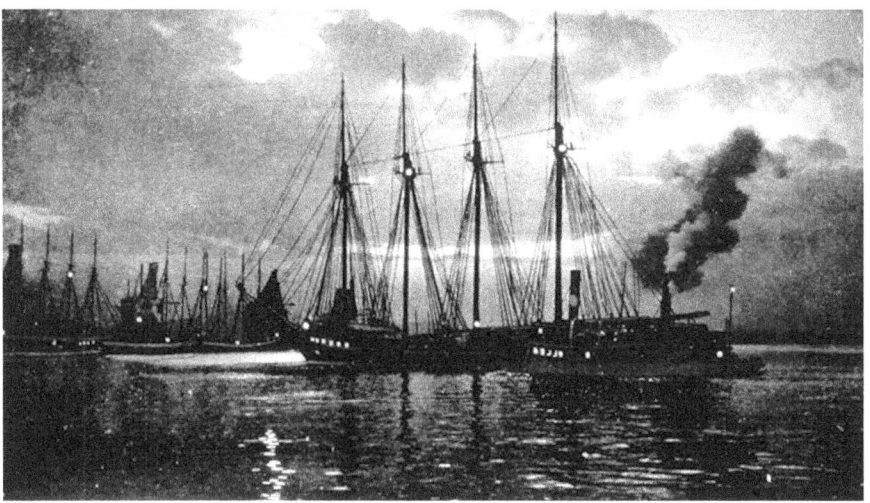

The port of Newport. Farm products from Conanicut Island reached markets in the southern colonies and as far away as the West Indies through Newport. *Courtesy of the Jamestown Historical Society.*

ported in Newport—numbered 120. With a major port so near, Jamestown developed no large-scale shipping of its own.

However, Conanicut Island's position at the entrance to Narragansett Bay made it strategically important to Newport's commercial growth. The approach to Narragansett Bay from the open ocean through Rhode Island Sound, though direct, is hazardous. Water depth decreases gradually from 150 feet to 75 feet, but rocks and reefs rise abruptly as the shore is approached. Visual clues to the bay entrance are few. Even at close range, the entrance to the East Passage is hidden behind Brenton Point. Brenton Reef, an underwater cluster of rocks stretching southwest from Brenton Point for three-quarters of a mile, creates a further barrier. From the sea, the contours of land from Point Judith to Narragansett blend into those of Jamestown, disguising the West Passage as well.

In the late seventeenth and early eighteenth centuries, a different kind of hazard also threatened Newport. The wars between England and France, known in the colonies as King William's and Queen Anne's Wars, resulted in privateering and piracy—often indistinguishable from each other—along the coast. The merchants of Newport wanted early warning of any intrusion, whether from a foreign power or a buccaneer.

Jamestown

The best place from which to guard both the East and West Passages was the southern tip of Conanicut Island, and a "watch house" may have been built there as early as 1667, before the town was incorporated. In any case, the structure evidently was not new when, in 1705, the town council ordered that "there be a chimney built at the watch house at the discretion of Captain Stephen Remington." Seven years later, on June 9, 1712, toward the end of Queen Anne's War, the council strengthened the watch at Beavertail, ordering Stephen Remington's son Gershom "to warn the Indians to build a beacon as soon as possible at Beavertail" and directing Benedict Arnold, the owner of the Beavertail land, to "look after the watch and see that it be faithfully kept." The council backed up the orders with a series of fines to be levied for failure.

For the next thirty years, Jamestown kept the watchtower and beacon in good repair, but the navigational help they provided was not sufficient, and by the 1730s, Newport ship owners were agitating for a true lighthouse. In

Record of payment by Thomas Richardson, general treasurer of the Colony of Rhode Island, to John Stevens for his work on the 1753 Beavertail Lighthouse. *Courtesy of the Jamestown Historical Society.*

Founding a Town

1749, according to the Newport town records, "a committee was appointed to build a light house at Beavertail on the island of Jamestown, alias Conanicut, as there appears a great necessity for a lighthouse as several misfortunes have happened recently for want of a light."

Peter and Joseph Harrison were hired as architect and contractor, respectively, and the first Beavertail light was built. The tower, largely made of wood, was sixty-nine feet tall, with the light rising eleven feet more. The octagonal stone base was twenty-four feet in diameter, tapering to eight feet at the top of the lantern. Abel Franklin was appointed the first keeper of the light.

Four years later, the light burned to the ground and was immediately replaced by a stone structure. The 1753 tower guided ships into Narragansett Bay until the current light was built in 1856, although the beacon was briefly darkened when the British torched the tower and removed part of the lighting equipment during their retreat from Newport in 1778.

Slave Trade and Slavery

The Beavertail light was of great importance to Newport merchants because, by the early eighteenth century, they were developing the highly profitable "triangle trade." Rum distilled from West Indian molasses in at least twenty-two distilleries in the Newport area was loaded on ships bound for West Africa. The rum was exchanged for enslaved Africans, and the ships returned across the Atlantic to the West Indies where most of their human cargo was traded for molasses. The molasses returned to Newport to be distilled into rum. Some of the slaves were sold in the southern colonies, and trade also developed along the coast in a north–south flow.

While the New England slave trade centered on Newport and, later, Bristol, the ownership of slaves, both African and Native American, was pervasive across Rhode Island and especially southern Rhode Island. The statistics from the colonial era do not always distinguish between free men of African descent and slaves, perhaps because of the 1652 Rhode Island antislavery law

that no black mankind or white [could be] *forced by covenant, bond or otherwise, to serve any man or his assignees longer than ten years, or until they became twenty-four years of age, if they be taken in under fourteen, from the time of their coming within the limits of the colony; and at the end of the term of ten years, they were to be set free, as the manner is with English servants.*

While the law was ignored in practice and the existence of slavery was recognized in other laws, the term "servant" seems to have been used independent of terms of bondage.

The population data for Rhode Island, collected by Governor Samuel Cranston in 1708, shows a great preponderance of black over white servants but does not contain information about the status of either. The high ratio of servants to inhabitants in Jamestown can probably be accounted for both by the agricultural nature of the economy and by the fact that some of the major landowners were freemen in Newport—or, to a lesser extent, Kingstown and Portsmouth—and would have been counted as inhabitants of those towns.

RHODE ISLAND COLONIAL RECORDS, 1708

Town	Total Inhabitants	White Servants	Black Servants	# Inhabitants/ Servant	% of Servants Listed as Black	Black Servants as % of Pop.
Newport	2203	20	220	8	92%	10%
Providence	1446	6	7	110	53%	0.4%
Portsmouth	628	8	40	12	83%	6%
Warwick	480	4	10	33	71%	5%
Westerly	570	5	20	22	80%	3%
New Shoreham	208		6	37	100%	3%
Kingstown	1200		85	13	100%	14%
Jamestown	**206**	**9**	**32**	**4**	**78%**	**15%**
Greenwich	240	3	6	26	66%	3%
State	7181	55		14	88%	6%

Founding a Town

Many wills and inventories of estates from the colonial period and early nineteenth century contain references to both African and Indian slaves. Caleb Carr, in 1695, left "to my said wife Sarah Carr, my Negro woman Hannah…unto my son Edward Carr my Indian boy named Tom…unto my daughter Elizabeth Carr, my Negro boy Joe." The inventory and evaluation of the estate of Thomas Carr, who died in 1776, contains reference to "one Negro man name Jem, 45 pounds; two Negro women, Rose and Kdonar, 20 pounds; one Negro boy Pero, 20 pounds."

By 1774, when the importation of slaves into Rhode Island was formally prohibited, the population of the colony had risen to 59,707 and the population of African Americans, both slave and free, to 3,668—still about 6 percent of the whole. In Jamestown, the percentage was much higher. Over 20 percent of the 563 people living on the island were Africans or African Americans, down from a high of 36 percent in 1756. How many of the African Americans in Jamestown were slaves and how many were free is hard to determine. In Newport at the beginning of the American Revolution, about 88 percent of the more than 1,200 African Americans were slaves. It is unlikely that the proportion in Jamestown differed much.

The eighteenth century saw the growth of antislavery sentiment, especially among Quakers, the dominant faith in Jamestown. Their position is conveyed in a manumission statement in the *Friends Records of Newport* in 1775:

> I, James Coggeshall, of Newport…believing it to be contrary to true Christianity, and divine injunctions of the author thereof, to hold mankind as my property, or continue her in a state so as to be subjected to slavery after my decease, and in consideration thereof, and other causes me thereunto moving, I do myself, my heirs, executors and administrators, manumit, release and discharge the aforesaid Negro from a state of slavery, and hereby declare her to be henceforth a free woman.

Laws that freed Rhode Island's slaves had to wait until after the American Revolution, and even then, emancipation was a gradual process. In 1784, the Rhode Island General Assembly passed the Negro Emancipation Act, freeing the children of slaves when the men became twenty-one and the women eighteen. In 1787, Rhode Island became the first state in the union

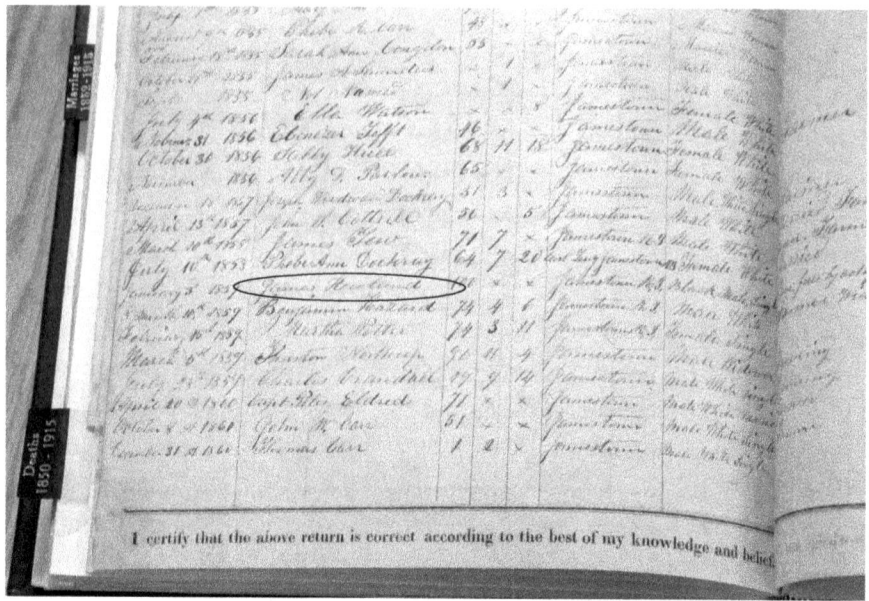

James Howland's death recorded in Jamestown's *Registry of Births & Deaths, 1850 to 1916*. He was "a Slave Freed by the Act of 1792." *Courtesy of the* Jamestown Press.

to prohibit its citizens from engaging in the slave trade—a prohibition that was universally ignored.

Neither law had any immediate impact in Jamestown, where economic considerations had reduced, but not eliminated, dependence on slave labor. A list of taxable assets from 1783 documents thirteen slaves between ten and fifty years of age. James Howland, reputedly Rhode Island's last slave, died in Jamestown on January 3, 1859. He was born in Jamestown one hundred years earlier.

THE AMERICAN REVOLUTION

In Jamestown's first one hundred years, the population of the town more than tripled. By 1774, 563 people were living and working on the island. The farms prospered. Ferries from Narragansett brought South County produce—mostly sheep and cheese—to Jamestown to be loaded on ferries to Newport. Inns and "houses of entertainment" were licensed near the docks to accommodate passengers required by the vagaries of the weather to wait for the ferry in Jamestown. Other small businesses rose up to support the farmers and travelers.

These years of growth and prosperity ended with the American Revolution.

TAXES AND CONTROL OF THE BAY

Newport's early mercantile success attracted the attention of the English government, intent on making its colonies income-producing ventures. A molasses tax was imposed in 1733, cutting into the profitability of rum production and the triangle trade. Other taxes followed. The government, however, found the new taxes difficult to collect from a distance and without local cooperation. Smuggling was common. In 1769, the armed sloop *Liberty* arrived to enforce the law. From 1769 to 1775, as the colony moved closer

to open revolt, the British revenue ships patrolled the bay under increasingly hostile conditions.

The first shots of the Revolution were fired in Massachusetts in April 1775, and in mid-June, the first naval engagement of the war took place off the north end of Conanicut Island. Earlier that month, the Rhode Island General Assembly had commissioned the sloop *Katy*, owned by John Brown of Providence and commanded by Abraham Whipple, a veteran privateer, "to protect the trade of this colony." The English knew that a ship was being armed and sent the *Diana*, a tender of the British flagship frigate *Rose*, from Newport to reconnoiter. Savage Gardner, master of the *Diana*, reported the incident to his superiors:

> *As I was standing off between the North end of Connecticut* [Conanicut] *Island and Gold* [Gould] *Island...a Sloop coming down before the wind, I lay'd too to speak her...She hail'd Us and told Us to bring too or she would sink Us immediately and directly fired a shot which we returned with our Small Arms and Swivels and kept a smart fire on both Sides for near half an hour, till by accident the Powder Chest with the remainder of the swivel Cartridges blew up...I thought it prudent to run her ashore which I accordingly accomplished near the North end of Connecticut* [Conanicut] *and got on shore.*

The men from the *Diana* separated and hid until the next day, when they could rejoin the *Rose*.

The vulnerability of the bay islands was not lost on the colonial leadership, which feared they would become sources of provisions for the enemy. In August 1775, the General Assembly voted "that all cattle and sheep, that are fit to be killed, be forthwith removed and carried off all the islands...and the stock of Jamestown be removed to South Kingston." Abraham Whipple and the *Katy* carried out the evacuation. The record for reimbursement shows that 45 oxen, 9 cows, 444 sheep, 24 heifers, 5 bulls, and 5 steers, valued at £850 and nine shillings, were taken off the island.

With the livestock went many of the inhabitants of Jamestown. The remaining men began protective actions. On October 16, the town council voted that a watch be set each night. About the same time, the town clerk moved all the town's records to the house of Matthew Allen in North Kingstown.

The American Revolution

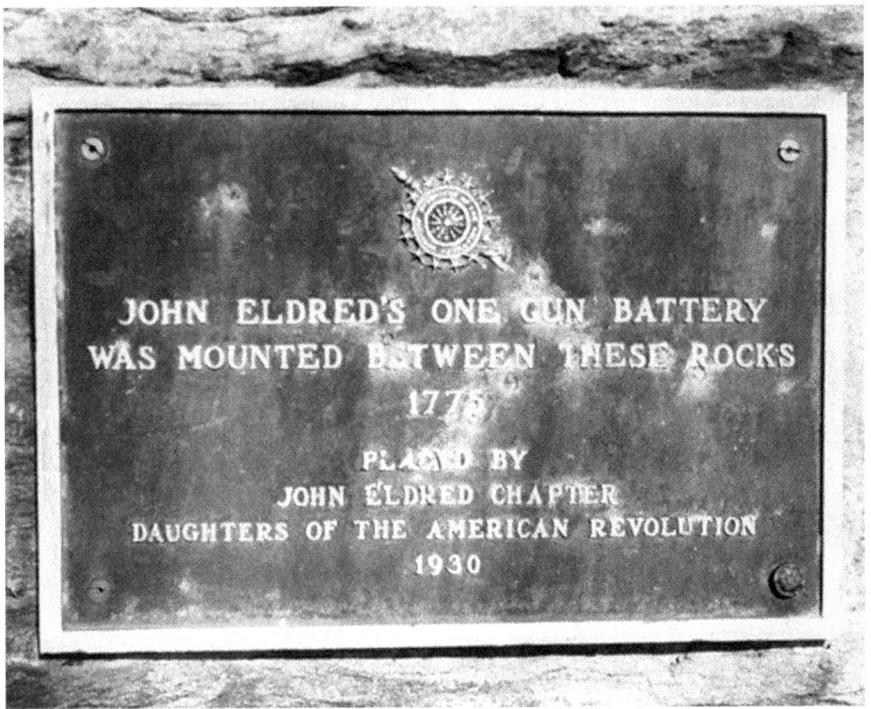

Daughters of the American Revolution plaque commemorating John Eldred's one-gun battery. *Courtesy of the Jamestown Historical Society.*

Some of the Jamestowners set out to harass and annoy the British. The most famous was John Eldred with his one-gun battery. Eldred owned a farm on the East Passage north of Potter's Cove. According to legend, he hid a cannon between two large boulders overlooking the bay and the entrance to Newport Harbor. Because he had some powder but no shot, he gathered appropriately sized rocks to use as cannonballs. He lobbed the rocks toward the revenue ships as they went up and down the bay. Most of the shots landed harmlessly in the water, but one found its mark, tearing out a mainsail. In response, the English sent a contingent ashore to make the cannon inoperable. Seeing the landing party, Eldred fled and found safety in the marsh around the Great Creek.

On December 10, reprisals began. Whether the English were responding to specific acts of harassment or merely continuing what had become a war of terror is unknown; the outcome for the islanders was the same. The most

complete story of the attack is found in the diary of the Reverend Ezra Stiles, pastor of the Second Congregational Church in Newport.

> *Dec. 11, 1775. About 1 o'clock yesterday morning a Bomb Brig, 1 schooner, & 2 or 3 armed sloops went to Conanicott & landed upward of Two hundred Marines Sailors & Negroes at the E. Ferry and marched in three divisions over to the W. Ferry, & set the several houses on fire there, then retreated back sett fire to almost every house on each side of the road, & several Houses and Barns some distance on the N. & S. side of the Rode, driving out Women & Children etc.*
>
> <div align="center">HOUSES BURNT & LOST</div>
>
> | Widow Hull | 1 house |
> | Jos. Clarke, Esq. | 2 houses & 1 Barn |
> | Thos. Fowler | 1 house & 1 Crib |
> | Ben. Ellery | 2 houses & 1 Store |
> | Benj. Remington | 2 houses |
> | Jno. Gardiner | 2 houses & 1 Tanyard |
> | Gov. Hutchinson | 1 house |
> | Wm. Franklin | 2 houses |
> | Abel Franklin | 1 house |
> | Bend. Robinson | 1 house |
> | Howland | <u>1 house</u> |
> | | 16 Dwellings |
>
> *A Company of Minute Men had left Conanicut the Aft. Before so that there were but 40 or 50 soldiers on the Island, of which 22 were well equipped. At the Cross Rodes there was a Skirmish our pple killed one Officer of Marines and wounded 7 or 8. Not one Colonist was killed or hurt in the Skirmish. The Kings forces fired on Mr. Jno. Martin, aet. 80 standing at his Door and wounded him badly. Mr. Fowler had about 30 Head Cattle: these the Regulars carried off and perhaps a dozen Head more, about 30 Sheep & as many Turkeys, and some Hogs, Beds, Furniture and other plunder. They returned on board at X or XI o'clock & came in this Harbor about Noon."*

The American Revolution

The story of the burning of John Howland's house is told in greater detail in Howland family lore as recorded by Mary (Mrs. John E.) Hammond:

> *They took possession of the house of John Howland after the family had retired for the night; and seizing Mr. Howland tied him fast, and carried him on board one of their vessels where they kept him for three days within sight of his ruined dwelling. After thus seizing him and binding him, they ordered Mrs. Howland to prepare for them a supper from the very best the house afforded…She brought out and placed before them the best of her well filled and capacious pantry and sent down into her cherished cellar stock of preserves, jellies, and relishes and they ate, drank and were merry. But after feasting their beastly stomachs, they were not content to depart and leave their victims with a shelter for their defenceless heads, but rising from the table, they threw the dishes and whatever they could lay their hands on into the blazing fireplace, robbed the dwelling of whatever valuables it contained and then applied the torch to the house and out buildings.*
>
> *The following day there was a dead calm on the waters of Narragansett Bay which prevented the vessels from sailing as planned. For three days the calm continued and each day at the break of dawn, Mary Howland rowed to the side of the vessel on which her husband was held a prisoner. No threats could drive her away, and although it was bitter cold, she kept her lonely vigil. Whenever the officer in command appeared on the deck, she begged him for the release of her husband. Finally the officer becoming exasperated with persistency, told her to come on board and after listening anew to her pleadings, he impatiently called to his aide, "Damn it! A woman who thinks so much of her husband should have him—release him and let him go."*

The English troops confined their destruction to the town. The farms at the North End and Beavertail were not harmed; even the Greene farmhouse, only about 350 yards north of the track the troops took across the island, was spared.

The small British fleet—eight armed vessels under the command of Captain Sir James Wallace—continued to control the bay and, as the Reverend Stile's diary testifies, to terrorize Jamestown:

JAMESTOWN

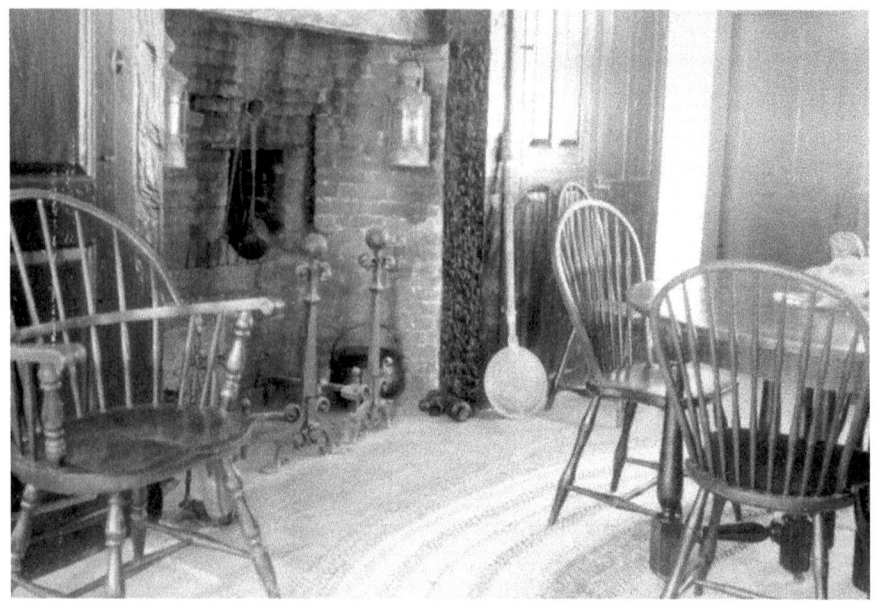

The interior of the Greene farmhouse on Shoreby Hill, one of the oldest houses on the island. *Courtesy of the Jamestown Historical Society.*

> *January 2, 1776. This day some of the ships fired upon Conanicut.*
> *Feb. 28, The Men o' War returning along Conanicott fired on it.*
> *March 2. The Fleet sailed northwards firing on poor Conanicott. One Gun a nine pounder there returned the fire & the shot entered Wallace's Ship.*

On May 4, 1776, the Rhode Island General Assembly renounced all allegiance to Great Britain. Soon after, Wallace and his fleet vanished from the bay, giving the farmers left on Conanicut Island a short respite from enemy harassment.

OCCUPATION

Meanwhile, Rhode Island was preparing for war. The General Assembly, at the March 1776 session, passed an act for the purchase of "two thousand stand of good firearms, with bayonets, iron ramrods, and cartouch boxes, for

The American Revolution

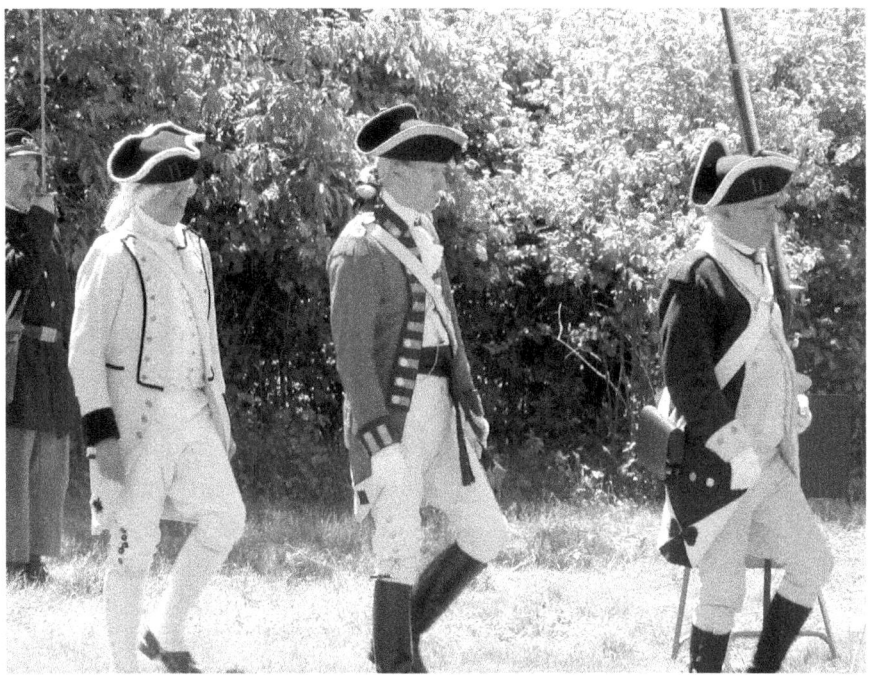

Colonial, British, and French officers representing the countries that occupied the Conanicut Battery celebrated the reopening of Conanicut Battery Historic Park in June 2002. *Photograph by Varoujan Karentz.*

the use of this colony." Of the eighteen companies formed by the legislation, four and a half were to be stationed in Jamestown. The Conanicut Battery, one of several batteries built along the shores of the bay, was erected on the west side of Beavertail near its northern end.

Men were needed to complete the companies, and in November, the General Assembly voted a levy of six men out of every one hundred male inhabitants in each town. Jamestown could not meet the levy—even though it was only six men. The events of 1775 and 1776 had severely depleted Jamestown's population. Over 40 percent of its people had fled the island. Those who remained were primarily either Tories, who refused to renounce their allegiance to Great Britain, or Quakers, whose faith forbade them to fight.

On December 7, 1776, a British convoy carrying six thousand British and Hessian troops sailed up the West Passage and around Conanicut Island to enter Newport from its more vulnerable north side. According to the

diary of Lieutenant Frederick MacKenzie, an officer in the Royal Welsh Fusiliers, "No enemy appeared on either side as we went up." The battery on Conanicut Island was clearly visible to MacKenzie as the fleet sailed by: "About 2 miles from the Light House, the Rebels had a Battery or Redoubt with 4 embrazures toward the channel. But it appeared to be abandoned."

On December 12, having secured Newport, the British sent a detachment from the Fifty-fourth Regiment to take possession of Jamestown, and on December 20, the entire regiment was quartered in Jamestown. Over the next year and a half, the British and their Hessian allies held the island. Aware that the West Passage afforded a path to flank their troops in Newport, they rebuilt the Conanicut Battery in its current configuration. They cut down most of the trees on the island for firewood. They harassed the remaining residents.

According to family tradition, as reported in W.L. Watson's *The House of Carr*, Nicholas Carr was one of those harassed. As the story goes, a British captain struck Carr on the head with his cane. Carr, despite his Quaker beliefs, responded by thrashing the captain with his own cane. The captain had Carr arrested and held prisoner aboard his ship.

> *Each morning he was brought on deck, a rope put around his neck, and given the choice of getting down on his knees and kissing the hand of the captain and being liberated, or being hung at the yard arm of the vessel.*
>
> *While he was thus held prisoner, William Battey, a Tory and near neighbor...went on board and interceded for him. Finding that the fear of hanging had no effect on this staunch patriot, and possibly because of this friendly act from a Tory, he was finally liberated and sent ashore.*

A brief break in the occupation occurred in late July 1778, with the arrival of the French fleet under Admiral Charles Hector, comte d'Estaing. When d'Estaing's fleet appeared at the mouth of the bay on July 29, the British withdrew all their forces to Newport. They spiked the guns at the Conanicut Battery on Prospect Hill and tossed the two twenty-four pounders they had installed at the Dumplings into the bay.

The French landed four thousand troops on Conanicut Island to join American forces under General John Sullivan for the assault on the British in Newport, a battle that became known as the Battle of Rhode Island. For

The American Revolution

a month, Jamestown was free of British domination. Following the failure of the attack, the British reoccupied Jamestown, rearmed the Conanicut Battery, and continued to denude the island of trees to keep the troops in Newport warm.

At last, on October 25, 1779, the British and Hessian troops evacuated Newport and Jamestown to join the British forces in the southern colonies. The desolation they left behind was complete. Food and wood were scarce; money to buy them with was almost nonexistent. Even the weather seemed to conspire against the islanders—for six weeks, the bay was frozen solid. Spring brought little cheer to the remaining families on the island—farmers with land and house but with little seed to plant and no livestock.

The French returned in July 1780. Jean-Baptiste Donatien de Vimeur, comte de Rochambeau, the French commander in chief, made Newport his headquarters, and General George Washington joined him there to plan the summer campaign that would end at Yorktown.

Jamestown's single moment in the sun arrived on March 6, 1781. General Washington with eight officers and aides took the Old South Ferry from Saunderstown to Jamestown, landing at the West Ferry. They crossed the island along what is now Narragansett Avenue and were met at East Ferry by a French barge that took them to the Rochambeau meeting and a gala celebration in Newport. Washington and his aides returned to his headquarters by way of Providence, so this short trip across the island is the only time he set foot in Jamestown.

Some of the French stayed in Jamestown for over a year, repairing and manning the battlements at the Conanicut Battery and patrolling the island. A French hospital was set up. The French presence was not always a boon. Over the year, the town council officially complained about the damage done to fences and walls and requested that soldiers "might not be Permitted to come on shore without some Good and Known officer over them."

With the end of the war, Jamestown settled into an era of limited expectations and limited growth.

REBUILDING JAMESTOWN

The Revolution and the British occupation left Jamestown depopulated, and its remaining inhabitants faced rebuilding a town practically from the ground up. For almost one hundred years, the island remained an agrarian backwater, a community dependent almost exclusively on agriculture in an increasingly urban and industrialized world.

The Economy

Before Jamestowners could rebuild the social fabric of their town, they had to establish ways of making a living. During the colonial period, under the shadow of Newport, Jamestown had never developed a mercantile tradition, and no significant shipbuilding or ship-chandlery industry existed in either place after the devastation of the British and Hessian occupation. Fishing was on a small scale, with the ferries absorbing most of the marine expertise. Although by 1780 other parts of the state were already being affected by the Industrial Revolution, Conanicut Island had no source of power to be harnessed for industrial use.

Conanicut Island's only resource was the land.

A View of Jamestown, RI, about 1830. The painter is unknown. *Courtesy of the Jamestown Historical Society.*

The farmers who had remained on the island throughout the conflict had already experienced the hardships of farming in an isolated and hostile environment. With the end of the war, they redoubled their efforts to produce a living from the land while initially remaining at arm's length from other communities around the bay. In the unsettled postwar days, returning families and newcomers swelled the island's population to over five hundred. But many did not remain, and by the 1820s, the population had slipped to about four hundred, where it stayed until the early 1870s.

Without easily available markets, these farmers concentrated at first on raising enough food for their families and trading the excess for necessities that they could not produce themselves. Real wealth, exclusive of land, was small. Job Watson, a latecomer to the island who was almost denied entrance to the town because it was feared he would become a burden, listed his assets in 1784: "360 Acres Land. 33 cows, 4 oxen, one two-year-old heifer, 1 ditto Bull, 1 ten-year-old horse, 1 ditto 3-year-old, 1 ditto 2-year-old, 12 hoggs, 7 silver spoons, 6 ditto tea spoons, cash 5d. Obligations against me to the amount of 8d more than I have owing to me." Twelve years later, Watson would be the largest landowner on the island.

Rebuilding Jamestown

THE JAMESTOWN GRISTMILL

One of the first communal postwar efforts undertaken by the struggling farmers was the building of a gristmill, which—because there was no waterpower on the island—was powered by the wind. Jamestown had had a windmill earlier in the eighteenth century, although it fell into disrepair sometime in the 1740s or 1750s. In 1787, the town petitioned the General Assembly for the grant of a part of Colonel Joseph Wanton's farm for the mill. Wanton, a Tory, had fled to New York City with the British in 1779. The state confiscated the farm and granted the town half an acre. Job Watson acquired most of the Wanton property, adding it to his already substantial estate.

The mill, known as a smock mill because of a fancied resemblance to a countryman's linen smock, ground primarily locally grown flint corn into johnnycake meal and feed for horses and cattle. An island mill increased the town's independence from its neighbors. The gristmill was paid for using a tactic familiar from earlier in the century: the selling of public highways to private owners.

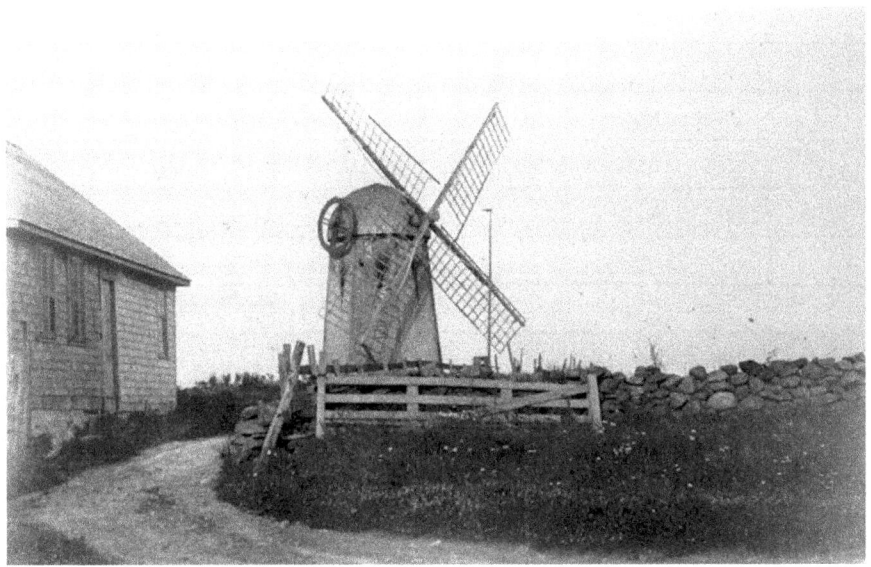

The Jamestown Windmill, built in 1787. Locally grown flint corn was ground at the mill primarily for use on the island. *Courtesy of the Jamestown Historical Society.*

Jamestown

Jamestown Windmill
Technical Data

Millstone
Diameter: 5 and a half feet
Thickness: 15 inches
Estimated weight: 3,500 pounds.
Spread of arms: 50 feet
Sail area: 540 square feet.
Gear ratio: 1 revolution of arms=5 turns of stone
Diameter of base: 20 feet
Diameter of base of bonnet: 15 feet
Teeth in ring gear at base of bonnet: 220
Turns of sprocket wheel necessary for quarter turn of bonnet: 16

The Millers, 1788–1896

1788–1795	Jethro Briggs
1795–1827	Nathan Munro
1827–1847	Caleb F. Weaver
1847	William G. Carr
1847–1850	Arnold Hazard
1850–1855	Job W. Hazard & Eben Tefft
1855–1874	John W. Potter
1874–1882	Isaac W. Potter
1882–1883	Elijah Anthony
1883–1888	William A. Barber
1888–1893	Philip A. Brown
1893–1896	Thomas A.H. Tefft & Jesse C. Tefft

The mill operated for 109 years. In 1896, the Jamestown miller found that he could no longer compete with the rolling mills in the West, which could produce cheaper steel-ground meal and flour, and he was obliged to close

the mill. In 1904, a group interested in the town's history bought the derelict building and repaired it. The Jamestown Historical Society now owns the mill and maintains the structure and machinery much as they were when the mill was abandoned at the end of the nineteenth century.

Ferries

The ferry between Jamestown and Newport was, until the last half of the twentieth century, the town's most important link with the world beyond the island's shores. Ferry service was well enough established by the 1690s that a 1699 law ordered "that ferrymen between said Newport, said Jamestown and Kingstown and all other ferries in said Colony shall carry…all persons on his Majesty's service ferriage free."

The first recorded license for the Newport–Jamestown ferry was issued in May 1700 to John Carr, one of Caleb Carr's younger sons, who had during his father's lifetime taken over the ferry and under his father's will received "my whole part of Rose Island and the whole of my warehouse standing upon my wharf here in Newport." That same year, the General Assembly also issued a license to Thomas Winterton to operate a ferry from Jamestown to Newport. The Jamestown–Newport ferry allowed the people in Jamestown to get to Newport and back on the same day, since a sail ferry could make at most one or two trips a day.

Ferries across the East Passage continued to multiply throughout the colonial period, even though most of the freight flowed east from Jamestown to Newport and only passengers with their personal purchases returned.

During the Revolution, the regular ferry service was suspended and the boats destroyed. Reconstruction of the ferries did not immediately engage the attention of the licensed ferrymen. Perhaps they saw little need for regular commerce between the two depressed towns. In response, in 1799, the General Assembly ordered the license holders, who still included the Carrs, to rebuild the ferries or to let Enoch Hazard put them in good repair and hold the tolls to pay for the work.

The East Passage ferries were soon back in service. Unlike the colonial period, when ferryboats ran from several docks on the east side of the island,

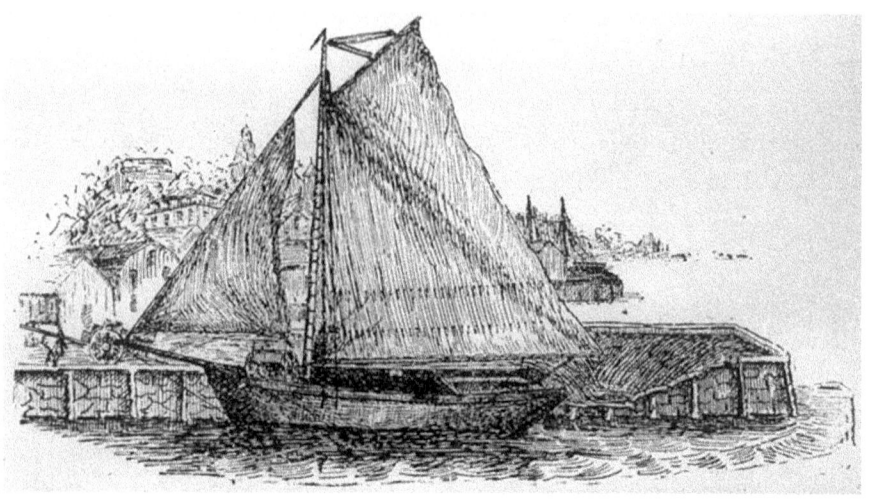

An 1846 sailing ferryboat on the East Passage. The plate of the wharf was angled to accommodate passengers and freight at changing tides. *Courtesy of the Jamestown Historical Society.*

ferryboats now used the ferry landing at the east end of Narragansett Avenue almost exclusively.

Ferries across the West Passage were less successful. The pattern established in the colonial era, when agricultural produce from the Narragansett plantations had flowed across Conanicut Island to Newport for distribution, was disrupted by the war and the destruction of Newport as a distribution center. New patterns of travel and trade developed. Jamestown was no longer a way station on a market route. A report from 1785 found the West Ferry boat worn but in good order. Amos Gardner, Ezekiel Gardner, and Benjamin Cottrell—all with farming interests on Beavertail—each controlled the ferry and ran the farm near the West Ferry pier for periods in the early nineteenth century and kept the route open with varying success.

A solution to the reduced need was found in the 1870s. Captain Lester Eaton of Saunderstown sailed his catboat to Jamestown four times a week with the mail, more often if he had passengers to the island. If someone in Jamestown wanted to cross the West Passage at any other time, the would-be traveler opened a large door on the west side of the ferry house. The house was white; the inside of the door was black. When Eaton saw the signal, he sailed across to pick up his passenger.

Rebuilding Jamestown

Farming

By midcentury, Jamestown was slowly moving toward a market economy. The 1850 census reported that over fifty-five hundred acres in Jamestown were devoted to agriculture and that the forty-five farms accounted for 93 percent of the value of the town. Most of the farms were small. Over half of the farmland was used for pastures and another quarter for hay and other fodder. Less than 15 percent was plowed. Both cows and sheep grazed in the pastures. Almost 8 percent of the cheese and over 2.5 percent of the butter produced in the state came from Jamestown. The island's 1,440 sheep produced 4,844 pounds of wool that year.

Both the herds and the flock increased over the next twenty-five years. By the early 1870s, when the introduction of easier transportation to and from the island brought about a dramatic change to life in Jamestown, the farms were comfortably supporting a stable population of just under four hundred people. About two thousand sheep annually produced over seven thousand pounds of wool. The herds of cows delivered over fifteen thousand gallons of milk annually, some of which was processed locally into butter and cheese. Animals grown for slaughter—primarily pigs and lambs—increased in importance and contributed significantly to the annual farm income.

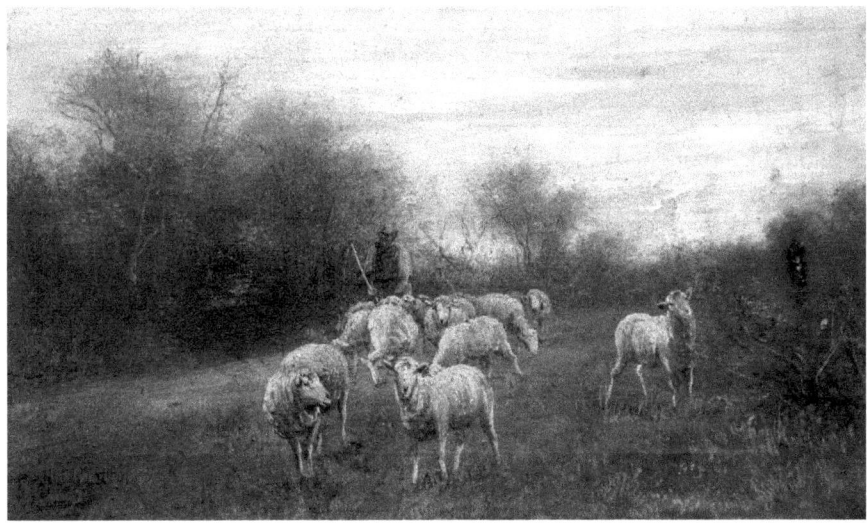

Mrs. B.E. Hull's flock on her farm at the North End about 1900. The painter was J. Davis. *Courtesy of the Jamestown Historical Society.*

Government

The American Revolution did not change Jamestown's method of government. A five-member town council ran the town. The town clerk, then an elected position, handled the day-to-day activities. Each spring, at the annual financial town meeting, voting citizens determined the budget for the year. The same surnames—many of them familiar from the original purchase agreements—appear over and over in the town records.

Elected Town Clerks, 1678–1974
Town of Jamestown

1678–1683	John Fones
1683	Oliver Arnold
1684–1688	Caleb Carr
1688–1698	John Hull
1698–1702	Edward Carr
1703–1704	John Hull
1705–1709	Edward Carr
1710–1716	Nicholas Carr
1716–1720	Tiddeman Hull
1721–1722	Nicholas Carr
1723–1731	Tiddeman Hull
1732–1738	John Hammett
1739–1743	James Carr
1744–1759	Joseph Clarke
1760–1782	Benjamin Underwood
1783–1787	John Weeden Jr.
1787–1803	Tiddeman Hull

Rebuilding Jamestown

1804–1807	Thomas Carr
1808–1811	John Remington
1811–1812	Joseph Weeden
1812–1844	John Remington
1844–1882	John E. Watson
1882	John E. Watson Jr.
1883–1884	John J. Watson
1885–1888	John E. Watson Jr.
1889–1890	Charles E. Weeden
1891–1907	William F. Caswell
1908–1924	William H. Severance
1925–1930	Preston E. Peckham
1931	Isaac H. Clarke
1932–1953	John E. Hammond
1954–1974	Rosamond A. Tefft

Most of the town's income—then as now—derived from property taxes, which gave the large farmers a vested interest in keeping the expenses of the town low. Members of the wealthiest farm families devoted many hours to public service.

In the early days, the state's bureaucracy was paid for by assessing the towns rather than by direct taxation. Jamestowners complained bitterly in 1793 when their town was assessed £105, an amount that translated into 2 percent of the state budget while less than 1 percent of the state's population lived in Jamestown. They sent their representatives back to Providence with a request that the tax be reduced and with objections to a pending bill ordering "one Company of Infantry in Jamestown."

The town developed sources of income to supplement the property tax. The town council issued three licenses for "publick houses"—the equivalent to today's liquor and victualing licenses—in 1701, soon after the state licensed the ferries. Ferries and the pubs and inns often went together, since travelers delayed by weather needed both a place to stay and something to do while they waited. The popularity and quality of its

inn could determine which ferry a traveler crossed on, and inns existed on both sides of the island.

In addition to renting the roads to farms so that cattle and sheep could graze without hindrance, the town leased out the artillery green at the Four Corners, which was also used as a burial ground. In 1818, Smith Cottrell paid four dollars for its use.

Fines for allowing animals to run loose on the roadways also contributed to the town's coffer, though at the price of maintaining a pound. Perhaps one of the reasons farmers happily rented roads that ran through their property was to avoid the alternate cost of the fines.

Collecting fees and taxes has never been easy. In 1818, the road supervisors were ordered to call on all delinquents "to work on there [sic] part of the last two Rode [sic] Taxes." In 1843, the town fathers directed the town auctioneer to collect back rent due for gathering seaweed on the town beach at Mackerel Cove. No action to collect the money through the courts, however, was permitted.

Politics were not always friendly. The millers are said to have ground their political rival's corn immediately after sharpening the grindstones, thus adding the loosened grit from the stones to the meal. Nor was nepotism unknown, as seen from the following letter:

> *Yesterday heard a flying report that John Potter had got Beavertail light but don't put any confidence in the story, although it is possible. He has applied for it and was at the Democratic convention in Providence…But I think the matter lays with J.A. Weeden, and he being a relative of an Aunt Dimmy and the biggest rowdy in the bunch, may save it for her.*

J.A. Weeden evidently came through; Demaris Weeden was the Beavertail Light Station keeper from 1848 to 1857.

As the strictly agrarian phase of Jamestown's history reached its final years in the 1870s, the town was still governed by men who treated most of their peers as family—often quite literally, as the families intermarried. The town council met at the homes of its members or occasionally at one of the public buildings designed for other purposes, as no town hall had been built, despite documented efforts as far back as 1690. Town business was conducted out of the houses of the incumbent council.

Schools

Public education had very little impact on colonial Jamestown, although as early as 1731 the town voted to subsidize the rent being paid by a schoolmaster. By 1733, it had also subsidized the building of a school. In 1750, with a total population of about 320 on the island, the town built a stone schoolhouse on Southwest Avenue near Sheffield Cove. The operations of the school, however—hiring a schoolmaster, student attendance, curriculum—were not matters of municipal concern.

Jamestown's scattered population and few resources made public education difficult. Some families used private tutors. A letter from Hannah M. Farley to John Carr in 1820 discusses one such arrangement for the education of the Carr children: "My father…informs me that you wish me to teach a school for you this summer and I have concluded to accept the proposal and if nothing prevents I shall be in Newport by the middle of April." Children on Dutch and Gould Islands, when families lived on those islands, were undoubtedly schooled at home, if at all. Nonetheless, in 1801,

South School class of 1885. *Courtesy of the Jamestown Historical Society.*

the town rebuilt the South School on Southwest Avenue and added two new one-room schoolhouses: the North School on North Main Road near Carr Lane and the Middle District School just north of the Great Creek.

A statewide structure for public education began to evolve in 1828 with a state law requiring the freemen of each town to elect school committees to manage the local schools. In response, in 1831, the new Jamestown school committee reported that it had two schools—the Middle District School had evidently been closed—and one hundred potential students from a total town population of just over four hundred, the smallest in the state. Attendance was low, and the school year lasted only three months; both circumstances were about average for the state. The state's financial contribution, $50.22 in 1828, was small.

Henry W. Clarke grew up on Beavertail and attended the South School in the 1830s. He later became a well-known and popular schoolteacher and school principal in Newport. His description of the conditions in the Jamestown schools of his youth was acerbic:

> *Well, all things having thus been prepared for the educational battle, a skirmish soon occurred, involving in the contest Daval's arithmetic, with its perplexing pounds, shillings, and pence; Smith's mystified grammar, arranged without due common sense…Peter Parley's History, full of pictures of Indians scalping captives and running a-muck…such were some of our foes, such some of our text books.*
>
> *As to teachers in those days, bearing in mind the Scripture injunction, "Judge not, lest ye be judged," it may not be advisable for me to criticise them too severely, having been a teacher myself for so many years; but I am free to say of one of them, that he had no more knowledge of English grammar than did a Choctow Indian of classic Greek.*

A more sophisticated school system waited on greater recognition of the value of education in the changing world of the late nineteenth century.

Rebuilding Jamestown

The Community

Immediately following the American Revolution, the needs of survival and the dispersion of farms left little energy for strictly social interaction. As the century progressed and a stable population developed, time was devoted to nonagricultural concerns.

Village

Like the ferries, the village, which had been so ruthlessly destroyed in the early years of the war, was slow to recover. Benjamin Remington, whose farm was close to the village and whose houses had been among those burned in 1775, rebuilt near the East Ferry in 1787. But there was no general rebuilding of the burned structures.

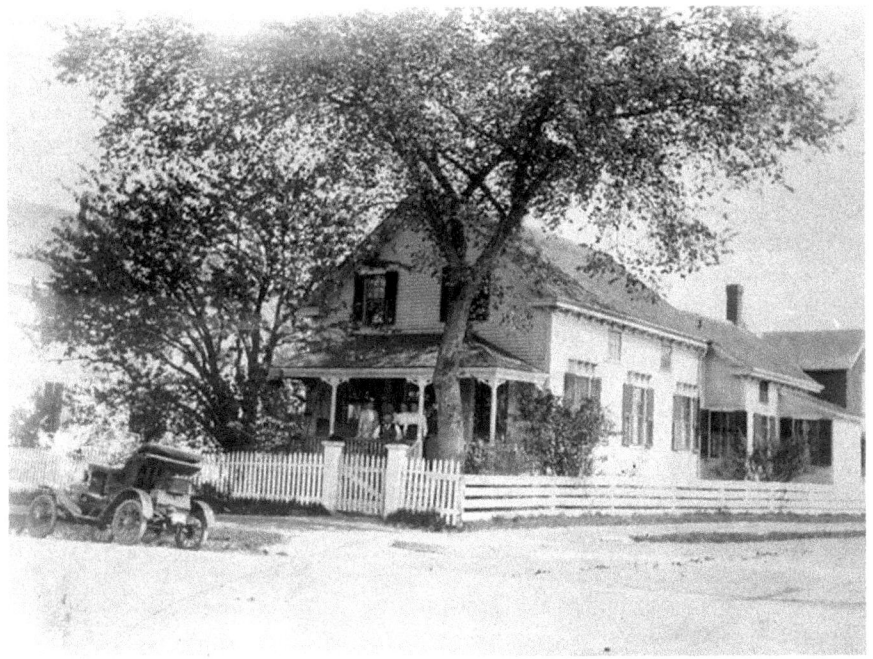

John E. Watson's house at Narragansett and Clinton Avenues. Watson was town clerk for almost forty years and had his office here from 1874 until 1882. *Courtesy of the Jamestown Historical Society.*

JAMESTOWN

In 1829, Isaac Carr built the first postwar store in town. The building was originally across from the East Ferry wharf. With the coming of the steam ferry in the early 1870s, Carr's store was moved to Narragansett Avenue, next to Remington's house. It was later reoriented on the lot—one of several buildings in Jamestown that have been moved more than once.

Postal service in the early nineteenth century did not extend to Jamestown. In 1844, William A. Weeden Jr. became the town's first postmaster. The location of the post office changed often over the next sixty years, with most of the postmasters operating the service out of their homes or stores. From at least 1874—when John E. Watson Sr., town clerk and postmaster, built his home and office at Narragansett and Clinton Avenues—it was on Narragansett Avenue.

Other members of the Watson family, which owned land on the West Passage south of the Great Creek, as well as much of Windmill Hill, had

Thorncroft. While John J. Watson made this house his headquarters, it was called the Retreat. The house was renamed Thorncroft in 1898. *Courtesy of the Jamestown Historical Society.*

earlier built houses in town: Meadowsweet farm at 191 Narragansett Avenue in 1843 and Thorncroft at 175 Narragansett Avenue about 1860. In the 1860s, Thorncroft was a boardinghouse. In 1872, John J. Watson, who later represented Jamestown in both the Rhode Island legislature and senate, moved there from the Windmill Hill farm and made the house the center of his political and farming activities.

Essential services began to coalesce around the East Ferry, which was, because of the reduced ferry service on the West Passage, Jamestown's only practical gateway to the rest of the world.

Library

The Philomenian Debating Society was organized in 1828, the same year that state law mandated the formation of a public school system. The members of the society agreed to pay one dollar a year toward a fund to start a library. The books were kept at Peleg Carr's house on Carr Lane. For many years, a second lending library also existed, this one housed in Cajacet, John J. Watson's house at the northern end of East Shore Road.

In November 1874, a group interested in forming a library in the village met and decided to combine the two libraries. The new entity, the Jamestown Philomenian Library, was entitled to financial assistance from the state board of education. Mrs. G.A. Clarke served as the first librarian and housed the collection at her home.

The word "Philomenian" is evidently a coined word. The Greek root *philo* is often used in English words to mean "love of," but no Greek derivation can be found for the *menian* part of the word. Perhaps people in the mid-nineteenth century just added syllables without meaning in naming their societies. There was a Philermenian Society, a Philandrian Society, and a Philophysian Society at Brown University during the same period.

Churches

Jamestown's early settlers—Carrs, Howlands, Weedens, Hulls—were Quakers, or Friends, and the Society of Friends built the first building for religious worship in 1709, near what is now Cedar Cemetery. In 1734, as the center of population moved south, a new meetinghouse was built on

Weeden Lane on land donated by Nicholas Carr. While both Baptist and Episcopal services were also held on the island during the colonial period, no church was erected or organization formed.

The Revolution was a watershed for religion in Jamestown. The British used the Quaker meetinghouse as a hospital, and according to the report of the Newport meeting in 1776, "the House…suffered considerably from them." For the next ten years, the Quakers met, like other religious groups, in private homes.

After the war, the Quakers in Jamestown tried to rebuild their house and their community. In October 1786, the Monthly Meeting in Newport agreed that a new meetinghouse was warranted, "provided that it can be accomplished in the way by them proposed viz to procure Monies by subscription to purchase the material and to do the Labour at their own expense."

The subscription fell short by seven pounds, a sum that was made up by the Newport Meeting. The shortfall was a sign of things to come. Membership in the Society of Friends was dwindling. In the early nineteenth century, the

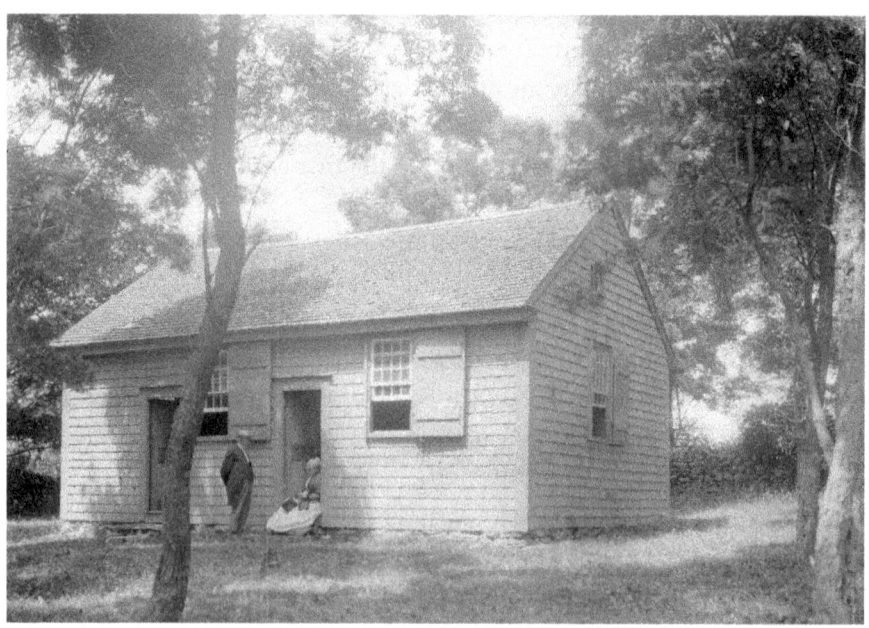

The Quaker meetinghouse on Weeden Lane about 1900. It was built in 1786–87 and is still used for Friends' meetings in the summer. *Courtesy of the Jamestown Historical Society.*

meetinghouse fell into disuse. It was not reopened until the coming of a large summer community almost one hundred years later.

No other faith immediately filled the gap. Religious affiliation was low, with less than 5 percent of the four hundred people on the island actively belonging to a church. Spirituality remained high, however, and in 1833, the town built a two-hundred-seat hall in the artillery green at the Four Corners for all denominations to use.

Perhaps spurred by the availability of such a meeting place, the Episcopalians under Lay Reader Washington VanZandt organized St. Matthew's parish as a mission of Trinity Church, Newport, in 1836. With the help of the Rhode Island Episcopal Convocation, the new parish purchased the multidenominational facility and remodeled it to become the first Episcopal church on the island.

At the same time, the Baptists were gaining strength among the farming community at the North End. The First Baptist Society officially organized in June 1841:

> *We the said Oliver Hopkins, Wm. A. Weeden, Daniel W. Carr, John E.G. Weeden and Elisha Case, Taking into consideration the inconvenience of holding religious meetings in the school house it being too small to hold those who attended, this day after meeting met at Wm. A. Weedens and agreed to meet at the North School House the first Monday in June, To associate ourselves together and become a society and petition to be incorporated.*

John E.G. Weeden and Daniel Carr, descendants of the men who had supported the building of the Quaker meetinghouse over fifty years earlier, were assigned to procure land for the Baptist meetinghouse. The land just south of Carr Lane on North Main Road was purchased from George C. Carr "in consideration of the regard I bear towards the Christian religion and also one Dollar to me in hand paid."

For several years, both the Episcopal and Baptist congregations struggled.

St. Matthew's congregation was small and grew slowly. The church depended heavily on the support of Trinity Church, Newport, whose members crossed the bay almost weekly to attend services and participate in church events and fundraisers. In 1879, under the leadership of the

St. Matthew's Episcopal Church soon after its dedication in 1880. The church was torn down in 1967. *Courtesy of the Jamestown Historical Society.*

Rebuilding Jamestown

Reverend George J. Magill, the rector of Trinity, the congregation began the construction of a new church building, more suitable than the barnlike structure it had purchased from the town.

The cornerstone was laid in August. Partway through the collection that followed the closing address, Isaac Carr, whose Jamestown shop catered to many of those in the church, stood up and begged those present not to give any money to the church if they owed anybody. "Some of you who have given money owe it to me," he shouted. "Don't give, don't give I tell you."

The new church, designed by George C. Mason of Newport and built by Jamestowner Gordon T. Oxx, was consecrated without incident on September 12, 1880. The money needed to pay for the $5,000 to $6,000 building had already been raised.

The Baptists faced different problems. An early controversy arose over whether the Lord's Day was to be considered the first or seventh day of the week, and for a while the two factions shared the building, each with allotted days.

Geography rather than dogma was, however, the greater threat to the longevity of the First Baptist Society. Farmers at the southern end of the island were unable or unwilling to travel the four or more miles from Beavertail to the meetinghouse near Carr Lane. In 1856, the members of the society agreed to look for property south of Weeden Lane but north of the village center. A new site was never found.

Finally, on February 21, 1867, the southern group—most of them members of the Gardner family—met for the purpose of organizing a church. That March, the organization officially named itself the Central Baptist Church of Jamestown. Reverend James Hammond, who lived on Fox Island in the West Passage, was called as the first pastor.

The Central Baptist Church built a chapel at the southeast corner of Narragansett and Southwest Avenues and, with a presence in the growing town and accessibility from both the northern and southern reaches of the island, soon proved to be the stronger of the two Baptist congregations. In 1905, the First Baptist Society officially discontinued and voted to "deed the Meeting House of this Society to the Newport Episcopal Convocation."

RESORTS AND SUMMER PEOPLE

Steam ferries regularly ran up and down Narragansett Bay from Providence to Newport and on to New York City starting in 1822. The fabled Fall River Line's floating hotels joined the bay traffic in 1847. A steam ferry between Newport and Jamestown was permitted under the charter of the Narragansett Bay Company in 1827, but steam power was never used. Horsepower was tried briefly instead. Another attempt to institute a steam ferry in 1854 was abandoned.

Finally, in 1873, Jamestown joined the steam age, forced into the new technology, according to "An Old Resident" writing for the *Newport Journal* in 1902, by "an immigrant from up the bay."

> *The antiquated sloop ferry between Jamestown and Newport was for sale, and he bought it...The ferry had been run largely for the benefit of the islanders, and was regarded as a sort of family or neighborhood arrangement. This he determined to change, and did so...It was evident that there was no way of getting on or off the island except to swim, use a private boat, or accept his terms. These were not always acceptable, in several particulars, and the disgruntled islanders began to broach and discuss privately, and later publicly, plans for relief. This eventuated in a movement for a steam ferry.*

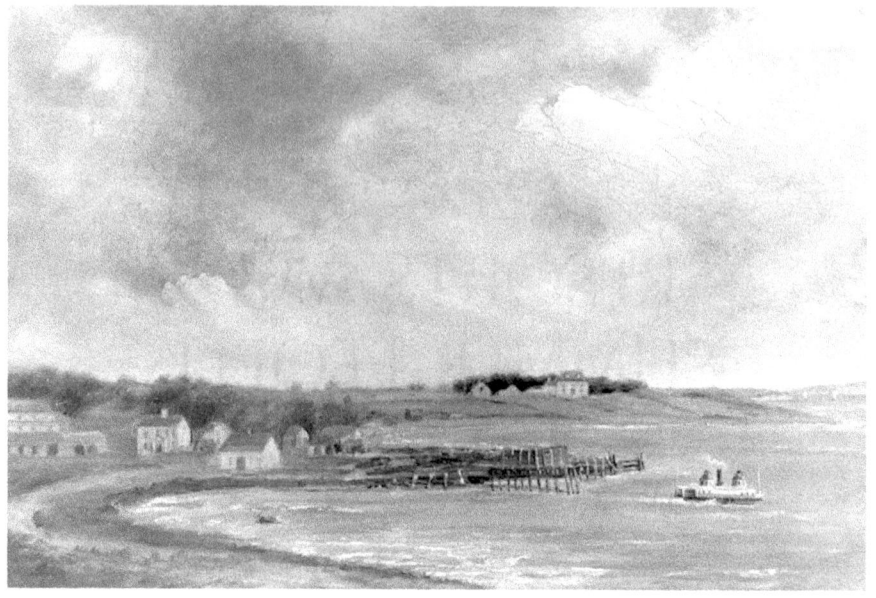

The ferryboat *Jamestown* leaving the dock in 1874. The large building on the far left is the original Bay View Hotel, built about 1872. *Courtesy of the Jamestown Historical Society.*

JAMESTOWN–NEWPORT FERRY

In the spring of 1872, citizens of Jamestown formed the Jamestown & Newport Ferry Company and asked the General Assembly for the necessary authority to establish steam ferry service between Conanicut Island and Newport. To ensure that the new ferry would, unlike the sail sloop, remain under town control, the voters also agreed to have the town buy 60 percent of the stock in the new company. The officers elected to direct the purchase of the ferryboat, the building of a dock on each side of the bay, and the operation of the ferry were George C. Carr, Thomas Carr Watson, and Elijah Anthony, thus reestablishing the Carr family's long association with the East Passage ferry.

A year later, in April 1873, the ferryboat *Jamestown* arrived at the new wharf at Mill Street in Newport. On May 12, it made the first of five scheduled daily trips between Newport and Jamestown. It landed at a new wharf just south of Narragansett Avenue on a site that John Howland had traded for $890 worth of stock in the ferry company, about 5 percent of the outstanding stock.

Resorts and Summer People

The *Jamestown* was a wooden-hulled paddle-wheeler, seventy-nine feet in length, with an eight-foot draft. A sixty-horsepower single-cylinder engine powered the paddle wheel, which was sixteen and a half feet in diameter. The boiler was wood fired. The paddle wheel, engine, and boiler were all on one side, causing the ferryboat to list when fewer than about six teams of horses occupied the carriageway on the other side.

For thirteen years, until the *Conanicut* replaced it in 1886, the *Jamestown* provided dependable and reasonably comfortable transport between Jamestown and Newport, changing the face of the village and the lives of its inhabitants. In 1888, it was put to work on a newly chartered West Passage route.

CONANICUT PARK

Before the village of Jamestown began to feel the effect of the steam ferry, events at the very northern end of the island gave the rest of the town a taste of what lay ahead.

In the early nineteenth century, no ferry—sail or steam—serviced this part of the island. The area was divided into five farms, ranging in size from 80 to 200 acres. In 1872, through a confusing series of sales and resales, the Conanicut Land Company acquired 480 acres, and one of its officers, Lucius C. Davis, bought another 80 acres. They paid about $40,000 for the property, a steep increase over the going rate for land in Jamestown; one of the farms that the group bought for $10,020 had sold for $3,500 only six years earlier.

None of the owners of the Conanicut Land Company had any earlier involvement on Conanicut Island. With the exception of Davis, they lived in Providence or Boston. Davis was the editor of the *Newport Daily News* and told the paper's readers that the land company proposed to

> *make extensive improvements in the way of building a wharf, laying out streets, erecting a hotel, and otherwise fitting the section for summer residences...and with a capital of one or two hundred thousand dollars make it one of the most attractive locations in our beautiful bay.*

Conanicut Park, as the development was called, extended from the East Passage to the West Passage, from the northern tip of the island south almost to what is now America Way. Its plan included 2,098 house lots, many as small as five thousand square feet, as well as areas set aside for parks, woodlands, and a common. The curved patterns of roads matched the contour of the land and shoreline. The wharf would accommodate the Providence–Newport ferryboats, which were substantially larger than the *Jamestown*.

While politically part of the town of Jamestown, Conanicut Park would be a separate village, occupied in the summer only. The only road between the two communities, North Main Road, had frequent gates to be opened and closed or stiles to be climbed. No ferry between the two centers seems to have been contemplated.

The development got off to a good start. By March 1874, the wharf and about eight miles of road had been completed. A hotel stood on the

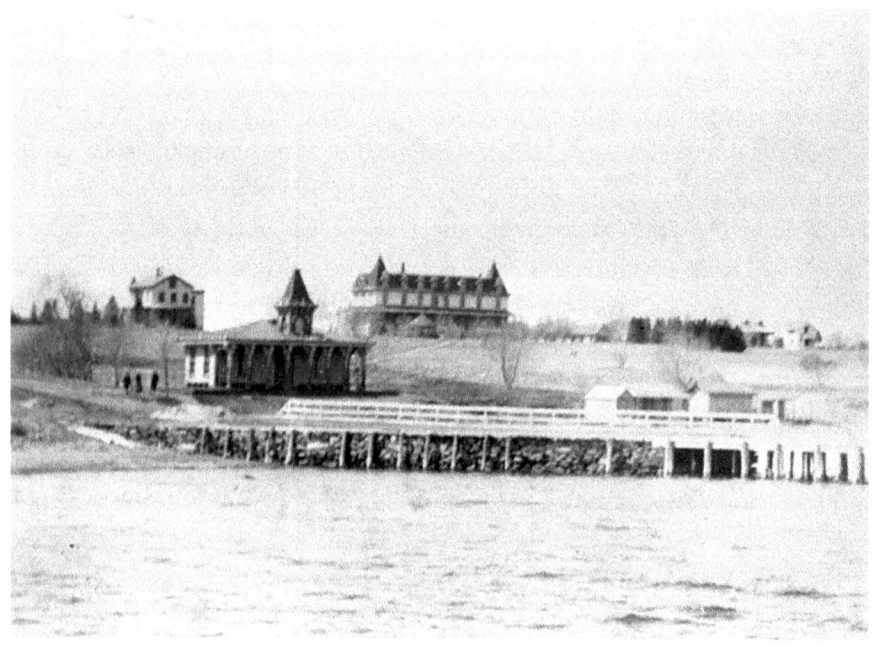

Conanicut Park Hotel and wharf about 1890. The building at the end of the wharf is the waiting room for the Providence steamer. *Courtesy of the Jamestown Historical Society.*

Resorts and Summer People

hill above the wharf, and a depot at the wharf offered a protected place to wait for the ferry. The Providence firm of Carnells and Mumford opened a grocery and variety store. A cottage on Hillside Avenue—now the northern reaches of East Shore Road—was offered for sale for $2,500.

The Conanicut Park Hotel was filled to capacity its first summer and enlarged to accommodate about one hundred guests two years later. Newspapers in the summer of 1876 reported that all the Narragansett Bay steamers touched at the Conanicut Park wharf, making it possible for men to manage their businesses in Providence and farther north from their summer retreats.

For ten more summers the hotel prospered, although fewer than forty cottages were built on the more than two thousand lots. Attractions at the hotel included boating, bathing, a livery stable, and a bowling alley. In the evenings, guest speakers lectured on varied subjects, and musicians played for dancing and singing. Magicians and ventriloquists entertained the children. Clergy from different faiths conducted Sunday morning services, and in 1886, a nondenominational chapel was added to the complex.

In July 1887, disaster struck. An illness that, according to the *Newport Daily News*, resembled "old-fashioned dysentery with cramps in the neck and back" hit everyone living in the hotel. A laboratory at Brown University tested the water from the hotel well and from a nearby stream and certified it fit for domestic use, but the visitors fled while the source of their illness was sought.

It was not hard to find.

As was common at the time, sewer pipes carried raw sewage from the hotel directly out into the bay. At Conanicut Park, the main sewer line was above ground, partially hidden by the raised floor of the laundry room. Near the laundry room of the hotel was an old well. Water from the well was used only to flush the toilets in the hotel and thus escaped the first round of testing. When the sewer broke under the laundry room, the sewage contaminated the well, essentially recycling the sewage back into the water closets.

The sewer was fixed, the well was filled in, and the hotel reopened. It never regained its popularity. In 1909, after ten years of only sporadic use, the hotel was torn down. The Conanicut Company auctioned off the land on which the hotel had stood and the remaining house lots. The purchase price for 450 acres was $11,000—less than one-third of what the company had paid for it thirty-seven years earlier.

Hotels in Jamestown Village

While at Conanicut Park a corporation was building a planned community for middle-class families from nearby cities, the people in Jamestown village were responding more slowly to an unplanned influx of visitors, many of them from cities outside New England.

Simple accommodations were readily available in the town. Ferry houses offered rooms for travelers, and boardinghouses, like the Watsons' Thorncroft, welcomed long-term visitors in informal homelike settings. William H. Knowles, who had run the sail ferry and later commanded the *Jamestown*, realized early that a regular, planned ferry service would bring a new class of visitor to the island, visitors used to a more sophisticated lifestyle than Jamestown offered. About 1872, Knowles built the Bay View Hotel, which gave visitors the option of a formal service-oriented establishment for either long or short visits.

The original Bay View Hotel stood on the north side of Narragansett Avenue behind the Ellery Ferry House, which occupied the corner of Narragansett and Conanicus Avenues. For ten years, it remained the only hotel in the village.

In 1883, another captain of the *Jamestown* opened the second summer hotel on the Jamestown waterfront. Captain Stephen C. Gardner and his wife, who had run a boardinghouse at Grove Cottage farther west on Narragansett Avenue, built Gardner House across from the new ferry wharf. When it opened, the hotel had thirty-eight guest rooms.

Both hotels flourished and grew. The Gardner House capacity expanded to fifty-four rooms, which was later increased to one hundred with the addition of a fourth floor. In 1889, Adolphus Knowles built a five-story addition to the Bay View Hotel, with a round tower that went up five stories more, on the site of the old Ellery Ferry House; he moved the old house around the corner to Knowles Court to house his employees. The same year, William A. Champlin built his Champlin House, later to become Dr. Bates Sanitarium, on the rise to the north of the harbor.

Newport entrepreneurs saw the potential in Jamestown. In 1889, Patrick H. Horgan, a Newport developer, built the Thorndike Hotel next to the Gardner House. After two seasons, Horgan leased the hotel to Charles Weeden, a Jamestowner, who ran it for the next ten years. Also in 1889, James A. Brown of Middletown decided "to transport his fine old country

Resorts and Summer People

William H. Knowles. Knowles built the Bay View Hotel about 1872 and owned the last sailing ferryboat between Jamestown and Newport. *Courtesy of the Jamestown Historical Society.*

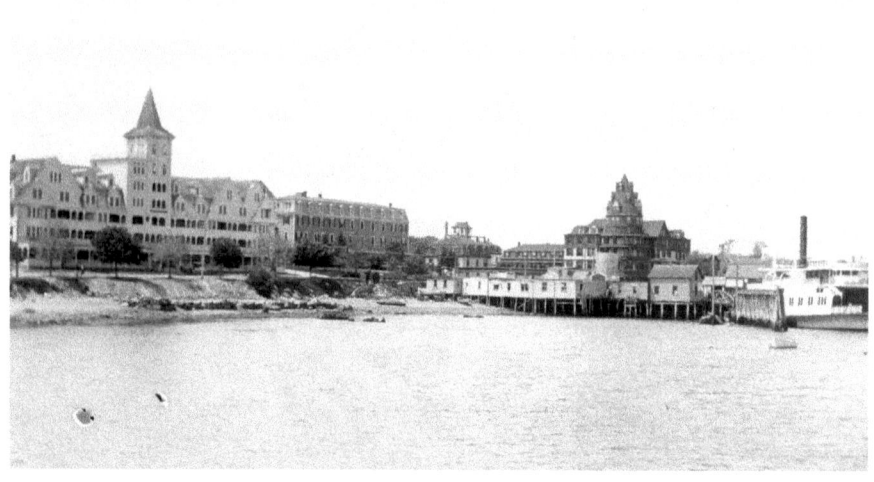

Jamestown waterfront about 1900. The three large hotels are, *from left to right*: the Thorndike Hotel, the Gardner House, and the Bay View Hotel. *Courtesy of the Jamestown Historical Society.*

house from deserted Middletown Heights, to the more prosperous shores of Conanicut Island." The ten-bedroom house, which had been built in 1860, was floated across the bay on a barge. The house, renamed the Bay Voyage Inn, was settled on a spot at the north end of the harbor near the Champlin House. The next year, a thirty-room wing was added.

By the early 1890s, the five hotels could accommodate about nine hundred summer visitors. Smaller hotels, boardinghouses, and informal room rentals in private homes expanded the number to over one thousand. The hotels offered not only rooms and three meals a day but also laundering, tailoring, entertainment, and even, according to bills that have survived, the occasional loan of cash to visitors without local banking facilities. Many summer visitors came for extended periods, and some of them stayed for the whole season.

Summer Cottages

While some of the summer people enjoyed the convenience of hotel life, others wanted the comfort and freedom of their own establishments. They

Resorts and Summer People

set about building summer cottages. John Howland sold twenty acres of his farm just south of Narragansett Avenue to the Island Villa Land Company even before the steam ferry was in operation. The lots in the area sold quickly, and Howland built himself a handsome mansion on the proceeds in anticipation of future sales.

Horgan and others were soon building cottages to rent for the season, and some Jamestowners built small seashore bungalows for themselves so that they could rent their larger winter homes to off-islanders.

Two major developments near the village catered to a growing number of wealthy summer visitors.

Ocean Highlands

Ocean Highlands was capitalized and organized—although not settled—by Jamestowners. With George C. Carr, Frederick Cottrell, and Philip Caswell Jr. as major investors, the Ocean Highlands Company bought a 265-acre

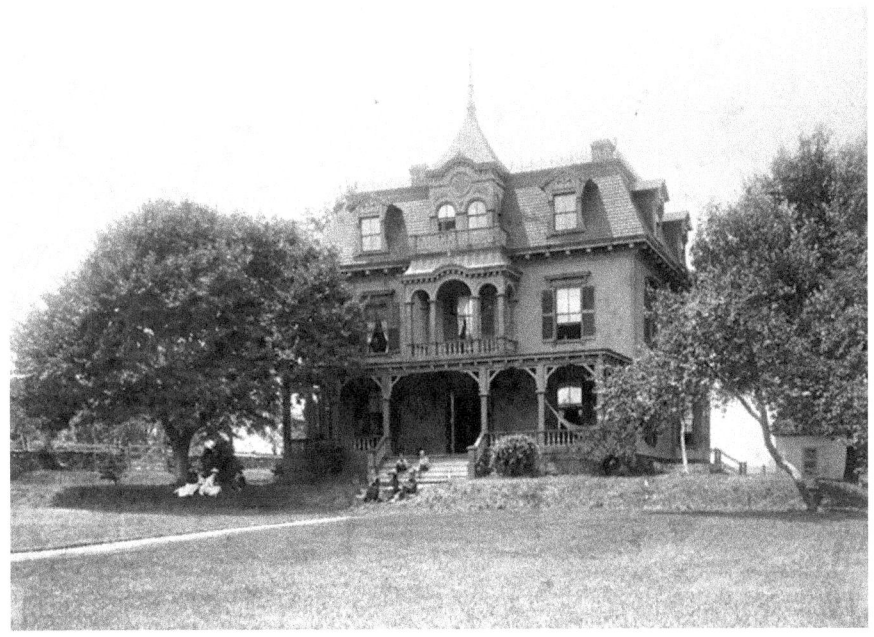

John Howland's house on High Street. This Victorian residence was built with the profits from selling parts of the Howland Farm to developers. *Courtesy of the Jamestown Historical Society.*

parcel "comprising the barren tract known as the Dumplings" in 1874. Although the tract was only about a mile south of the East Ferry, it was practically inaccessible; no road connected the area to the village, and the intervening pastureland was rocky and rough.

Land in the Ocean Highlands began selling in 1875, but no houses were built until 1881. That year, William Trost Richards, a marine artist from Philadelphia, bought—or, according to some sources, was given—land and built a cottage. If Caswell did give Richards the lot, the investment paid off. A number of the artist's Philadelphia friends followed his lead and built large summer cottages on the rocks above Narragansett Bay: Joseph Wharton (1882), Charles Wharton (1882), Benjamin Shoemaker (1882), and the artist James B. Sword (1883) were among the earliest. Others soon joined them. In 1888 alone, C.W. Larned of West Point, Mrs. Tilden of New York, and General Robert Patterson and J.H.M. Newlin of Philadelphia joined the already established Philadelphia summer people.

In 1884, Walcott Avenue was extended, and three years later the farm between Ocean Highlands and the village was platted for development. Even with the road, most families living in the Dumplings area found it

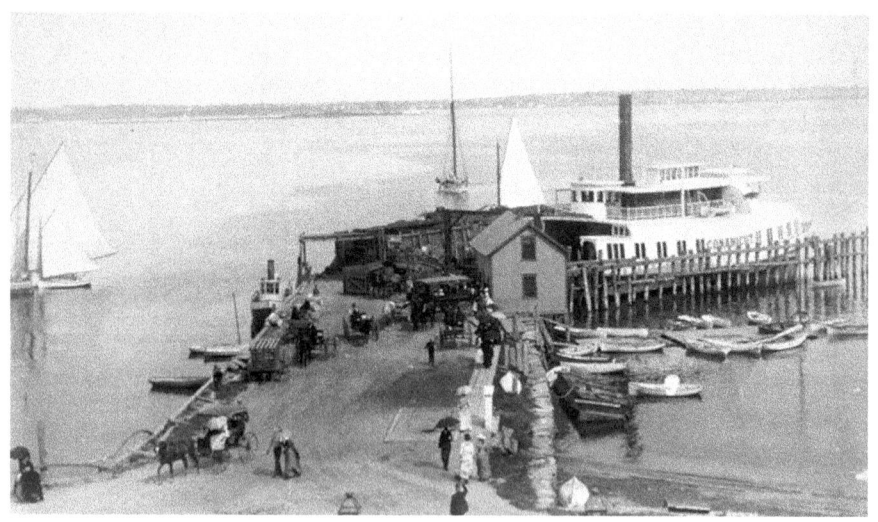

Ferry wharf about 1890. The small steamer to the left of the dock is the *Dumpling*, which ran between the village and the Dumplings. *Courtesy of the Jamestown Historical Society.*

easier to travel to their homes on the new steamer *Dumplings*, which in 1888 began making regular trips between the village and the Dumplings.

Unlike Conanicut Park or the slightly later development of Shoreby Hill, Ocean Highlands offered the people who bought the property few amenities. A hotel was suggested but never built. The only planned road was a "five-mile drive." Each home was responsible for its own sewer and water. On the other hand, the plots were large, measuring in acres rather than square feet. The views were magnificent, and the only restriction was the banning of any "noxious, dangerous or offensive trade or business."

Shoreby Hill

Shoreby Hill was the brainchild of two successful businessmen from St. Louis: Ephron Catlin, a drug manufacturer, and James Taussig, a lawyer.

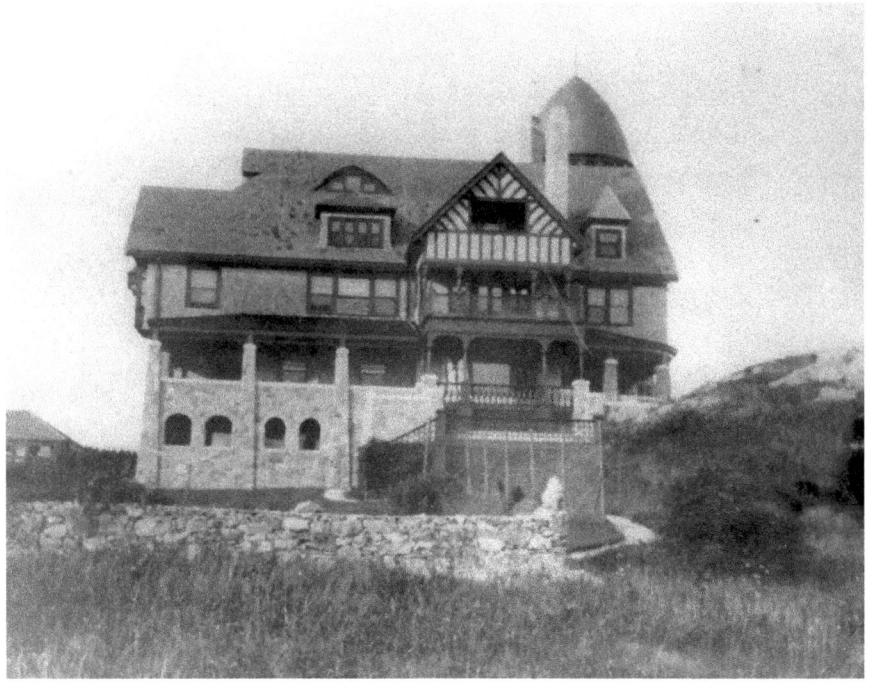

Isaac Clothier's Harbor Entrance. Like many cottages in the Dumplings, Harbor Entrance was designed by Charles L. Bevins. The house was demolished in 1966. *Courtesy of the Jamestown Historical Society.*

The Catlin and Taussig families summered in Jamestown for several years before deciding, in 1895, to buy the Greene Farm and build an exclusive and attractive vacation enclave for themselves and their St. Louis neighbors.

The Greene Farm, fifty-eight and a half acres of rolling farmland, lay two blocks north of the ferry wharf and looked out over Jamestown Harbor between the Bay View to the south and the Bay Voyage to the north. To transform the farmland into a sophisticated "suburb," as they called it after similar private developments in St. Louis, the two men hired Ernest W. Bowditch, who had recently designed the private community of Tuxedo Park, New York.

Bowditch's design featured curved roads that followed the contour of the land and afforded maximum visibility of the waterfront. A private dock stretched out into the bay in front of a lawn that was to be used as a commons. Stone pillars at each entrance created an air of exclusivity. The lot

Shoreby Hill Pier about 1920, with the boardwalk and Shoreby Hill green in the background. *Courtesy of the Jamestown Historical Society.*

sizes averaged three to four times the size of the Conanicut Park lots. Deeds defined building and landscaping restrictions. Buried sewer lines funneled waste from the planned houses far out into the bay.

Unlike Conanicut Park, there was no hotel; Shoreby Hill residents built their homes and returned to them each summer.

The first homes were ready for occupancy in the summer of 1898. By wintertime, the *Newport Journal* reported that eight cottages had been built or were in the course of construction. The Greene farmhouse, one of the oldest houses on the island, was kept as a residence for the overseer of the property, Ferdinand Armbrust, and then his brother Peter. They directed maintenance of the common property and kept an eye on the empty houses during the winter.

Around the Island

Not all the summer cottages were built within platted developments. New homes went up near the West Ferry, southward from the village on both sides of Walcott Avenue, and northward along the East Passage. A few Philadelphians left the Dumplings and summered across Mackerel Cove on the northern part of Beavertail.

Summer people generally arrived in June. According to a July 1 issue of the *Electric Spark*, the monthly newsletter of the Bates Sanitarium, "Many of the summer visitors are here and others are arriving daily. It is not until after July Fourth that the festivities and amusements begin in earnest, with the formal openings of the Conanicut Yacht Club and the Casino." While some people left at the end of August, the Casino, a private social club, remained open with nightly dancing through September.

GROWING PAINS

A map of Jamestown village today would not differ greatly from a map of the same area in 1875. Walcott Avenue has been straightened to eliminate the ninety-degree turns, and development has added a few short streets, but from Knowles Court to Hamilton Avenue and from Walcott Avenue to Southwest Avenue, the streets follow the same pattern.

The population of Jamestown in 1875 was 488, an increase of 18 percent over 1870. By 1900, it had more than doubled—to 1,091. Twenty years later, the population was 1,633; it would hover between 1,600 and 1,800 for the next twenty years. For three or four months of the year, the summer visitors swelled the town by another 2,000 or 2,500.

Both the visitors and the new townspeople put severe strains on the infrastructure—both physical and psychological—of the town. The summer visitors asked for improved public services—safe water, paved roads, sewage and waste disposal, streetlights, fire and police protection, and postal facilities. Many in the town, while recognizing the wealth the visitors brought, resented the implied criticism and begrudged the cost. The backgrounds, skills, and, in some cases, native languages of the new inhabitants were different from those of the earlier island's residents.

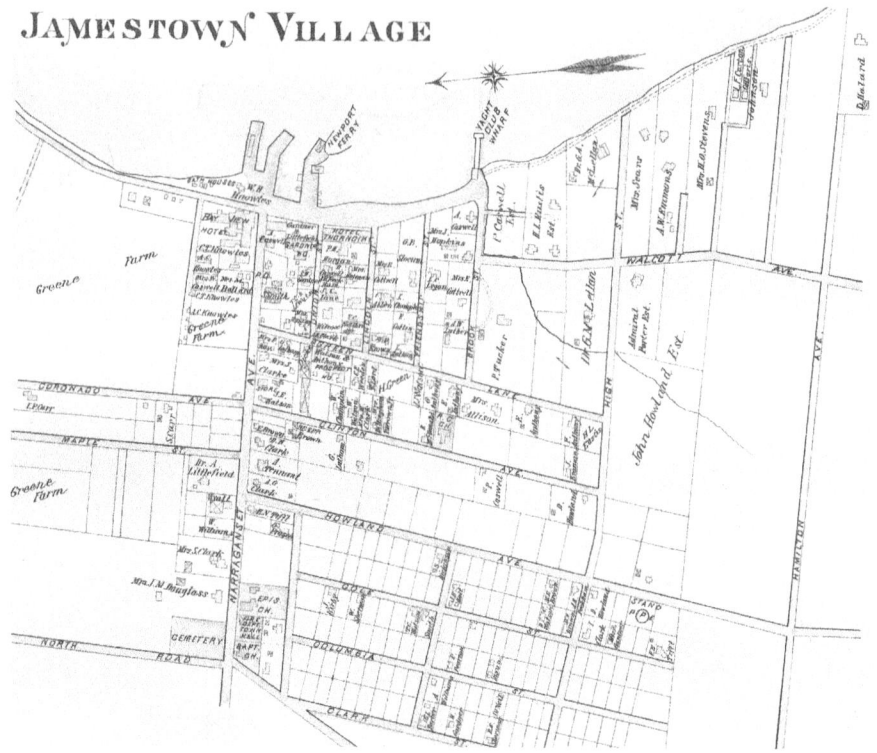

Jamestown Village in 1895. From the *Topographical Atlas of Surveys of Southern Rhode Island*, published by Everts and Richard, 1895. *Courtesy of the Jamestown Historical Society*.

THE ECONOMY

The economics of a resort community are very different from the economics of farming. New skills were needed to deal with the new realities.

Demographics

According to the census taken in June 1880, of the 35 percent of the population actively engaged in an occupation—homemakers, children, and retired people were excluded—over 50 percent were engaged in farming. Another 20 percent were equally divided between marine and building occupations, from whaling boat captain to stonemason. Only about 10 percent were involved in the service economy, including boardinghouse

keepers, tavern owners, and a number of "servants," most of whom were employed in private homes.

The population was overwhelmingly American born. Of the thirty-eight householders or their spouses whose parents had been born in foreign countries, only five came from countries outside the British Isles or Canada. One of these five was from Portugal—an early sign of changes to come. The largest foreign-born group was from Ireland—about 8 percent of the total population.

Twenty years later, in 1900, the census was again taken in June. The same percentage of the population—383 of 1,091—reported their occupations. The number listing themselves as "farmer" or "farm laborer" had dropped only slightly, from seventy-nine to seventy-one individuals, but these men were now only 19 percent of the workers on the island.

The building trades had increased in importance. The number of carpenters more than doubled, from twelve to twenty-seven, as did the number of masons. The services of an architect and a civil engineer were now available locally. Many of the sixty men who classified themselves simply as "day laborers" also probably worked on the construction of homes and summer cottages.

Whole new occupations appeared, most of them associated with the summer visitors: butler, caterer, custodian, grocery driver, livery stable keeper, waiter, yacht captain. Jobs like these, including thirty-nine "servants," occupied about 24 percent of the population.

Where the people came from had changed, too. Over 30 percent were immigrants or children of immigrants. While almost half the immigrants came from the British Isles or Canada, another 30 percent—more than twenty-five families—came from Portugal, primarily the Azores.

By 1930, only fifty-two people, about 10 percent of the total workforce, were engaged in farming, although another eleven listed themselves as florists or nurserymen, and there were twenty-five gardeners and landscapers. The Jamestown & Newport Ferry Company was by far the largest single employer on the island, employing fifty Jamestowners in jobs ranging from captain to stenographer. Another thirty worked at the Torpedo Station, making the United States government the second-largest employer. Dr. Bates Sanitarium and the Town of Jamestown were close behind with twenty-six and twenty-five employees, respectively.

JAMESTOWN

Crew on deck of the ferryboat *Conanicut* in the 1920s. *From left to right*: Manuel Neronha, Chas Dodge, Manuel Lewis, Harry Clarke, John Sheehan, Pat Drury, Manuel Sylvia, and Manuel Cunha. *Courtesy of the Jamestown Historical Society.*

The building trades—carpenters, masons, plumbers, and painters—remained strong. Some of the new occupations, such as garage mechanic, reflected changing technology, while others, like salesman, tell of changes in ways of doing business. The 1930 census was taken in April, before the arrival of the first wave of summer visitors, which may be part of the reason "servants" and related occupations, like hotel steward, gardeners, and landscapers, were only about 20 percent of the workforce.

Immigrants or children of immigrants now presided over about half of the four hundred households in Jamestown, a dramatic change from fifty years earlier. Portuguese families made up almost 20 percent of the population, followed by the Irish at 8 percent and the British, including Scotland and Wales, at 7 percent. Most of the other immigrants were from northern Europe or Canada, but no one country in this group accounted for more than about 1 percent of the population.

Farming

Before 1885, the last year for which state agricultural figures are available, the summer people had bought and taken out of production about 20 percent

of the land. Farms throughout the island, but especially north of the Great Creek and on Beavertail, operated as they had in the past, although total acreage continued to shrink. Profits from wool and grain fell as production of meat and poultry rose.

Some of the farms were given a new purpose. Early in the 1900s, Dr. William Lincoln Bates, a Carr descendant, purchased the Champlin House and the nearby Cory Farm, where he ran a health spa known as Dr. Bates Sanitarium, or Maplewood. The farm at Maplewood supplied much of the food consumed by the patients and staff. The *Electric Spark* regularly reported on farming activities. The cream and milk were from the farm's herd. The farm supplied meat, poultry, and eggs; 205 pounds of chickens were killed in 1914, and 272 pounds in 1919. In 1914, 1,331 dozen eggs were gathered. In 1916, 2,200 pounds of pork were provided. In 1914, 100 pigeons were purchased; four years later, 120 pounds of squab were killed. Vegetables were grown, harvested, and preserved. The 1918 canning season produced 530 quarts of tomatoes, 150 bottles of catsup, 135 quarts of blackberries, and comparable amounts of other preserved fruits and vegetables.

A new kind of agriculture flourished in the village, brought there by Samuel Smith. Smith was born in England in 1834. In 1864, he and a partner

Haying at Dr. Bates Sanitarium in the early twentieth century. *Courtesy of the Jamestown Historical Society/Barbara Magruder Collection.*

Wedding picture of Samuel and Bridget (Delia) Smith. The Smiths were married on April 3, 1883. *Courtesy of the Jamestown Historical Society.*

began a florist business in Newport, growing flowers and selling them to the increasingly affluent summer community. Their successful company opened a branch store in New York City—one of only five florist shops in that city at the time. Smith moved to Jamestown, and beginning in 1882, he built several very large greenhouses on Clinton and Narragansett Avenues. He opened a shop on Narragansett Avenue and spent the next forty years building this business using five horse-drawn delivery trucks and later opening branches in Boston and Providence. Smith's enterprise rated a special note in the state report on agriculture in Jamestown in 1885: "Greenhouses & frames, square feet of glass: 3,200."

Growing Pains

Government

The legal structure of the town government remained unchanged. At the annual financial town meeting in April each year, voters elected the five members of the town council, the town moderator, one member of the school board, and over thirty other town officials. Professionals now hold most of what were then elective offices, such as town clerk, town treasurer, and collector of taxes. After 1873, the town's representatives on the board of directors of the Jamestown & Newport Ferry Company were among those elected.

On the Saturday following the election came the financial town meeting. It was a full day affair, sometimes continuing through another day. The attendees debated the budget (including salaries, investments, public works projects, and tax assessments), passed ordinances, and established special committees to investigate issues that could not be decided.

At the national level, Jamestown was a one-party town: Republican. Until the Great Depression, the Democratic presidential candidate received, on the average, only about 20 percent of the votes cast. At the local level, politics were more personal. A candidate ran for a specific council seat rather than at large, as is now done. He—and throughout the period all candidates were male—did not have to declare a party affiliation and often did not. (Women were not allowed to vote until 1920, and none stood for town council until 1958.) The incumbents or candidates selected by the group in power were simply known as the "Regular Party" and the challengers as the Independents. Sometimes the sides rallied under the names of their leaders, as when, in 1905, "the side led by John E. Watson" defeated "the John J. Watson forces."

As the Republican Party became more firmly entrenched as an organization, the election could be decided in caucus, but not without a repeat of the competition in the election itself. In 1920, for example, at the caucus, James Masterson challenged William Caswell for the moderator slot and lost 75 to 70. In the general election, Masterson ran as an independent. He lost again, 113 to Caswell's 159. The other independents, all of whom had tried their strength within the party first, also lost. A state law passed in 1920 put an end to these shenanigans by prohibiting anyone participating in one party to be active in another party for twenty-six months. In the long

run, the law weakened the Republican Party by driving the minority to form a Democratic Committee in Jamestown.

The town's pool of political leaders expanded with the increased population. Town leaders still often carried the surnames of the original proprietors; for example, Charles E. Weeden and George C. Carr. Newcomers from England and northern Europe, such as Samuel Smith, Albert Boone, and Ferdinand Armbrust, gained political strength and served as councilmen and state representatives. The Portuguese immigrants did not integrate as easily. The first man of Portuguese extraction to run for town council was Manuel Silvia, who ran on the Democratic ticket in 1922, the year the disaffected Republicans first ran a Democratic Party slate. He was defeated. The first person of Portuguese descent elected was Frank Furtado in 1929.

Public Services

The growth of the village, as well as the increasingly insistent demands of the summer visitors, called for public services that the town had never before felt were needed. In general, the town was slow to act, leaving much of the development to private enterprise.

Town Hall

In 1870, Jamestown did not have a town hall. In 1845, the minutes record a meeting in a "town house," which stood on the east side of North Main Road just south of the North Ferry Road (Eldred Avenue). Neither that building nor a second North Main Road house was used consistently, and the council continued to meet and store records in private homes. After the Civil War, the town moved temporarily to a remodeled U.S. Army hospital built near Clinton Avenue during the war.

At the financial town meeting in April 1883, a committee of Elijah Anthony, George C. Carr, and Frederick N. Cottrell was tasked to find a place and obtain an estimate for building a town hall. The committee worked quickly. They tried to purchase a lot near the ferry landing, but none was available. John J. Watson offered the lot "between the Baptist and

Growing Pains

the Episcopal church." By midsummer, John F. Gill's plans for a fifty-two-by thirty-two-foot single-story building were approved, and by December, James D. Hull had completed the construction.

Considering that it had taken almost two hundred years to start the construction—the first resolution to build a town house was passed in 1690—the eight-month construction time was miraculous and reflects the resourcefulness and power of the committee members.

In addition to being the official meeting place of the town council, the hall served a variety of purposes, both public and private. Elections took place there; a peephole in a door at the rear was supposedly used to spy on voters to make sure they supported the candidate they had promised to. The building served as a classroom for Sunday school and for the public school when overcrowding made extra space necessary. Dances, dinners, and theatrical performances, as well as religious services, were held there. Organizations, such as the Royal Arcanum, met there.

In the early part of the twentieth century, the 1883 building underwent several renovations to keep it useful. The tower was removed. Water was laid on. The building was electrified when electricity reached the island in 1913. The next year, an addition holding the town clerk's office was built onto the front. The interior was rearranged and redesigned several times.

As early as 1905, the *Newport Daily News* reported the possibility of "moving the present hall back, to be used for housing road machines and tools, and

Herbert J. Wetherill's 1927 design for a municipal center. Only the three-bay fire station on the left was ever built. *Courtesy of the Jamestown Historical Society.*

building the new town hall where the present one now stands." In the mid-1920s and again in the mid-1930s, the town council considered plans for a municipal building that would house all town departments, including police and fire. Herbert J. Wetherill of Philadelphia, a summer Jamestowner, drew up plans for such a building in 1927. A similar concept would be put forward several times in the second half of the twentieth century.

Schools

With the growing population, the town's two one-room schoolhouses quickly proved inadequate, both in size and in level of instruction. As an interim measure, the town built a one-room primary school in 1886, but it, too, was soon overcrowded. A large, central school building—later known as the Carr School—was opened in December 1897 with a spectacular dedication ceremony attended by the governor and many other dignitaries. The building, an imposing two-story structure with two large towers, stood on Clarke Street at the corner of West Street. The four large classrooms were light and airy. Each individual classroom had more space than any of the preceding one-room schoolhouses. There were washrooms for the students in the basement and separate fenced playgrounds for the boys and girls.

For the first time, Jamestown had a fully "graded" system—all the students from primary through grammar school were in separate grades. An increasing number of students were able and motivated to go on to high school, usually in Newport, although they were required to take entrance exams to ensure that the standards for graduation from the Jamestown school system equaled those of Newport.

Nine grades in four classrooms in 1897 meant, however, that even at the beginning there would be at least two grades for each teacher in each room. And as the year-round population of Jamestown grew and families increasingly saw the advantages of regular schooling, crowding intensified. The number of students in the school system expanded from 104 in 1896 to 242 in 1916. The number of graduating students rose from 6 in 1898 to 15 in 1917.

Shortly after the school was built, there were more students at Carr than there were seats. In 1913–14, the town added two more classrooms. Even this was not enough. The next year, some classes were taught in the town hall, and space was rented in the old Isaac Carr store downtown.

Growing Pains

The Carr School, designed by J.D. Johnston and built in 1897 by G.D. Anthony. More classrooms were added in 1914. *Courtesy of the Jamestown Historical Society.*

Carr School class of 1898. Graduates Susan Brayman, Mary Elizabeth Clarke, Nicholas Carr, Mabel Watson, Mary Alice Barber, and Jessie Knowles with their teacher, Miss Morgan. *Courtesy of the Jamestown Historical Society.*

Debate about size, function, and cost of a new school began in 1917, when the school committee presented a plan at the financial town meeting to construct a new school building. The plan was rejected as too costly, and committees were formed to evaluate all options. Five years later, at the financial town meeting in 1922, the voters approved the necessary funding. The Clarke School opened on the site of the present town library in 1923. The building was low and shingled. It had four classrooms on the main floor for the fifth through eighth grades.

Water

Jamestown had a good supply of fresh water, more than enough to support its nineteenth-century farm community. Nearby wells and springs initially supplied water to the new hotels, too. The early hotels, after all, did not have separate toilet facilities for each room, and daily baths were unheard of. A cistern on the hotel roof, filled by pumping well water using steam or wind power, sufficed for daily needs.

In May 1888, aware of the increasing population density in the village area and perhaps spurred by the contamination of the well at Conanicut Park, Pardon Tucker and George C. Carr of Jamestown and James H.M. Newlin, a Philadelphian who summered in Jamestown, received permission from the Rhode Island General Assembly to establish the Jamestown Light and Water Company. The act of incorporation made the operation "subject to such rules and regulations in respect thereto as are or may be prescribed by the Town Council of Jamestown."

The water company was a private enterprise, but it needed to use public rights of way for the water mains, and the town would be one of its major customers. Public support was essential. In June 1890, a plan presented to a special financial town meeting proposed that water from Clarke's pond on Southwest Avenue be pumped to a standpipe on the top of the hill on Howland Avenue north of High Street. Gravity would then bring the water to the town. Despite questions and some opposition, the voters accepted the plan.

Construction began immediately. By August 30, 1890, water was flowing through pipes that ran from Howland Avenue to High Street to Green Lane to Narragansett Avenue and then west to the churches on Narragansett

Growing Pains

Pumping station for the Jamestown Water Company on Southwest Avenue. The superintendent and his family lived in an apartment on the left side. *Courtesy of the Jamestown Historical Society.*

Avenue and along the shore as far north as the Champlin House and as far south as High Street.

Over the next ten years, the water company acquired parts of the Watson Farm, where South Pond is located, and the Carr Pond, now the North Reservoir. These reserves were not enough, even after the town switched to using salt water to subdue the dust on the unpaved streets of the village. In 1899, per capita water use in Jamestown was reportedly ten times that of Newport, and sanctions were threatened.

Much of the problem lay within the system itself. The main that brought water through the marsh at the Great Creek corroded quickly because of salt; the problem was solved with larger and stronger pipes. Other leaky mains were also replaced. The Carr Pond was dredged and a higher embankment built. The system was expanded to include new areas of the village.

No serious problems or water shortages were reported until 1914, when the metal standpipe on Howland Avenue began to leak. The directors of the water company ordered a concrete tower to replace it. The new tower held 250,000 gallons, an increase of more than 20 percent over the original tank.

The Jamestown Water Company remained in private hands until 1970, when the town purchased it for $300,000.

Jamestown

Sewage, Trash, and Garbage Disposal

Four hundred people dispersed across six thousand acres had few concerns about how to dispose of their waste products. A community of three thousand, most of them concentrated on about five hundred acres, needed—as the illnesses at Conanicut Park demonstrated—to learn new ways of dealing with that waste.

Immediately following the Conanicut Park Hotel disaster, the Jamestown Town Council passed its first sewer ordinance (August 22, 1887). It said, in part, that

> *any well, cesspool, or any drainage…shall be constructed in accordance with the direction of the said Health Officer…All property owners having drain pipes running into the Bay shall extend the same into the bay to a point a least fifteen feet below low water mark, and that said pipe shall be properly trapped.*

The regulation seems to have been sufficient. The method for sewage disposal did not change for over eighty years. In the early 1970s, the town and many individual households still funneled untreated sewage directly into the bay.

About the same time, the town council began to regulate dumping. Evidently, the beach at Mackerel Cove was already being used as a dump, because the first reference to a dump in September 1889 directs that signs designating where to dump be posted. Not everybody was bothering to go to Mackerel Cove, and in 1892 and again in 1894, the council passed anti-littering ordinances with hefty fines for the day: five dollars for the first offense and ten dollars for the second.

The town dump became a political issue as the population increased. The dump moved around the island—sometimes because the designated area had been filled in but most often because nearby homeowners complained of smoke from trash fires, rats and the danger from rat hunters, and unsightliness. At different times, the wetlands at Spring Street, the Great Creek, and farther north at Eldred Avenue were used.

Growing Pains

Jamestown Fire Department

When the *Newport Journal* commented in early 1889 that "there are now about 100 houses within a radius of a quarter of a mile and should a fire get started in the thickly settled part of the village there would be little hope of extinguishing it," the town was already taking steps to address the issue. The budget approved at the 1888 financial town meeting contained $500 to buy a fire engine and to build a shed for it.

In short order, John J. Watson purchased a hand engine, known as Hope, from the Newport Fire Department for $200, and Eben N. Tefft recommended that an engine house be built next to the town hall. In December 1890, Henry L. Smith was appointed chief of the fire department.

In late January 1891, the *Newport Daily News* reported that, after several unproductive meetings,

> sufficient names were secured to warrant the formation of one engine and one hose company. For these Thomas King was selected as foreman for the engine company, with James Oxx as assistant. Adolphus Knowles, foreman of Hose No. 1, and Jeremiah Tefft, assistant; Nathaniel Littlefield, hydrant man; C.E. Weeden, Secretary and Treasurer of the department.

A hook and ladder company was formed the following week.

By 1894, a fire station just east of the town hall housed the pumper Hope, used by the firemen to pump water manually through hoses; five hundred feet of hose, equally divided on two hand reels; and a hand-drawn hook and ladder truck, equipped with a fifty-five-foot extension ladder. A bell in the tower of the station served as the alarm.

A fire at the Riverside House, a hotel on Conanicus Avenue just south of Narragansett Avenue, proved both the worth of the organization and the need for more sophisticated equipment. According to a story in the *Newport Daily News*, when the alarm for the fire was turned in at 3:00 a.m. on June 4, 1894, the four-story wooden building was already in flames from end to end, the north end of the Gardner House was starting to burn from the heat, and flying cinders had ignited the tower on the Bay View Hotel. Newport was asked to send help. The Jamestown firemen directed their efforts to wetting down the

Jamestown Fire Department volunteers practicing on the Bay View Hotel tower with the new hook and ladder truck that was purchased in February 1892. *Courtesy of the Jamestown Historical Society.*

surrounding buildings. When the Newport firemen arrived more than an hour later, the other buildings were safe, and they concentrated on ensuring that the ashes that had been the hotel would not again burst into flame.

The town council quickly authorized Nathaniel Littlefield, James Oxx, and Henry Smith to purchase a suitable horse-drawn steam engine at an expense not to exceed $3,500. The LaFrance steam pumper, Tashtassuck No. 1, purchased for $3,300, arrived in late August. It was a magnificent machine, capable of pumping six hundred gallons a minute and with a "steaming boiler...guaranteed to generate a steam pressure of thirty pounds in from three to three-and-one-half minutes, and eighty pounds in from five to six minutes from time of lighting fire." This meant that it would usually arrive at a fire with a good head of steam and ready to go to work.

From 1900 on, the fire department lobbied annually for larger quarters, a stable attached to the fire station to house the horses, and more and

Growing Pains

better equipment. At least some appropriation for new equipment was generally approved, but a new fire station remained a dream. The department set up its own building fund and, in 1907, commissioned Charles L. Bevins to design the building. In August, the *Newport Daily News* offered support in a long article on the history of the department that concluded:

> *The department is now in good condition so far as apparatus is concerned, to fight any fires except perhaps a large one in the hotel district, but is badly handicapped for want of an adequate station…With the present crowded condition of the apparatus and the keeping of the horses at a distance, the station being too small for their accommodation, much valuable time is lost in answering an alarm, and only careful work in spite of the hurry saves a bad tangle or a smash-up in coming out of the narrow front of the building.*

The newspaper's caveat about the department's inability to fight a large fire in the hotel district was borne out by the Thorndike Hotel fire on October 5, 1912. The hotel was closing for the winter. The last guests boarded the ferry for Newport and, as was customary, were seen off with fireworks. Usually the fireworks were set off on the porch or lawn, but this time someone evidently climbed to the tower to give a grander display and left smoldering debris behind. The alarm was sounded about 11:00 p.m., and the Jamestown volunteers responded with their steam pumper. But the blaze was clearly out of control and—as with the Riverside fire—they bent their efforts to saving nearby buildings. The great blaze was visible across the bay, and volunteers came from all over to help. There were firemen with two steam pumpers from Newport, apprentice seamen from the Training Station, soldiers from Fort Wetherill and Fort Greble, sailors from two torpedo boats, and even a contingent of German sailors from the visiting cruiser *Victoria Louise*. Nothing could be done to save the hotel, but the fire was prevented from spreading. No one was killed.

The proven effectiveness of the fire volunteers, however, did not encourage the town to build a new fire station. The firemen continued to raise money on their own, but it was slow work. In 1923, with $3,888.32 in the building fund, the department again asked the town for help:

Jamestown

> *The Jamestown Fire Department respectfully petitions your honorable body that the sum of $5000 be set aside annually for two years beginning with the year 1923 for the purpose of construction of a new fire station with assembly hall above.*

This time the petition for funding was successful. Detailed negotiations continued while the building fund grew, and the department independently purchased two parcels of land upon which to build a fire station. Finally, in 1927, the fire department conveyed ownership of the land to the town, and Charles Sullivan of Newport began building the new station, using Herbert J. Wetherill's design for the municipal center. The fire station was dedicated on February 2, 1928.

Telephone Service

The first attempt to bring telephone service to Jamestown, made by the newly formed Conanicut Telegraph and Telephone Company in 1883, failed. The underwater cable linking the company's offices in Jamestown and Conanicut Park to the Newport exchange worked only sporadically and then failed completely. The failure destroyed the company and delayed service for ten years.

In March 1893, the Newport Telephone Company decided to try again. The company proposed two stations—one in the Thorndike Hotel for summer use only and one in John Watson's grocery store for year-round use—and offered to extend the line to anyone who wished to subscribe at a charge of about forty dollars rent. After getting town permission to erect and maintain a telephone line "provided that [they] erect suitable painted poles, thirty feet high," the company laid a cable across the bay to a terminus at Weeden Lane. On Thursday, May 16, 1894, at 5:15 p.m., Walter Wright, the telephone company agent in Newport, called Charles Weeden at the Thorndike Hotel to check the circuit. The telephone had come to Jamestown.

To publicize the event, Wright announced that there would be no charge for Jamestown calls until Monday. Many Jamestowners got to talk on the phone for the first time that weekend.

To place a call with the new phone system, Jamestowners dialed an operator and told her or him—most of the night operators were men—the number they wished to call. During the summer, the operator at the Gardner House

Growing Pains

Certificate number two in the Conanicut Telephone and Telegraph Company. The certificate was issued to William H. Knowles on August 11, 1882. *Courtesy of the Jamestown Historical Society.*

The switchboard at the Narragansett Avenue telephone office opened in 1922. *From left to right*: Dot VonHoffer, Janice Whitehead Fletcher, and Marilyn Crowell. *Courtesy of the Jamestown Historical Society.*

switchboard serviced the island, but in the winter the call had to go through the Newport exchange. The delay and expense of calling Newport to talk to a neighbor or report a fire irritated the subscribers. The town council complained and even invited Wright to a meeting to hear the complaints in person.

In 1916, the telephone company finally installed a switchboard to be manned year-round by local operators. Until 1964, the operators routed all calls in and out of Jamestown. While professionally discrete about information they could infer from the calls they connected, the operators were also fonts of knowledge about local affairs. They knew where the fire was, if a friend had returned home from the hospital or a trip, and often how to get hold of someone in an emergency.

Lighting and Electricity

Like other improvements in the town, streetlights came to Jamestown because of the summer people and, for a time, were a benefit only in the summer. A request for lighting on Narragansett and Walcott Avenues was first presented to the town council in July 1887 by George C. Carr, along with three summer Jamestowners: Robert King of St. Louis and Edward Roth and James Newlin of Philadelphia. The council appointed a committee to look into it. Nothing more was done that year.

In July 1888, the council received a similar petition signed by Carr, Roth, and Newlin, this time joined by Pardon Tucker, J.R. Hopkins, and John Marshall:

> *Owing to the rapid increase in population of the Island of Conanicut and its growing importance as a sea side resort and having in view of the necessity of making proper Sanitary regulations for the changing condition of the Island and procuring light, water, and improving the roads and landings and in increased postal facilities and in other respects contributing to the safety and comfort of the residents, your memorialists ask that the Council will appoint a committee to take into consideration the state of the Island in the premises and to report from time to time to the Council their recommendations for the public Welfare.*

The signers were appointed to the committee. On August 1, the town council met to hear and act on the committee's recommendations.

The recommendations concerning lighting, the committee's initial focus, showed a political sensitivity to the unwillingness of native Jamestowners to incur expenses from which they did not see a direct benefit. The lighting

Growing Pains

Police Chief Charles E. Hull with his wife, Nettie, and daughter, Mabel. A professional police force was not established until 1958. *Courtesy of the Jamestown Historical Society.*

would be in place "for at least four months in the year"—that is, when the summer people were enjoying their nightlife—and the expense of the lights would be covered by increased valuation of the property directly benefiting, not by increased taxation on the whole town. To a community of farmers used to responding to the natural cycles of days and seasons, streetlights were frivolous and unnecessary.

The council acted immediately, voting that lights be placed three hundred feet apart along major thoroughfares in the village. The *Newport Daily News* congratulated Newlin on his victory.

For several years, until 1897, the lights were taken down at the beginning of October and put up again early in June, despite repeated petitions to the town council to keep them lit year-round. Even in 1897, only some of the

streetlights were kept up. Because each streetlight had to be lit and extinguished individually, and over the years several different fuels were used, the decision not to incur the expense was not as unreasonable as it might appear.

Perhaps the council was also looking forward to a different kind of streetlamp. As early as 1890, representatives of electric light companies had lobbied the town about installing electric lighting. The Jamestown Light and Water Company's 1888 charter authorized it to do it, but the company concentrated on the water issues.

Electric power first came to Jamestown in 1899, when the Gardner House and the Thorndike Hotel, closely followed by the Bay View Hotel, installed private generators for interior lighting and elevators. At about the same time, a new power company, Conanicut Light and Power Company, came forward to request a charter to power the island. The effort died. Finally, in 1913, the Jamestown Town Council signed an agreement with the Newport Illuminating Company, which supplied power for the city of Newport, giving the company an exclusive franchise to furnish electricity for heating, lighting, and power.

> *In case it furnishes electric current from a plant in Newport...* [it] *will provide at least two cables for the transmission of electricity to said Town or if only one cable will establish and maintain an emergency plant in Jamestown for a supplementary supply in case of accident.*

The lights were turned on in the village in July 1913, and service was extended to Conanicut Park in 1923.

Healthcare

In 1881, the *Newport Daily News* stated boldly: "Jamestown is a healthy place with the rate of mortality less than in any other town in the state." The healthfulness of the town was fortunate because at the time the nearest medical care was at Newport Hospital, and the only way to reach the hospital was by a ferry that, unless the patient's need coincided with the ferry schedule, had to be sent from Newport. No doctors lived on the island.

As the century ended, the island's reputation for health attracted healthcare providers. The earliest facility was Seaside Camp, just south of Conanicut Park. The Young Women's Christian Association (YWCA)

Growing Pains

established the summer camp at the North End in 1887, when a physician recommended sunshine and fresh air at the seashore as a cure for a girl at the YWCA's Providence facility. Twenty-nine boarders and 118 day visitors, most of them in poor health, stayed at the camp the first year. The focus of the camp, which operated until 1970, soon shifted to more traditional camping activities for young girls.

In 1906, the Rhode Island Hospital used the old Conanicut Park Hotel as a children's ward for the summer months.

Dr. Bates Sanitarium, founded in 1900 and continuing in operation until 1944, served the Jamestown community the longest. The sanitarium—part resort, part health spa, and part nursing home for the chronically ill—offered the islanders the use of its surgery and its maternity services, as well as a few free beds for indigent Jamestowners. Between 1915 and 1935, at least 136 Jamestown babies were born at the sanitarium. Except in emergencies, such as the 1918 influenza epidemic, the sanitarium did not treat communicable diseases.

Jamestown's only inpatient facility after 1944 was the Harbor View Nursing Home, which operated from 1953 to 1978.

The first physician to live and practice in Jamestown arrived in 1901. Dr. Ernest C. Bullard was born and trained in Vermont and stayed on the island until 1911. When he left, Dr. Arthur M. Mendenhall—who had learned about the island while he was stationed at Fort Greble on Dutch Island as a member of the Medical Reserve Corps, Coast Artillery—became the town doctor. Dr. Mendenhall and his successors, Dr. Henry Ecroyd, Dr. Partick J. Lyman, and Dr. Richard P.S. Arlen, all worked closely with Dr. Bates and his wife, Dr. Martha Boyce Bates, at the Dr. Bates Sanitarium.

During the summer months, when the population of the island more than doubled, the number of physicians more than doubled, too. Doctors in all specialties, many of them from the Philadelphia area, summered in Jamestown. A few, like Dr. David B. Birney and Dr. Henry J. Rhett, had an active summer practice; others, like the surgeon Dr. George B. McClellan, were on call when their special services were needed. The result of having these visitors on the island is captured in a *Newport Journal* story about an accident on the Jamestown dock in 1892:

> *Captain McDonald, who saw the accident, immediately ran to the Gardiner House for a physician. In five minutes there were five doctors*

on the spot, Dr. Bradley, who is stopping at the Gardner House being the first to arrive. Dr. Birney arrived very soon after, and assisted by Drs. Bradford, Wicker, Lieber and Rankin, removed several large pieces of skull and sewed up the wound.

Since the mid-twentieth century, Jamestown has had one, and usually two, full-time doctors with offices on the island. Dr. Charles Barrus Ceppi and Dr. Alfred B. Gobeille both practiced on the island from the 1940s to the early 1970s. Both were active in town affairs. Dr. Gobeille was president of the town council and responsible for the adoption of the town's health code. In 1984, Dr. Joseph J. England started the Jamestown Family Practice.

Other medical services arrived shortly after the doctors. Dr. Bates Sanitarium bought its first ambulance in 1913 and announced that it could be hired by anyone "at a moderate price." The sanitarium offered it free of charge to the Red Cross during World War I. The Jamestown chapter of the Red Cross, founded in 1932, bought its own ambulance during World War II and, in 1949, turned it over to the town. The Jamestown Ambulance Association, renamed the Jamestown Emergency Medical Service in 2005, has provided emergency ambulance service since then.

Thomas E. Hunt, a Newport pharmacist, opened the village's first pharmacy in 1929, although it was only open in the summer. The drugstore stayed in the same building at the corner of Conanicus and Narragansett Avenues, under different owners, until 1983. Timothy Baker opened Baker's Pharmacy on Narragansett Avenue in 1977.

Dr. Bates Sanitarium offered the town the services of a district nurse in 1913, but a public health nursing service was not available until 1935.

The Community

With more free time and with the businesses in the village assuming greater importance, the churches, as well as both old and new clubs and organizations, flourished.

Growing Pains

Churches

Only two churches were active in Jamestown in 1870: St. Matthew's Episcopal Church, still a mission of Newport's Trinity Church, and Central Baptist Church. The increased population of the island strengthened both churches.

The Central Baptist congregation drew members from both the islanders and the summer community. By 1890, it had outgrown the original chapel built in 1868. In keeping with the Jamestown tradition of repurposing buildings, the chapel was moved to Cole Street to become the home of Mount Zion African Methodist Episcopal (AME) Church, and a new church was built on the lot at the corner of Narragansett and Southwest Avenues. The building, according to the *Newport Journal* in July 1891, "has the largest seating capacity of any house of worship in that place."

St. Matthew's Episcopal Church, having completed its new building in 1880, became independent of Trinity Church in 1896. Almost at once, the first rector, Reverend Charles E. Preston, began building a new chapel—a movable one. The missionary purpose of the chapel was to bring church services to the remote areas of Jamestown. For ten months of the year, the chapel would be located about three miles north of the village and serve the year-round farm community. In the summer, it would be moved to the northernmost part of the island to serve the summer residents at Conanicut Park.

Charles L. Bevins, the architect of the Thorndike Hotel, designed the chapel. The building was eighteen feet wide, and from the floor to the ridgepole, it stood eighteen feet high. The cross and belfry added several more feet. Inside, pews could seat one hundred people. Construction began in 1898 in a lot next to St. Matthew's Church. In 1899, the chapel was moved, with great difficulty, by ten yoke of oxen to a spot on North Main Road. There it remained, used as a chapel for at least part of the time, for ten years. In 1909, it was moved to Carr Lane. It never did reach Conanicut Park.

Some of the newcomers brought their own religious beliefs. The first Roman Catholic Mass was offered at the Thorndike Hotel in August 1889. Patrick Horgan, the owner of the hotel and himself a Catholic, provided a rent-free room for the service, and two summer visitors arranged for a

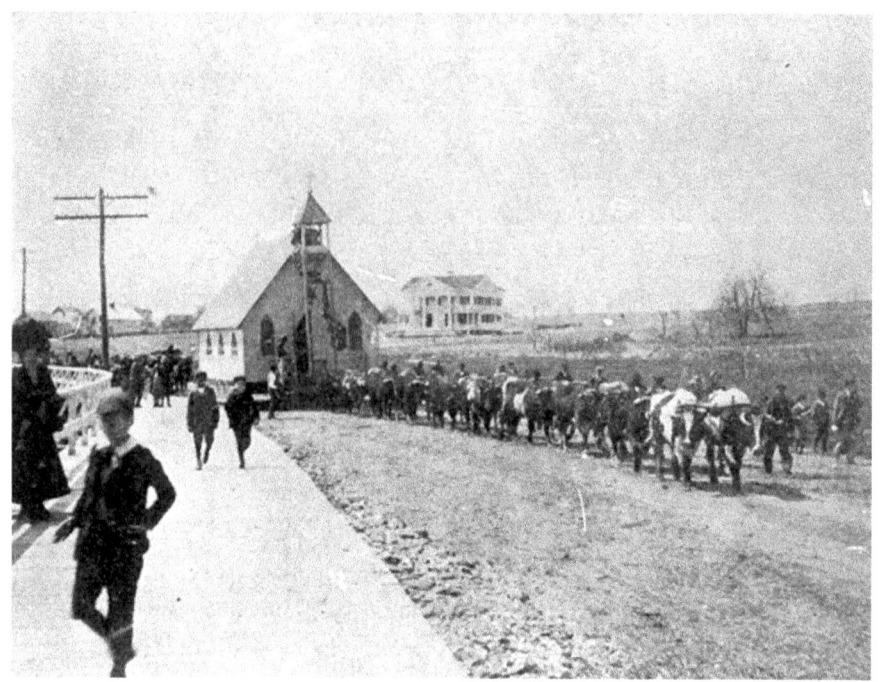

The Movable Chapel of the Transfiguration in front of Shoreby Hill. *Courtesy of the Jamestown Historical Society.*

celebrant. The Chapel-by-the-Sea, as the Jamestown church was called, became a mission of St. Mary's Parish in Newport.

Two years later, with Bevins again as the designer, a Catholic church building was started on donated land at 43 Clinton Avenue. The nave was completed that year, and at least one fundraiser was held in the bare building. The event was well attended, and a reporter commented: "It is a pleasant thing to see the different denominations helping each other in their works of charity and surely it can be said that the Catholics have the good will of their fellow Christians here." The next year the chancel and transept were built onto the nave. The porch and towers in Bevins's design were never added, evidently because money for them could not be found.

In 1909, the Providence Diocese accepted the congregation as an independent parish called St. Mark. In December of that year, the building was moved to a much larger lot, with an existing home to be used as a rectory, at 60 Narragansett Avenue.

Growing Pains

The Society of Friends, dormant on the island for almost a century, revived with the arrival of the summer visitors from Philadelphia. The Quaker meetinghouse on Weeden Lane was reopened for the summer months and attracted Friends from Newport, as well as the Dumplings.

Clubs and Societies

The churches offered discussion groups, sewing and knitting clubs, and lectures on a variety of religious and secular subjects. The members of the Temperance Society, which had been founded in 1830, continued to meet, to reiterate their promise to abstain from distilled spirits, and to proselytize on the evil of drink. The town was officially "dry," but enforcement was evidently sporadic.

Several new types of organizations also came into being, including organizations of businessmen, fraternal organizations, and cultural and sporting clubs.

In 1891, George C. Carr, organizer of the Jamestown Light and Water Company, and a group of year-round businesspeople started the Jamestown Improvement Society. The society began immediately to improve the village in practical ways. It hired men to remove weeds and mow the briars along the roads. It put out refuse cans. It created a small boat wharf near the ferry dock. It organized an annual parade. The money for these improvements came mostly from donations, although the town contributed a small amount. By 1929, the society was unable to raise the money to continue its work and disappeared. The Board of Trade was formed the year the Jamestown Improvement Society died with essentially the same purpose but a less ambitious, hands-on approach. In 1939, the Board of Trade became the Jamestown Chamber of Commerce with the idea of "broadening its activities for the greater benefit of Jamestown, and of obtaining as much cooperation as possible between all groups of the town."

The Conanicut Council of Royal Arcanum, an international fraternal organization with the objectives of "giving moral and material aid to its members" and of "teaching morality without religious distinction," met for the first time in March 1889. Abbott Chandler, who ran the boat livery at East Ferry, was the first Regent, and the group met twice a week at the town hall. While the Royal Arcanum no longer exists in Jamestown, similar

objectives guide the Jamestown Rotary Club (1941) and the Jamestown Lions Club (1953).

The Conanicut Grange, the Jamestown chapter of the National Grange Organization, also met for the first time in 1889. The Conanicut Grange is still actively engaged in promoting farming in Jamestown.

The first Jamestown Brass Band was formed in March 1903. The band stayed together until 1913. Since then, Jamestown has had fife and drum corps, drum and bugle corps, and, since 1993, the Jamestown Community Band.

The summer people had their own organizations, some of which remained after the resort hotels closed. The Conanicut Yacht Club, founded in 1892, is one of the oldest yacht clubs on the bay. The Jamestown Garden Club first met in 1912 and was revived in 1922 after a two-year hiatus. The Quononoquott Garden Club, founded in 1949, was started by Jamestown Garden Club members who wanted to meet year-round. Of three golf clubs, only the Jamestown Golf and Country Club (1901) is still in operation, and it belongs to the town. The Jamestown Historical Society, started in 1912 to preserve the derelict Jamestown windmill, now has responsibility for other historic properties as well.

THE DOWNHILL SLIDE

Jamestown's growth spurt ended when the popularity of hotel resorts declined after World War I. Many factors contributed. The automobile and paved roads made traveling easier. With so many places to go and an increasing ability to do so, the attraction of a summer holiday spent in a single town faded. The war had sent men and women whose parents had never left their hometowns to faraway places, and they brought home the excitement of the experience. For many, the quiet of a peaceful island town was too quiet.

The stock market crash of 1929 and the Great Depression that followed affected Jamestown severely. It had become a resort community, and resorts do not fare well in desperate times. Then on September 21, 1938, the hurricane that swept through New England devastated the community.

Slowing Down

The people of Jamestown didn't feel the effect of the changing market at first. While the number of hotel accommodations declined slightly in the 1920s, homes were still needed for the people who had moved to Jamestown in the previous decades. Some new summer cottages were built. Secure in a

prosperity that had now lasted over twenty-five years, the town built the Clarke School in 1923. In the latter half of the decade, from 1926 to 1930, at least sixty-seven homes and seventeen commercial or town buildings were built.

Jamestown's first movie theater, the Palace, opened at 34 Narragansett Avenue in 1921. The idea of the theater grew from Ferdinand Armbrust's experience using a movie projector at the Red Cross hut at Fort Wetherill during World War I. Armbrust worked with two other Jamestowners, LeRoy Meredith and Aaron Richardson, to finance the project.

The Conanicut Grange built a hall at 6 West Street in 1926. The Grange stressed the importance of fraternity, organization, education, and cooperation among farm families, and the hall quickly became a community resource for village and farm families alike.

The following year, the town contracted with Ralph G.P. Hull to build a bathing pavilion at Mackerel Cove. The *Newport Daily News* reported on June 13, 1928, that the pavilion would be opened to the public the next day:

> *There are more than 100 large, roomy, well ventilated bathhouses, nice wide porches, etc., for the accommodation of the public. The pavilion dance hall is an attractive and airy place where there will be dances three nights each week.*

Mackerel Cove Beach Pavilion. The building at the town beach was constructed in 1928 and destroyed by the Hurricane of 1938. *Courtesy of Sue Maden.*

The Downhill Slide

Men of the New Portuguese Society of the Holy Ghost at the celebration of the Feast of the Holy Ghost, May 30, 1926. *Courtesy of the Jamestown Historical Society.*

The pavilion originally stood on the north, or Sheffield Cove, side of the road. In the fall of 1929, it was moved to the Mackerel Cove side, and in 1931 more bathhouses were added.

As a further sign of the growing importance of Portuguese families on the island, the Holy Ghost Society, a religious and social organization with its roots in the Azores, built Holy Ghost Hall at 138 Narragansett Avenue. They broke ground in early April, and Hull, the contractor, had the first floor ready for the annual Holy Ghost celebration on June 29, 1930.

The 1920s saw increased tension between the townspeople and the summer people. The decade began on a sour note with a letter in January 1920 from Walter Lippincott, self-identified as "a taxpayer, a property owner, and a summer resident of Jamestown," to the town council:

> *Through the enterprise of summer residents and visitors, Jamestown has an attractive Casino, a very good golf ground and a yacht club with an almost perfect clubhouse…what have the town people done? They have had one good road built across the island, have kept the other roads in such an abominable condition that they are the source of continual complaint and managed the ferry connections of the place as if they were doing a favor to have such a facility at all.*

Politically, responding to the demands of the summer people was tricky. The businessmen and farmers depended on the summer income. Many of

the part-time residents devoted time and energy to improving the town. They paid taxes and could, if they were property owners, vote on town issues, although few did. They also formed an articulate pressure group. On the other hand, to be seen as kowtowing to them was political suicide.

When possible, benefits for the summer people were combined with benefits for the town. For example, after three years of trying to obtain matching funds from the state, the town financed a road to Beavertail—which would be used primarily by non-Jamestowners—with the bonds that also built the Mackerel Cove Beach Pavilion.

The road to Beavertail was not the only one that needed improvement. As Lippincott's letter intimated, only Narragansett Avenue had been paved, and the traditional oiled sand roads could not stand up to automobile traffic. A more stable crushed-stone roadbed was needed. The same 1928 financial town meeting that approved the bonds for Beavertail Road approved a municipal facility for crushing stone. The town quickly purchased quarry

Town's stone crusher. The heavy equipment needed to crush stone from the town quarry stood between the quarry and North Main Road, north of Carr Lane. *Courtesy of the Jamestown Historical Society.*

The Downhill Slide

equipment, a stone crusher, land on the west side of North Main Road north of Carr Lane, and a couple of trucks for hauling the crushed stone. That fall, Alton Head, superintendent of the stone quarry and road construction, began work on roads around the island.

Financial trouble at the ferry company affected town finances, too. The town auditors' report to the financial town meeting in April 1920 complained that the ferry company's accounts "are kept in such a way that no one can say they are absolutely correct." Resolutions at the meeting called both for the town to buy all outstanding stock and for an external audit. In August, a letter signed by twenty-one summer residents pointed out that the audit had not been done and that the ferry company owed the town $69,500.

> *It is clear that if a material part of the indebtedness of the Ferry Company were paid to the Town* [money] *could be used for the betterment of roads, police protection, lights, new pavements, cleanliness, increased fire protection...and other facilities.*

Price, Waterhouse & Company conducted the required audit. Their report was damning:

> *No original records, such as the pursers' reports and daily office cash reports, were available...The only books which the Company has kept are the cash receipts and disbursements...Government reports are prepared by arbitrary methods and do not conform to the requirements of the Federal Income Tax Law and regulations.*

Attempts were made to put the company on a more businesslike footing. By 1925, the company had bought back all the outstanding stock held by individuals, making the ferry a municipal service. Not all of the problems were solved, but for the fiscal year ending in February 1930, the ferry company showed a profit of $28,034.66.

Service was also improved. In 1923, the *Jamestown* (II) with a capacity of forty automobiles was purchased, and a contract for a new ferryboat, the *Governor Carr*, was signed. The *Governor Carr* went into service at the beginning of the summer of 1927. The *Newport Journal* reported that the *Governor Carr* would follow the regular summer schedule between Jamestown

and Newport "excepting for three excursion trips around the fleet each day…During this period, the steamer *Conanicut* supplemented by the *Beaver Tail*, if needed, will operate in place of the *Governor Carr*." The *Jamestown* (II) moved to the West Passage.

In 1926, the company built a waiting room at Saunderstown and two years later added a new waiting room, storeroom, and public comfort station at East Ferry. The Saunderstown waiting room included an information bureau.

The spending spree on public works in the 1920s was followed, even before the effects of the Great Depression were felt, by a deliberate campaign to "save the town's money." The voters authorized the last spending on public works in 1929.

The Great Depression

Until 1933, Jamestown—like the rest of the country—was on its own in dealing with the Depression. No unemployment figures are available for Jamestown, but in December 1930, Peter Cassese, a barber at the corner of Narragansett and Conanicus Avenues, offered free haircuts to children whose parents were unemployed. Early in 1931, Joseph Martin Sr. at Beavertail Farm was reported to be supplying poor families with milk and vegetables free of charge.

Acts of God played a part in relieving the misery. Two barges carrying about twelve hundred tons of anthracite coal foundered on the rocks off Beavertail in October 1930. More than one hundred Jamestowners braved the cold waves and scoured the rocky beaches to salvage the coal. The *Newport Daily News* reported the frenzy:

> Coming ashore with each crash of the heavy seas, the hard coal from the barge Howard Sisters, which is a complete wreck, piled several feet deep at the tide line, and was eagerly shoveled into bags, baskets, wheelbarrows, pleasure cars and trucks, and even horse-drawn vehicles of sundry descriptions. Judging from the crowd on the beach, it seemed as if the entire town would be well supplied with fuel for the winter months.

The Downhill Slide

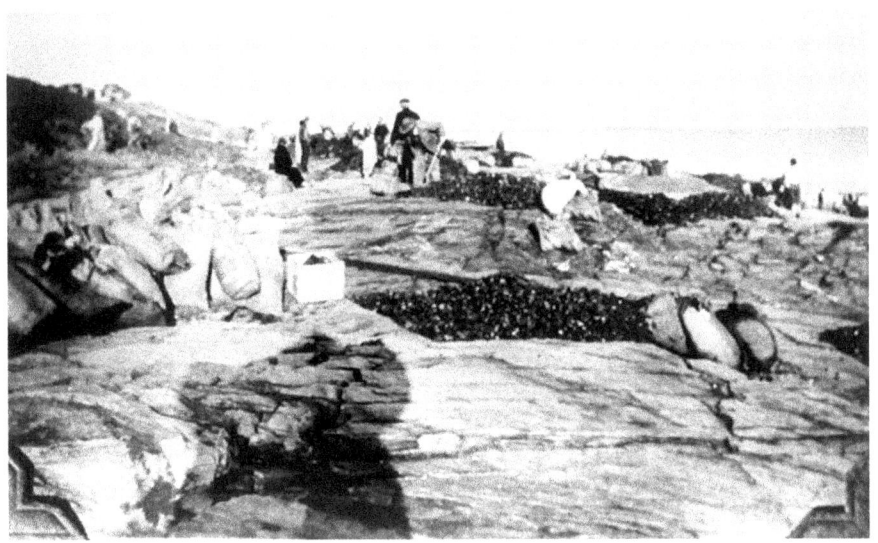

Gathering coal washed ashore from the shipwrecked *Howard Sisters* at Beavertail in October 1930. According to one estimate, each Jamestown household collected seven months' supply of coal. *Courtesy of the Jamestown Historical Society.*

Community groups worked to improve the economic situation. The Board of Trade sent letters to each of the summer taxpayers in January 1931, requesting that any repairs to their homes in Jamestown be made early to ease the winter unemployment and the congestion in the spring. Responders heartily endorsed the idea and directed that work around their summer homes start at once. The American Legion sponsored a bridge and whist tournament to benefit the unemployed. In January 1934, the Jamestown & Newport Ferry dismantled the obsolete ferryboat *Mohican*, giving the lumber from its superstructure to the unemployed. "Each day," reported the *Newport Daily News*, "a crew of six men take what they can carry away, and each succeeding day a new crew will take more."

In November 1931, the town council appointed a committee on unemployment. An Unemployment Relief Fund began in December 1931, and in January, the *Newport Daily News* reported:

> *The civic committee under the direction of the town council gave work to 10 men who will be paid from a fund raised by the American Legion, Board of Trade and popular donations. There were also 12 on the list*

of unemployed working at the crusher. These will be paid from the funds borrowed from the state.

The state contributed $3,750 to the fund in the 1932–33 fiscal year. The fund paid for several local projects, including upgrading the roads and building stone walls around the artillery green and next to the town hall.

The resort hotels that had fueled the town's growth before World War I became liabilities rather than assets. The huge buildings, unoccupied and uncared for, decayed. The Thorndike was razed by its owner in 1938, only twenty-five years after it had been rebuilt following the devastating 1912 fire. The town acquired the Gardner House for taxes in 1939 and razed it in 1941. A disastrous fire destroyed the men's ward at Dr. Bates Sanitarium in March 1931. Five people lost their lives. The sanitarium, now more a resort hotel than a medical facility, struggled on until 1943, when the Savings Bank of Newport took it over. The main building, the former Champlin House, burned down soon after.

Only the Bay View Hotel and the Bay Voyage Inn remained.

With the loss of the hotels and the customers they brought to the waterfront, the whole East Ferry area was, in the words of Fred C. Clarke, president of

North side of East Ferry Pier in 1937. Small and often badly maintained commercial buildings lined the pier and continued north along Conanicus Avenue. *Courtesy of the Jamestown Historical Society.*

The Downhill Slide

the Board of Trade in 1938, "unsightly and deplorable" and strewn with "dilapidated buildings, fallen docks and walls and has the appearance of a dump." The Board of Trade wanted the town to propose a cleanup of the area as a federal relief project.

The worst year of the Great Depression in Jamestown was 1933. The first shot of federal adrenaline came from the Federal Emergency Relief Administration (FERA), authorized in May of that year. Much of FERA money was used for direct relief, but in Jamestown it also enabled crusher work at the quarry and continued the upgrading of town roads. An alphabet soup of agencies followed FERA. Some of the younger men left the island to serve in the Civilian Conservation Corps (CCC). The Works Progress Administration (WPA), which directly employed unemployed workers on local projects, and the Public Works Administration (PWA), which financed and oversaw large projects, had the largest effect on Jamestown.

WPA money kept some Jamestown men working from 1935 to 1941. (The agency name changed to Work Projects Administration in 1939.) Over $55,000—in days when laborers made forty cents an hour—was spent on island projects. In April 1935, forty-seven workers received an average of $6.50 a week. In 1939, when an improving national economy led to cutbacks

WPA and PWA medallions. WPA plaques are embedded in the sea wall at East Ferry. The PWA plaque is from the old Jamestown Bridge. *Courtesy of the Jamestown Historical Society.*

in WPA funding, there were thirty-two men employed, eight of them on the East Ferry waterfront upgrade. Early projects proposed by the town and paid for by the WPA included upgrade of the roads, new athletic fields on Lawn Avenue, and stone walls along High Street. After the Hurricane of 1938, the WPA funded the cleanup effort.

The PWA helped finance the first Jamestown Bridge.

The Hurricane of 1938 and Its Aftermath

The Great New England Hurricane of 1938 was the most destructive and powerful storm to strike Rhode Island in modern times. The storm made landfall on September 21 at high tide, moving north at sixty miles an hour. The storm surge washed the ferryboats ashore, destroyed homes, and—most traumatic for the citizens of Jamestown—swept a school bus with eight children aboard into Sheffield Cove. Seven of the children died.

It was a day that everyone who was on the island at the time remembers.

Dolores Guimarey, who was eight, and her classmates were sent home from school when the wind started to blow hard. "Everything was very yellow and you could smell the sea," she recalled. She and her sister Roselyn did not have far to go; they lived just across the street.

Mary Westall was eighteen. She and her boyfriend started down to Beavertail to watch the storm, but the car stalled on the Mackerel Cove causeway. They saw another car and the school bus go by but got scared and ran back to Southwest Avenue. She learned later that neither the school bus nor the couple in the other car made it across.

Bill Pemantel, later captain on the Jamestown ferries, almost capsized his launch in Newport Harbor before he found a haven at the navy Torpedo Station on Goat Island.

Clingstone, the House on the Rocks, was still standing after the storm, but was so battered that it remained deserted for over twenty years. Smaller houses close to the water disappeared or were left in piles of rubble. All that was left of the Mackerel Cove Beach Pavilion were the cement steps.

On the East Passage, the storm beached both the *Beaver Tail* and the *Governor Carr*.

The Downhill Slide

The *Governor Carr* had left Newport on September 21 at 2:30 p.m. with seventy high school students onboard. It arrived in Jamestown at 2:50 p.m. and, with the wind increasing to gale force, was ordered to stay in the slip. Captain Harry M. Fillmore reported in his log:

> *Tried to secure her in slip. 3.15 boat secured and holding her off dock under difficulty. 3.30 p.m. tide rising very fast. Tide rose three or four feet in 30 minutes.*

Captain Arthur G. Knowles came to relieve him at 3:30 p.m., and both men stayed with the boat. The next log entry was signed by both Fillmore and Knowles:

> *Guards over and riding and pounding on piling. This bringing a tremendous strain on hull and danger of piling going through bottom. After parting nearly a hundred fathom of hawser and piling giving way continually. This forced us to leave for Newport. At about 5.55 p.m. with 3 cars and 12 passengers on board. When half way to Rose Island engineer informed pilot his Engine was disabled with something in propellers. We prepared the anchor and as the strong S.E. gale was forcing us on the beach we immediately put the anchor over. Anchor did not hold and we were forced on the lee beach. About one/2 mile North of Jamestown East Ferry Landing—at about 6.30 p.m. vessel brought up on the beach and we were able to land our twelve passengers in safety with our ladders. Three automobiles still on board. When tide fell found a hawser in one propeller. Three automobiles secured. Crew standing by. Vessel laying on bilge and no holes in bottom.*

The *Beaver Tail*'s fate was worse. It had been in Jamestown, where it was being overhauled, when the hurricane arrived. It bolted for the safer harbor of Newport and ended up on the beach at the North End with a broken keel and a hole in its hull. It was the oldest ship in the fleet and had been used only as a backup for fifteen years. It was sold for salvage.

On the West Passage, the hurricane damaged the wharves and terminals. The *Hammonton*, carried above the West Ferry pier by the storm, settled back partially on top of it. The landing in Saunderstown was washed away.

Once the immediate terror of the storm had passed, the cleanup started. The town had demolished most of the stores on the east side of Conanicus Avenue earlier that year; the storm swept away the gas station and what little else was left. The WPA helped clean up the debris and built a sea wall from the ferry wharf north.

The storm isolated the town. To restore service on the East Passage until the *Governor Carr* could be repaired, the ferry company leased the *Narragansett*. Stillman Saunders, whose ferry service had challenged the Jamestown & Newport Ferry Company at the turn of the century, had built the *Narragansett* for his West Passage run, and the federal government had used it between Newport and Goat Island until 1937. Within weeks, service on the East Passage resembled normal winter service.

Meanwhile, the WPA built a cradle under the beached *Governor Carr* and blasted and bulldozed a path to the water. On December 7, the *Governor Carr* was refloated. On February 21, 1939, it was back in service.

Relaunching the *Governor Carr*. The *Governor Carr* was driven ashore during the Hurricane of 1938. It was back in service about four months later. *Courtesy of the Jamestown Historical Society.*

The Downhill Slide

On the West Passage, the situation was less easily corrected. The ferry could not run until a new wharf at Saunderstown, with attendant services, was built.

The loss of ferry service on the West Passage had the effect of propelling forward a project that had been under discussion for over a decade: a bridge across the West Passage. As one of its advocates said, the bridge would "transform the inconveniences of a natural island to the conveniences of an artificial peninsula." But others felt differently. The estimated cost, $3,120,000, was too high, they argued, and there would certainly be overruns. The bridge would ruin the island.

In April 1937, the state had created the Jamestown Bridge Commission to construct, operate, and maintain a toll bridge. The War and Navy Departments, with an eye to the war clouds hanging over Europe, and the State Emergency Public Works Commission had approved the proposal. In July 1938, after the commission filed a copy of a contract for the purchase of bonds in the sum of $1,600,000, the PWA Finance Division recommended approval of a $1,404,000 grant, about 45 percent of the total cost.

When a Jamestown town meeting was scheduled for September 26, 1938, to enable the town's voters to have their final say on the bridge project, the opposition was still strong. Five days before the meeting, the hurricane knocked out the ferries. At the meeting, the vote was 240 to 23 in favor of the bridge.

In December, final arrangements for the financing were made.

One of the terms of the PWA grant was that work had to begin before the end of 1938, a stipulation that meant that engineers had only five weeks to accomplish what normally took six months. Bridge plans were drawn up, and bids for three of the five major contracts were received on time. Work on the bridge began.

The construction workers were both permanent employees of the contractors and local temporary help. The jobs paid well, sixty cents an hour for laborers and one dollar an hour for skilled workers. The men worked for eight hours with thirty minutes for lunch. There were no fringe benefits and no coffee breaks.

The contractor for the substructure reported that 90 percent of the employees came from Rhode Island, many from Jamestown. The town also profited in other ways. Workers from out of town lived in boardinghouses,

JAMESTOWN

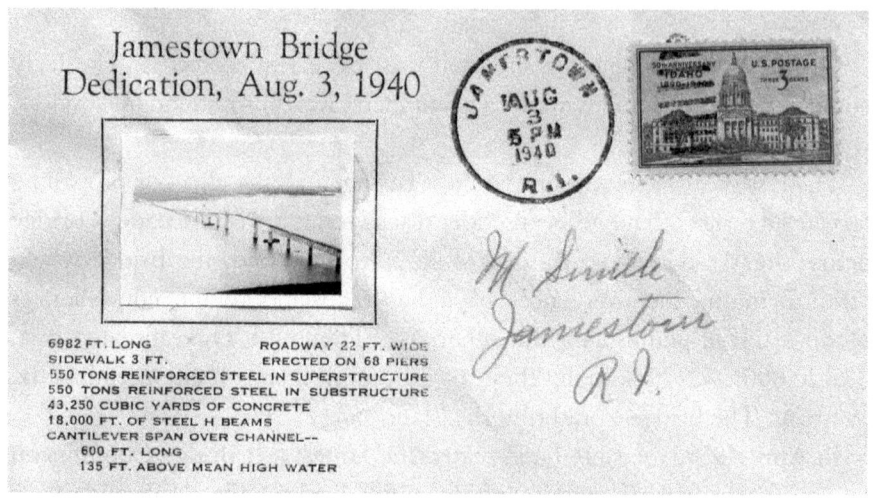

Commemorative envelope for the Jamestown Bridge dedication, August 3, 1940. The photograph of the bridge was individually affixed to each envelope. *Courtesy of the Jamestown Historical Society.*

rented homes, or roomed with local families. A June 21, 1939 article in the *Providence Journal* stated, "Real estate men are literally tearing their hair trying to find apartments and tenements."

Approval and financing of the bridge had taken six years; actual construction was completed in just eighteen months. When the bridge opened on July 27, 1940—pressed to do so to reap the revenue from summer traffic—it was only two months behind schedule and almost $118,000 under budget.

The bridge shortened the travel time between the military installations in Jamestown, North Kingstown, Saunderstown, and Newport. Unlike roads in other areas that were only lightly used during the war because of gas rationing, traffic on the Jamestown Bridge remained almost level. The resulting income ensured that the bonds that paid for the bridge were redeemed on schedule.

JAMESTOWN AND THE MILITARY

Military installations and other federal government sites are common in Jamestown, although since the mid-twentieth century only the lighthouse at Beavertail—the oldest of the installations—still fulfills its original purpose. Before satellites and air surveillance, the position of the island in the center of the entrance to the bay made it a critical observation post when an enemy threatened from the sea. The importance of Newport as a commercial and, later, military port contributed greatly to Jamestown's significance, although its forts and lighthouses protected all of Narragansett Bay and its shipping.

Early Installations

At the end of the American Revolution, only two government sites existed in Jamestown: the Conanicut Battery, which quickly reverted to farmland, and the light station at Beavertail. Rhode Island reluctantly transferred Beavertail light to the federal government in 1793.

In November 1799, in response to growing uneasiness about relations with France, the government decided to construct a fort on Conanicut Island overlooking the narrowest part of the passage between Newport and

Jamestown

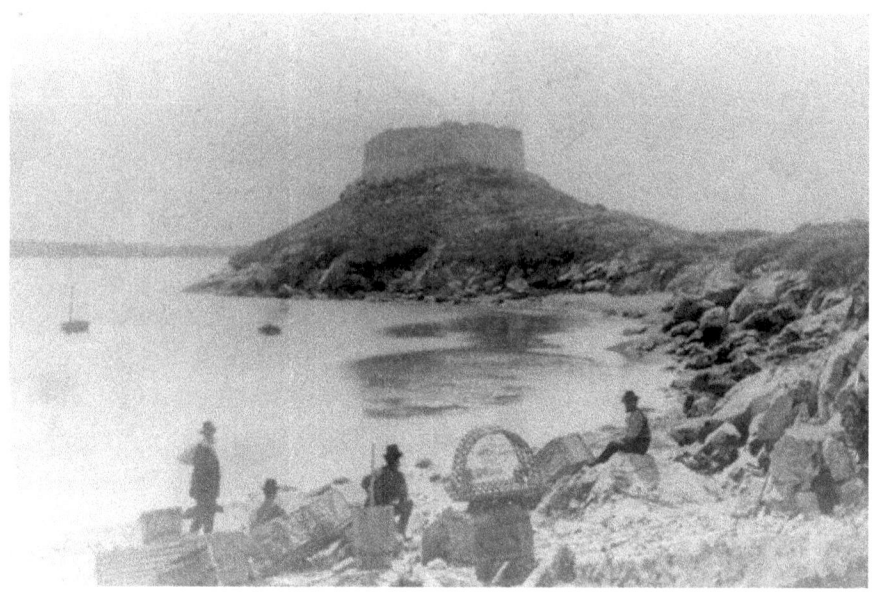

Fort Dumpling. The Martello tower–type fort, which commanded a magnificent view of the East Passage and Newport, was blown up in 1898. *Courtesy of the Jamestown Historical Society.*

Jamestown. Ebenezer Sherman sold the six and a half acres for the fort for $600. He included in the agreement a clause reserving to his heirs, forever,

> *the exclusive Rights of takeing Carrying away all sea weed rockweed or other sea manure, and of pileing the same in Convenient Heaps for that Purpose with the Privileges of a way For Carrying the same thru the land Hereby granted.*

The fort at the Dumplings was an elliptical stone tower, 108 feet long and 81 feet wide, with walls varying in height between 12 and 24 feet, depending on the underlying rock formation. It was obsolete before it was completed and was never manned.

The deserted fort became a favorite picnicking spot, touted in guidebooks such as William Cullen Bryant's *Picturesque America* in 1874. Unfortunately, the soldiers at Fort Adams, directly across the bay, used Fort Dumpling for target practice, making it a potentially dangerous place to play. On July 4, 1877, a woman was accidentally wounded. She recovered, and the incident did not deter others from picnicking, fishing, and even camping out on the fort grounds.

Jamestown and the Military

Fort Dumpling was blown up in 1898—taking with it about twenty-five feet of the promontory on which it stood—to make way for more up-to-date fortifications.

On the West Passage, a lighthouse and its keeper's cottage were built at the southern tip of Dutch Island in 1826 on land ceded by the State of Rhode Island to the United States government the previous year. The light was first lit on January 1, 1827. For the next 120 years, until the Coast Guard automated the light in February 1947, a keeper lived on the island, tending the light. Many keepers brought their wives and children with them. Until the Civil War, it was a lonely outpost, since no one else lived on the island, which lacks a satisfactory source of fresh water.

During the Civil War, two military camps were established in Jamestown, one (Camp Bailey) on Dutch Island and the other (Camp Mead) in the town proper.

The federal government started construction at Camp Bailey in 1863, although it did not buy the land until the following year. The first units of the Fourteenth Rhode Island Heavy Artillery Regiment (Colored) arrived in early September. The regiment constructed an eight-gun earthworks south of the center of the island in the first two months. The Lower Battery, about seven hundred feet north of the lighthouse, was built next but was never armed because the site flooded. An outbreak of smallpox during the winter of 1863–64 took the lives of sixteen of the men. Their bodies were originally buried on the island, but their remains were moved to the Long Island National Cemetery in 1948.

After the war, military activity on the island continued, but at a much slower pace. By the mid-1870s, the population on Dutch Island had dwindled to thirteen people: one light keeper and twelve at Camp Bailey (an engineer, his household, and one soldier). Twenty years of virtual inactivity followed.

The in-town camp, Camp Mead, was a recruiting station for the Third Rhode Island Cavalry, which was formed on July 1, 1863, and disbanded on November 25, 1865. All Third Rhode Island recruits—about one thousand over two years—trained at the sixteen-acre camp that ran from Narragansett Avenue south to just beyond Brook Street between Green Lane and about halfway between Clinton and Howland Avenues.

For a while after the war, the town and others used some of the camp buildings. Then Camp Mead vanished, leaving no trace.

Early Twentieth Century

The U.S. Navy valued Newport's deep, sheltered harbor, although without a supporting infrastructure the port was not used extensively until after an experimental Torpedo Station, established on Goat Island in 1869, and the Naval War College, begun in 1884, brought a permanent navy presence to the area. The navy influenced Jamestown both economically and socially. Once the steam ferry ensured that Jamestown workers could get back and forth across the bay without worrying about the weather, the Torpedo Station became a major employer. Both the Naval War College and the visits of the fleet to Narragansett Bay brought a large number of navy personnel to the area. Jamestown became

Jamestown women visiting the USS *Kearsage* (BB-5). The USS *Kearsage* was the flagship of the North Atlantic Fleet from 1900 to 1906. *Courtesy of the Jamestown Historical Society.*

Jamestown and the Military

a favorite vacation spot and often the retirement home for officers. In the 1930s, Rear Admiral Spencer S. Wood's annual birthday party attracted between fifteen and twenty admirals, many of them Jamestown residents.

The building of three forts within the town between 1898 and 1906 created a U.S. Army presence as well.

The War Department began an evaluation of the country's coastal defenses in 1885 and quickly determined them to be inadequate. Congress authorized the upgrade of existing fortifications in 1890, but large-scale construction did not begin until almost the end of the decade.

The rebuilding of the Civil War camp on Dutch Island—now called Fort Greble in honor of Lieutenant John T. Greble, a Philadelphian who had been killed early in the Civil War—began in 1897. Battery Hale, with three ten-inch breech-loading rifles on disappearing carriages, was built on the east side of the island just below the crest of the central rise in 1897–98. Other batteries followed in 1900 and 1906. Construction of permanent

Fort Greble on Dutch Island about 1915. The large buildings on the far right are the barracks. *Courtesy of the Jamestown Historical Society.*

housing and support facilities made the island virtually a town of its own. Barracks housed over three hundred enlisted men. Officers and their families lived in attractive single or duplex homes, while noncommissioned officers had similar, smaller quarters. A hospital and commissary served the military community and, with special permission, the lighthouse keeper.

Fort Getty, on Conanicut Island south of Dutch Island and north of the colonial Conanicut Battery, overlooked the narrowest part of the West Passage. It was about half the size of Fort Greble. The United States government acquired the land by condemnation in 1900. According to the *Newport Journal*:

> *The lands in questions are situated on Fox Hill in Jamestown, the property of Benjamin S. Cottrell. A judgment was entered for $60,000 for the owner of the land...A wharf will be built out from the property, in order that the material for the new fortifications may be landed. The battery which will be placed here will occupy a position that will enable its guns to command the entrances to both the east and west passages.*

Construction of the fortifications began in 1901, and the fort was garrisoned in 1909.

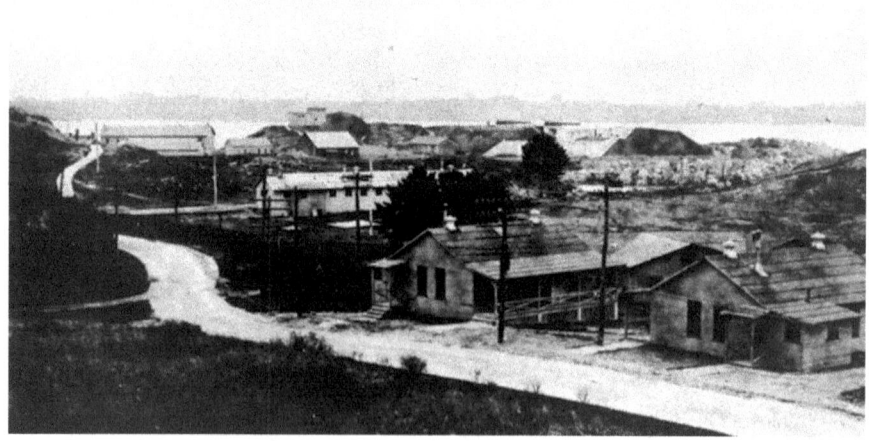

Fort Wetherill about 1917. The two twelve-inch guns of Battery Varnum are visible at the right above the roofs of the barracks. *Courtesy of the Jamestown Historical Society*.

Jamestown and the Military

Fort Wetherill, on the East Passage facing Newport's Fort Adams, was named for a summer resident of Jamestown, Captain Alexander M. Wetherill, U.S. Infantry, who was killed at San Juan, Santiago de Cuba, during the Spanish-American War. To build the sixty-one-acre fortification, the federal government took land surrounding old Fort Dumpling, in the process razing three of the summer houses in the area, including that of William Trost Richards, the artist who had been the first to build in the Ocean Highlands development.

Construction began in 1902 and continued through 1907. Fort Wetherill's artillery included twelve-inch disappearing guns that could be lowered out of sight.

World War I

Long before the United States declared war, Jamestown began to feel the effects of the European conflict.

Early in 1915, the Rhode Island National Guard and the regular army practiced artillery and infantry maneuvers on Dutch Island. In July, the *Newport Journal* reported that the firing maneuvers were being rushed and that the program was ahead of schedule. In January 1917, thirty recruits from Ohio strengthened the coast artillery garrison at Fort Greble.

The government acquired land on Conanicut Island for the Prospect Hill Fire Control Station, on the crest of the hill above the colonial Conanicut Battery, in 1916. After the United States entered the war in April 1917, the West Passage was closed to shipping, giving the waters west of the island a deserted appearance. A submarine net south of Dutch Island enforced the ban.

Jamestown also felt the impact of the buildup at the Torpedo Station on Goat Island. In October 1915, a story in the *Newport Journal* said, "Were 100 capable machinists to report today…they would be employed at once, though the number of men there Monday was in excess of 1,100." Many of the machinists lived in Jamestown.

> *It is stated by an authority on real estate in Jamestown that the supply of tenements there available for machinists at the Torpedo Station is exhausted and there must be more construction if the population is to increase in this*

direction. It is estimated that the increase already has been from 150 to 200 from this source, and some of the new arrivals are contenting themselves with what have heretofore been simply summer camps.

On January 26, 1918, an explosion at the Torpedo Station killed twelve employees outright and injured seven, one of whom later died of his injuries. A second incident occurred in May, and two men died. (No Jamestowners were involved.) The incidents prompted Congress to authorize the July seizure of Gould Island for storage of torpedoes and explosives and as a base for aircraft that test-fired aerial torpedoes. Building on Gould Island began soon after the November 1918 armistice.

Once the war began, Jamestowners supported the homefront initiatives as well as serving in the armed forces. Less than three weeks after the declaration of war, the Central Baptist Church hosted a preparedness service. A committee was formed to register landowners who were willing

Jamestowner Alfred V. Richardson in his World War I uniform. *Courtesy of Donald Richardson.*

to let others raise food on their land and to match gardeners with plots. Mrs. Mary H.C. Hammond appealed to the women to serve the country in a campaign against waste and declared her confidence in the patriotism of the homemakers. Isaac H. Clarke, speaking of the food wasted in the manufacture of alcoholic drinks, demanded that Congress act immediately on Prohibition.

The winter of 1917–18 was unusually cold. Shortages, particularly of coal, plagued the islanders. In mid-February, the grammar school closed because the classrooms could not be heated, and trips were cut from the ferry schedule. The shortage continued until late March.

That spring saw efforts to provide a service club for the men at the forts. Reverend Patrick J. Sullivan offered the St. Mark guild house as a reading room and lounge for the enlisted men. Placards around town made appeals for magazines and reading matter for the men stationed on the island. A "Penny a Week" club was formed to raise funds for a clubroom. At her graduation from the Jamestown school in June 1918, Catherine Carr talked about the same issue:

> *In every city where there are forts or camps, service clubs are provided for the benefit of the soldiers and sailors, but there is nothing of the kind in Jamestown. If every one in Jamestown would donate a little, a service club could be enjoyed by a number of soldiers. While a new North road, a new schoolhouse and a recreation park would improve our town, I think a service club is needed at once and I hope one will be established as soon as possible.*

The next month, the Bay View Hotel opened a dining room formerly used for the hotel servants as a clubroom for servicemen. In November, a formal YMCA Community Center opened in the Gardner House. A call went out for old rubber of any description to be left at the express office on the wharf; the proceeds would go toward maintaining the service club during the winter.

Other material was collected as well. The inscription on a barrel in the post office read: "Save your peach stones here, to save the boys over there." Peach, plum, and prune stones deposited in the barrel were used to make gas masks; two hundred peach stones made one mask.

The servicemen quickly dispersed after the war. According to the *Newport Journal*, the party at the Community Center on December 13, 1918, was

one of the jolliest parties of the winter.... Many of the boys bade good-bye to their friends, as they leave today for their homes. They said they would remember Jamestown, the many happy evenings they had spent and the hospitality received at the hands of the hostesses in charge. At the end of the evening three cheers were given for Jamestown.

Between the World Wars

Following the war, all of Jamestown's existing fortifications were reduced to inactive caretaker status under control of the Tenth Coast Artillery Regiment stationed at Fort Adams.

Fort Greble was allowed to decay. None of the batteries had guns that would protect against attack from the air. Supplying the island camp with potable water was a continuing dilemma. A system of cisterns stored water pumped from a deep well on the island and brought through pipes beneath the bay from Saunderstown. As a last resort, the *J.A. Saunders*, a ferry built by Stillman Saunders especially for the West Passage run, had specialized water-carrying tanks. It wasn't enough. The water pipes from Saunderstown froze in the winter of 1917–18. Ice on the West Passage stopped the ferry from reaching Dutch Island during severe winters. When the Jamestown Bridge replaced the West Passage ferry in 1940, no commercial transport remained that could include a stop at Dutch Island in its schedule.

During World War II, while the lighthouse keeper continued to live on Dutch Island, the only military use was as a rifle range. After the Coast Guard automated the lighthouse in 1947, the island was deserted except for occasional picnickers. All the buildings and roadways were overgrown by underbrush. In 1974, Dutch Island became the first component of a proposed Bay Island Park system.

At the same time, the development of torpedo and air warfare led to extensive building on Gould Island. Beginning in 1919, the navy constructed air detail hangars for seaplanes and kite balloons, a water tower and underground distribution lines, a wooden pier for personnel at the north end of the island, and a concrete pier for torpedoes at the southeast point of the island. A former farmhouse was converted to barracks for the marines who guarded the magazines. A railroad connected the concrete pier to the new buildings. Later, a rail line was built from the torpedo storage building

Jamestown and the Military

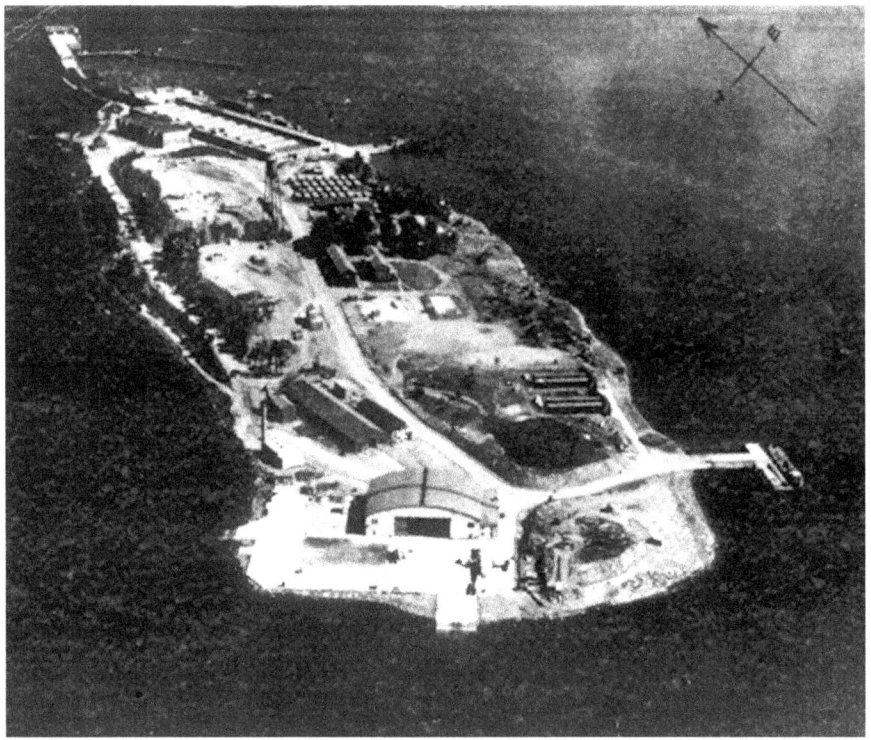

Military installations on Gould Island, August 1943. The torpedo testing facility is at the north end and the seaplane hangar at the south. *Courtesy of the Jamestown Historical Society.*

to the seaplane hangar at the south end of the island.

In 1921, a concrete platform and ramp were constructed at the south end, and two naval torpedo planes—modified by the addition of pontoons—arrived at Gould Island. Lieutenant Thomas H. Murphy, head of the air detail, made the first successful U.S. airdrop of a torpedo in the waters off Gould Island late that year.

About the same time, the navy reorganized the U.S. fleet into two main groups: a Battle Force (battleships and destroyers) stationed on the West Coast and a Scouting Force (cruisers, destroyers, and seaplanes) stationed on the East Coast. The Scouting Force was based in Narragansett Bay in the summers.

Development of torpedoes and airplanes to launch them continued on Narragansett Bay throughout the 1930s, bringing a steady stream of naval officers to Jamestown and providing employment for many islanders. The

research was not without incident. In August 1937, an unarmed torpedo fired from the submarine *Cachalot* off Gould Island passed between Vincent Astor's yacht *Nourmahal* and Frederick H. Prince's yacht *Lone Star*, struck a ledge, leapt into the air, and plowed through an iron fence at Pen Craig, the Newport residence of Hamilton Fish Webster, not far from John Nicholas Brown's Harbour Court. A similar incident occurred fourteen months later, when a torpedo fired by the test-firing barge off Gould Island came to rest in Brenton's Cove near Beacon Rock.

Test drops of turbine-powered torpedoes from aircraft stationed at Gould Island began in 1939. From 1941 to 1945, a total of forty-three hundred test drops of the Mark 13 torpedo were conducted in the waters east of Gould Island.

As Hitler's aggression in Europe widened in early 1940, the army's Harbor Defense Board made recommendations for reactivating and strengthening existing Narragansett Bay defenses.

World War II

Despite the shock of Pearl Harbor, American entry into World War II did not come as a surprise, especially in places like Jamestown, where the buildup of both the navy and army was visible. The Rhode Island National Guard had been called up as the 243rd Coast Artillery Regiment in September 1940 to take over the duty of defending the bay. Construction of winter quarters and support facilities at Fort Wetherill and Fort Getty began immediately. The joint army-navy Harbor Entrance Control Post (HECP), with the responsibility of identifying all ships approaching the bay, was established near the Beavertail Lighthouse in July 1941. Early in 1942, the navy installed two submarine-detection loops, consisting of ninety thousand feet of magnetic cable, which were monitored at the HECP.

Soon after the war began, the World War I observation posts on Prospect Hill were reactivated. Underwater mines and anti-boat booms were placed across the East and West Passages. In August 1942, the army took over 118 acres north of the Beavertail Lighthouse, removing summer cottages and fishermen shacks that had dotted the area, and created Fort Burnside.

Jamestown and the Military

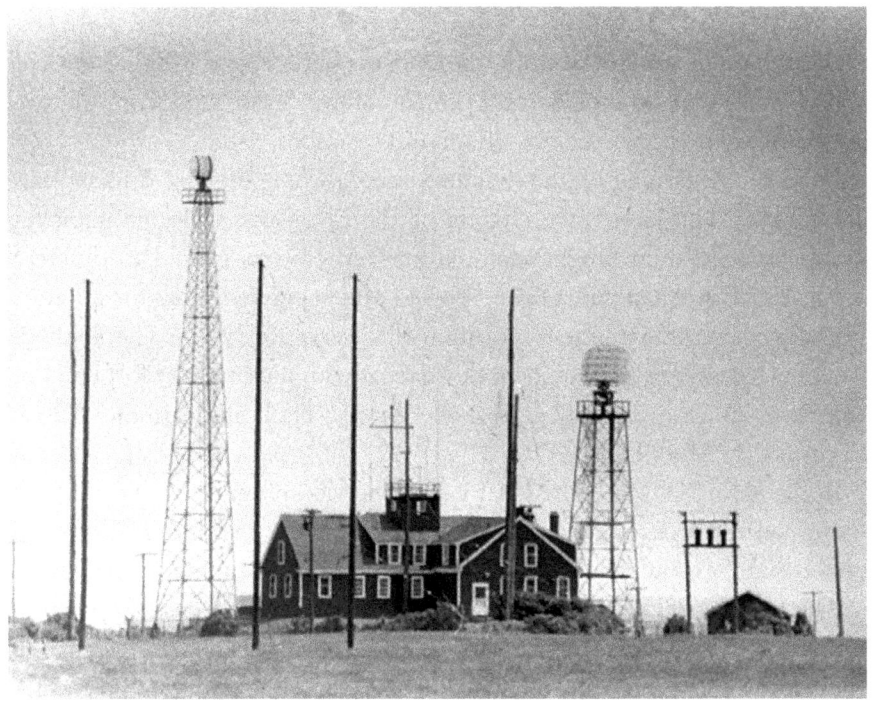

The Beavertail Signal Station occupied the former Harbor Entrance Control Post after World War II. *Courtesy of the Jamestown Historical Society.*

The fort was named after Major General Ambrose E. Burnside, who had commanded the Army of the Potomac during the Civil War and was later governor of Rhode Island.

The construction of Fort Burnside changed the tasks assigned to personnel at Fort Wetherill and Fort Getty. Some of the heavier armaments were moved to Fort Burnside or to other forts nearer the mouth of the bay. Mining and anti-torpedo boat duties occupied the two more inland forts for most of the war.

In 1945, both forts became sites of reeducation schools for German prisoners of war. In June, shortly after Germany surrendered, the army established the School of Administration at Fort Getty. The sixty-day curriculum of the school included language, military government, and German and American history with the aim of indoctrinating the students in democratic principles. In August, a Police School was set up at Fort Wetherill. Here the curriculum focused on history and government, especially law enforcement. In addition

to thirty days of classroom work, the students participated in thirty days of police training. A total of 1,166 prisoners of war graduated from the two programs before they were phased out in December 1945.

From the beginning of the buildup, Jamestowners organized to support the military. The Jamestown chapter of the Red Cross collected items for European relief and taught multiple first aid courses geared to different age levels. The American Legion studied and suggested reorganization of aircraft warning systems and relocation of observations posts. The Soldier's Welfare Committee sponsored weekly dances with music by the fort band or orchestra. The dances were held at the Grange Hall, St. Matthew's Parish House, or St. Mark Hall.

In the spring of 1941, the local United Services Organization (USO) set about building a permanent recreation center for the servicemen. The town agreed that the center could be erected on town land. The problem was where.

The Gardner House across from the East Ferry had been torn down in January 1941 and replaced by a park with a bandstand. The USO wanted to build there. The town council had a different plan. The town had used WPA funds to develop playing fields on a town lot bounded by Lawn Avenue, Watson Avenue, Melrose Avenue, and Arnold Street near West Ferry. The council wanted the USO to build there so that after "the present national emergency" the building could be used as a community center in conjunction with the sports field.

The town lost. In October, federal court judge John Hartigan entered an order of judgment transferring title of the Gardner lot at East Ferry to the War Department. Building began at once, and the USO center was dedicated on February 28, 1942.

With the issue decided and the "national emergency" evolved into war, the town rallied behind the USO and other war efforts. Like the rest of the country, Jamestown accepted rationing. Tires, cars, gasoline, and sugar were among the first products rationed. The local ration board decided who would be allowed to purchase restricted commodities; the Vieira Coal Company got permission to buy two tubes and two tires. Summer visitors were reminded to keep enough gasoline coupons to get home.

The old ferry pier in Saunderstown that had been destroyed by the Hurricane of 1938 was rebuilt for small boats in case water evacuation of the bay islands was necessary. In June 1942, metal identification tags were

Jamestown and the Military

USO center. The town bought the building and its contents in 1947 for $30,000; it is now the Recreation Center and houses the Teen Center. *Courtesy of the Jamestown Historical Society.*

issued to every child from birth to high school age regardless of whether they registered for evacuation.

By midsummer, the 243rd Coast Artillery was practicing firing the heavy twelve-inch guns at Fort Wetherill and Fort Getty. Jamestown residents were advised to keep their windows open to avoid damage by concussion.

For more than four years, the USO building was open from early morning to midnight seven days a week. Dozens of volunteers freely offered their time and talent. One popular feature was "Ye Never-Empty Cookie Jar," which stood on a table near the front door and was kept filled by the combined efforts of over two hundred Jamestown women.

More than four hundred Jamestowners—including summer residents—served in the armed forces during the war. On August 23, 1942, the first panel of a Roll of Honor, listing everybody then in the service, was dedicated at the recreation field with about eighty names. The panel was later moved to a site at the fire station, and panels were added on each side as more and more men and women donned uniforms.

After the war, a more permanent monument was wanted, and in 1946 the town council voted that "the area at the easterly end of Narragansett Avenue be named Memorial Square in honor of all who died in the service of their Country." The square underwent several changes in the next fifty years and was totally refurbished in 1997. On July 27–28, 1946, there was a Veterans Welcome Home Celebration. The program for the event listed all

World War II Roll of Honor. The multi-panel sign listed everyone who served in the armed forces. The girl behind the floral wreath is Helena Anderson. *Courtesy of the Jamestown Historical Society.*

those who served—both full-time and summer residents—and, on a separate "In Memoriam" page, honored the twelve who had died: Everett Alward, Howard H. Arnold, Edward B. Brooks Jr., Charles H. Brooks Jr., Lewis H. Burdick, Damon M. Cummings, Arthur C. Day, Delvert Gravatt, Frank T. Leighton, David Masterson, James L. Williams, and Francis X. Zweir.

Jamestown and the Military

Post World War II

When the war ended, the forts began to shut down. Fort Getty was the first to close completely. The town bought the forty-acre fort in 1955 for $5,500 and created a town park and campground.

The army removed its guns and moved its troops out of Fort Wetherill in the late 1940s, and in 1950 a navy harbor defense unit occupied the fort. The navy used only the wharf and harbor area, letting the rest of the buildings and defenses deteriorate. The Naval Station was closed officially in December 1959. In response to the town's request that the land be returned to the tax rolls, the navy said that the installation was not being declared excess or surplus and could be reactivated on short notice. Although the fort was condemned in 1966, it was not until 1972 that the federal government declared it surplus property and it became a state park.

Fort Burnside and the Harbor Entrance Control Post at Beavertail presented the most complex problems. The navy continued to maintain a high-tech communications center there and closed the whole point to civilians. The town, hoping for off-island visitors who would use the toll bridge, periodically convinced the navy to allow recreational use of the area, for a time even paying for a guard to be on duty. The naval radio facility closed in 1958, but navy concern about radioactivity from the large towers on the site delayed any action to release the property from federal control. Finally, in 1978, the state, with the help of Senator Claiborne Pell, was given the land and created Beavertail State Park.

The ships based at Newport were relocated to southern ports in April 1973.

The most devastating closure for Jamestown was that of the Torpedo Station. Jamestowners had worked at the Torpedo Station since the late nineteenth century. In 1951, the navy farmed the building of torpedoes out to private industry and transferred the responsibility for proofing, storing, maintaining, and issuing fleet torpedoes to the West Coast. The Torpedo Test Facility on Gould Island became part of the Naval Ordnance Station. It later merged with other underwater laboratories to become the Naval Undersea Warfare Center, tasked with research and development. Long before most of Gould Island was transferred to the state in the 1970s, the Torpedo Station and its adjunct services had ceased to be a source of jobs for Jamestowners.

Beavertail Lighthouse, built in 1856. The lighthouse is the only remaining federal government installation on Conanicut Island. *Courtesy of the Jamestown Historical Society.*

Almost all fortifications and military installations erected during the nineteenth and twentieth centuries are gone now, except for the massive, graffiti-marred concrete bulwarks and gun emplacements that can be seen in the parks that stand in their place.

POSTWAR ADJUSTMENTS

As the forts closed and the military left the island, the Jamestowners who had gone to war came home to a troubled town. It would be difficult to overstate the problems the town faced.

The population, which had remained steady for twenty years, began to grow. With a larger population and more regulations coming from the state and federal governments, the town needed to be more efficiently administered.

Development, which in the past had depended on the self-interest of the developers, needed to be controlled with the interests of the town as a whole in mind. A clean water supply was critical. The children in the growing town needed schools.

There were not enough jobs to go around as the nation switched back to a peacetime economy, and Jamestown had still not found an economic engine to take the place of the resorts that had fueled its earlier growth.

The bridge over the West Passage, which brought more people to the island to live, also brought more transients who just wanted to get to Newport, straining the capability of the town-owned ferry system.

Jamestown's tercentenary cake, August 1957. The giant cake, sponsored by the American Legion, stood at the foot of Narragansett Avenue and could be seen across the bay. *Courtesy of the Jamestown Historical Society.*

A NEW TOWN CHARTER

Jamestown was growing too large for the part-time government that had previously served it well. The governance was highly democratic—with a small "d"—resting in the hands of the voters at regular and special financial town meetings. The town council acted as a representative body between the town meetings, but administration fell largely to the elected town clerk.

At the financial town meeting in the spring of 1946, the voters appointed a committee "to study and to suggest any change which in its judgment might tend to give a more efficient administration of town affairs." The committee recommended a council–town manager form of government. The proposed charter retained the annual financial town meeting, keeping the approval of the budget directly in the hands of the voters. The town manager, hired by the town council, would be the chief administrative officer. The elective offices were the five-member town council, elected for staggered five-year

terms; the school committee; the directors of the Jamestown & Newport Ferry Company; and the town moderator.

In November 1947, the voters decided—326 to 325—to ask the Rhode Island General Assembly to approve the new charter. The bill died, perhaps because the assembly was considering a constitutional amendment that would define how towns could modify their own charters without state action. The state's Home Rule constitutional amendment was adopted in June 1951. That November, Jamestown was the first town in the state to create a charter commission. The revised charter, presented to the voters in November 1952, was similar to the charter the town had sent to the General Assembly for approval in 1947, with the exception that all council members were elected biennially. It was rejected by the voters, 522 to 494.

Despite multiple attempts to revive the council-manager charter, the town continued to elect all public officials from councilmen to town clerk to tax assessor for another twenty years. Elections were annual until 1959, when they were changed to every other year. In May 1973, a new charter commission was elected. The charter the commission proposed in 1974 contained many of the provisions of the 1952 charter, providing for biennial elections of the town council. The five council seats were awarded to the top five vote getters instead of council seats one through five being decided by head-to-head contests.

The new charter was approved in November 1974 by a vote of 676 to 406. The council hired Robert W. Sutton Jr., who had helped draw up the charter, as the first town administrator. He stayed in the post for seventeen years. Rosamond Tefft, who as the elected town clerk had taken care of the town's day-to-day business for the previous twenty years, remained as the first appointed town clerk for five more.

Controlling Development: Planning and Zoning

In January 1945, the state authorized towns to plan for and control subdivision development and defined the role of a Planning Commission. The Jamestown Town Council passed a Planning Commission ordinance on April 28, 1947,

giving legal status to the existing postwar planning commission. The exact date of the ordinance is important because the first four plats of the largest single subdivision in Jamestown—Jamestown Shores—were recorded on March 22, April 24, and April 28, 1947. According to Rosamond Tefft, the platting was completed and recorded before many people in the town were aware of the plans.

The first "Rules and Regulations Governing and Restricting the Platting or Other Subdivision of Land" were passed by the Planning Commission on May 17, 1947, effective July 1. The rules set the minimum lot size in a subdivision at ten thousand square feet with a seventy-foot frontage. The provision would bring on the first of many collisions between the town and the Federal Building and Development Corporation, the developer of Jamestown Shores, when the developer submitted plans for plat 6 in 1949.

Jamestown's first zoning ordinance in 1935 had been a simple affair: it created two use districts, residential and business; described the kind of buildings and activities appropriate to each; and set up a five-member zoning board of review. The law remained essentially unchanged until 1956, when the town council changed the ordinance to allow a third use district (refinery) in support of Commerce Oil's application for a license to build and operate an oil refinery on the island.

In 1960, the Planning Commission, aided by the Rhode Island Development Council, redrafted subdivision rules and, in 1966, rewrote the zoning code and map. The changes were controversial. One of the strongest opponents was the Roman Catholic Diocese of Providence, which objected to the provision that denied churches and schools the right to build in the residential districts. For both ordinances, the town council amended several proposals of the planners.

Almost annual review and changes to the zoning code followed, as the town tried to anticipate the impact of the bridge that was under construction across the East Passage to Newport.

Two large landowners/developers—the Federal Building and Development Corporation (Jamestown Shores) and Commerce Oil—clashed with the town over zoning changes that affected the use of over one thousand acres they controlled. In 1970, the town, which had tripled the size of lots to be sold in Jamestown Shores in order to avoid pollution of water by sewage, won a court case against the corporation. The developer

Postwar Adjustments

appealed, and in December 1973, the state Supreme Court found that all zoning in Jamestown had been invalid since 1962 because amendments to the zoning ordinance were insufficiently advertised. The court decision left the town with a 1962 ordinance that had just three types of zoning classification: residential, business, and refinery. Many areas that had been rezoned residential reverted to business under the ruling.

At the same time, a developer associated with Commerce Oil sought an amendment to the zoning ordinance to allow cluster housing at the North End. When the town passed a zoning ordinance without cluster housing in 1974, Commerce Oil unsuccessfully asked the Superior Court to void the zoning ordinance and asked for a zoning change for 250 acres of its property from two-acre to one-acre lots with a share of open space to be sold with each lot.

The tension between developers and planners continued into the twenty-first century.

Sewer and Water

Jamestown's growth after the war depended to a great extent on the availability of potable water. Only buildings in the village and on Beavertail were connected to the privately owned Jamestown water system. Outside that limited area, individual wells supplied each home. The municipal sewer system served an even smaller area, and the sewage was directed, unprocessed, into the bay.

Water distribution changed very little in the postwar years. Every ten years or so from 1934 on, the water company raised the price of water. In response, the town of Jamestown made attempts—some more serious than others—to purchase the company. Finally, in December 1969, the voters authorized borrowing $300,000 to buy the company and up to $150,000 to repair and renovate the infrastructure, an effort that an engineering firm had said would cost $1.4 million and take thirteen years if the system were to handle the anticipated increase in population.

Town ownership did not mean that the price of water would be contained or that supplies would be adequate. Progress to update the antiquated system was slow and expensive, and costs were passed on to the users. Throughout the 1970s, the water supply remained uncertain.

Sewage treatment during the same period changed dramatically. In 1947, the state legislature passed an antipollution law. Most of Jamestown's sewer lines led into the East Passage, where tidal action and the relatively small amount of outflow minimized the pollution. Mackerel Cove, however, was already polluted. That problem was temporarily solved by diverting the wastewater outflow to one of the East Passage lines.

Until 1968, the town continued pumping untreated sewage into the East and West Passages. Then the state Department of Health took a hand, demanding immediate action by the town on a sewage treatment plant. In 1971, the department notified the town council that no more building permits could be issued for homes that would tie into the town sewer system until and unless the system met with the department's approval.

The voters needed to decide two issues: where to put a wastewater treatment plant and how to pay for it. Money turned out to be less of a problem than site; after a slightly smaller bond issue was rejected in 1972, a $3.5 million bond issue passed easily in 1973. Between 1970 and 1975, twelve sites were suggested: Eldred Avenue at East Shore Road, East Shore Road near the Newport Bridge toll plaza, Taylor Point, Bull Point, Stanton Road in the Dumplings, Fort Getty, Beavertail, Fort Wetherill, South Pond, Jamestown Shores, Gould Island, and Dutch Island. The last three were quickly eliminated because of cost. Fort Wetherill and Beavertail were still controlled by the federal or state government. The town council rejected Taylor Point, Bull Point, and Fort Getty. The voters rejected the toll plaza area in 1972 and Fort Getty and Eldred Avenue in 1973. In 1975, Taylor Point and Stanton Road were presented to the voters as their final choices. Taylor Point was selected, 475 to 363.

When the Taylor Point facility went into operation on February 17, 1980, it serviced about nine hundred households, about 60 percent of the population of the island.

Schools

The increase in population that began in 1945 was not as dramatic as it had been at the beginning of the century, but it was steady. By 1965, more than twenty-five hundred people lived on the island, an increase of almost 50 percent over twenty-five years. A substantial portion of the increase was the

result of the postwar baby boom; the grammar school population increased by about 150 percent over the same period.

Two schools served the island. Kindergarten through fourth grade attended the Carr School, and the older students went to the Clarke School. In 1951, with 340 students in the schools, the school committee found itself renting space in the Grange Hall and negotiating for space elsewhere.

In November 1952, the school committee proposed spending $810,000 for a twenty-classroom building near the Lawn Avenue athletic fields, where the town had wanted the USO to build the community center. The proposal was too expensive and too elaborate for the voters. At the financial town meeting in May 1953, the voters reduced the number of classrooms to thirteen and eliminated the gymnasium to bring the cost down to $450,000.

The Lawn Avenue School, built to accommodate 450 students, opened in September 1955. By 1972, over 500 students were jammed into the building. This time, the voters agreed quickly to expansion, and the enlarged and renovated building was dedicated in 1973. Over the next two decades, state and federal mandates for computer education, an expanded health curriculum, and other services required additional space. Unable to expand the Lawn Avenue School because of the discovery of more Native American graves, the town built a new school for the elementary grades on Melrose Avenue in 1991.

Development at Jamestown Shores

The development of the Jamestown Shores area began in late 1946. The Federal Building and Development Corporation, led by James G. Head (no relation to the Head family that had lived in Jamestown since the nineteenth century) purchased the Tefft Farm that stood at the foot of the Jamestown Bridge and the Gladding and Maxfield Farms to the north of it. The adjacent Hammond Farm was added in August 1947.

The developers envisioned a seaside community of summer homes, similar in some ways to the Conanicut Park development seventy-five years earlier, and planned accordingly. They created a common beach and laid out roads but made no provision for water, sewer, electricity or other form of

power. These were the responsibility of the individual homeowner, although property owners were promised electric power if fifty of them guaranteed to pay $6.56 a month for five years.

The corporation moved quickly to subdivide the farmland into over one thousand homesites. The majority of the lots were 60 by 120 feet, or 7,200 square feet, and cost $995. Waterfront parcels were larger, with 75-foot frontage on the street and total size depending on changes in the shoreline. The deeds required that the major structure on the lot be at least 576 square feet.

The first lot was sold on May 27, 1947, and within three years, 110 families had built homes in the area. Some of the lots along Eldred Avenue contained provisions for commercial development. James Head attended the Planning Commission meeting in May 1947. In response to questions about his intent, he replied that "that artery is his only business section" and would have "lots not less than 60 x 120 feet." He promised to work with the Planning Commission to keep the area free of "cheap and unsightly structures." He left Jamestown, however, and illness prevented his active participation in the continued development of Jamestown Shores.

Jamestown Shores residents created their own tightly knit community with minimal dependence on the village or the developer. Electricity came to the area through the action of a Jamestown Shores resident, Armand Girard, who in 1949 contracted with the Newport Electric Co. to pay one dollar per month per pole for each pole on North Main Road between Eldred Avenue and Frigate Street. As customers subscribed to the service, the cost was divided among them until enough homes were electrified to allow metering. Since the Federal Building and Development Corporation did little beyond selling the lots, the residents formed the Jamestown Shores Association in 1950 to promote the welfare of the area in "an atmosphere of friendliness and neighborliness."

One important problem that faced the association was road maintenance. The roads in the development had been deeded to the town shortly after the project opened. Legally, however, the town had no obligation to repair or improve the roads, and the association brought political pressure to include the roads in the town budget. The beach for Jamestown Shores residents, which had been a selling point in the original prospectus, belonged to the developers. The association arranged a lease in 1955, and the beach later became a town park.

Postwar Adjustments

Jamestown Shores in 1939 and 2004. The left-hand photo shows the area before the Jamestown Bridge was completed. The right-hand picture was taken sixty-five years later. *Courtesy of the Jamestown Historical Society.*

Without James Head's salesmanship, homesite sales in Jamestown Shores dropped off in the early 1950s. Relations between the residents of Jamestown Shores, who often felt they were treated unfairly and needed a larger voice in town government, and the older residents of the island, who felt crowded and ignored by the newcomers—many of whom worked off-island and did not participate in the day-to-day life of the village— were wary. Members of both groups realized that platting such a large area into small house lots without provision for sewer, water, power, fire protection, or police protection was a mistake. The Shores community set about rectifying the error by advocating for the services it needed. The village, represented by the Jamestown Forum, a community business group similar to the Chamber of Commerce, began pressing for a stronger zoning ordinance and building code.

Industry in Jamestown

At the end of the war, farms still occupied most of the nonmilitary land on Beavertail and almost all of the land north of the Great Creek. Based on earlier figures, these farms offered jobs to no more than sixty people. The acreage being farmed was reduced over the next decades as more people made their homes in Jamestown, further reducing the need for farm labor.

Both before and after the war, governmental or quasi-governmental agencies were the largest employers in Jamestown. The Jamestown Bridge and the Jamestown & Newport Ferry Company, both essentially public services, although in theory self-supporting, were major employers. Men went to work at Davisville–Quonset Point naval facilities. Few of the women worked off-island, limiting them to jobs with the town or the ferry company or to service jobs at one of the two remaining hotels or with individual families.

In addition, deteriorating military installations kept over three hundred acres, in addition to Gould and Dutch Islands, off the tax rolls despite the town's repeated attempts to reclaim them.

The desire to provide local jobs, as well as the tension between keeping the property tax low and at the same time providing services, led successive town councils to try to attract industry to Conanicut Island.

Hoof-and-Mouth Disease Laboratory

Hoof-and-mouth disease is an easily transmitted, nonfatal viral infection that affects animals with cloven hooves, causing sores in the afflicted animal's mouth and on its feet, as well as drastic weight loss. The virus is not considered a threat to humans. While the disease regularly attacked animals in Mexico, no cases had been reported in the United States since 1929. Then, in January 1948, the *Newport Daily News* reported that the Department of Agriculture was considering Prudence Island as the site of a laboratory to research the disease. The requested budget for the lab was $35 million, plus $3 million annually for maintenance.

When the residents of Portsmouth objected to a project that could potentially pollute the bay and gravely endanger the state's dairy industry, Jamestown showed interest. In March 1949, at a meeting attended by

members of all but one of the island's organizations and clubs, Major John C. Rembijas of the American Legion Post was selected as chairman of a committee to promote Conanicut Island as the site of the laboratory. Shortly after, the town council voted to support the project, with the stipulation that the question be put before the voters.

Jamestown was probably never a serious contender as a site for the laboratory, and the issue never came to a vote. However, the prospect of the introduction of an industry that might seriously threaten Narragansett Bay awakened protoenvironmentalists from Portsmouth to Westerly.

Commerce Oil

More divisive, because it was more real and fought closer to home, was a proposal by Commerce Oil—backed by Gulf Oil, although that fact was not known at the time—to build an oil refinery at the North End. Prudence Island was again the first choice of the developers, but opposition from Portsmouth residents caused them to turn to Conanicut Island early in 1956. On April 25, Harold M. Geller, vice-president of Commerce Oil, presented the plans, which were still tentative, at a special financial town meeting. The eight-hundred-acre facility would be located north of Carr Lane. Crude oil would arrive at a two-thousand-foot pier in the East Passage. The refinery itself would be north of the piers; it was later moved to the West Passage, just north of the Jamestown Shores plats. North of the refinery would be a large reservoir surrounded by a park that Geller compared to Central Park in New York. On the east side of North Main Road and north of the pipeline bringing the crude oil from the holding tanks at the pier to the refinery would be an athletic field with a baseball diamond, a swimming pool, tennis courts, and other amenities.

Sides were drawn almost immediately. As Rosamond Tefft remembered in a 1985 interview:

> *It was a period, economically…when a great many people in Jamestown were delighted to think there might be an oil refinery coming. Many of them looked with great anticipation on this possibility. But, there was another faction in Jamestown that wanted no part of it. And you can imagine who the factions would be…There were the working people on one hand and*

Conceptual view of the Commerce Oil Co. refinery on the West Passage. The East Passage pier and storage tanks for incoming crude oil are not shown. "Refinery Site Plan," *Providence Sunday Journal,* March 9, 1958. *Copyright © 2009 the* Providence Journal. *Reproduced by permission.*

> *there were people who knew* [the island] *as a lovely lovely place to come to spend the summer...There was every indication that it was going to be fought tooth and nail...And my dear little village that was so close knit, so cooperative about helping each other, was in for some hard days.*

The factions were not quite as clear-cut as local versus summer people. The opponents tended to be people who had experience in business or the navy or were, like the Godenas, North End farmers who did not want the refinery for a neighbor. The Jamestown Shores Association immediately went on record as opposing the project.

While the proponents responded to promises of over three hundred jobs and an installation variously reported to cost from $45 to $70 million, the opponents questioned the assertions that the plant would produce no objectionable odors, that there would be no smoke or flames, and that the water used in cooling would be as cool after processing as it was when it was pumped from the ground. Navy officers who had retired to the island asked what the navy's attitude was toward a refinery on the direct air route into Quonset.

Postwar Adjustments

On June 2, 1956, at a special financial town meeting, a straw poll showed that 70 percent of Jamestown voters were in favor of the refinery. On September 27, the town council amended the zoning ordinance to establish a refinery use district and issued a license to Commerce Oil to operate.

Over the next year, both factions continued the fight. Those in favor of the refinery advertised the advantages of bringing industry to the island. The opponents founded the Jamestown Protective Association and recruited antidevelopment forces from Westerly to Newport. The navy came forward with specific objections to details of the plan, which Commerce Oil countered by modifying it. In the spring of 1957, the Rhode Island Development Council set up an advisory panel to study the plan.

The Jamestown Town Council elections on May 1, 1957, seemed to spell victory for the refinery. The Democrats, who had campaigned on a pro-refinery platform, won all five seats. Led by Dr. Alfred B. Gobeille, they promised to do their "utmost to carry out the will of the people during the next year." The *Newport Daily News* editorialized:

> *The rank and file of the electorate, who consider the refinery the economic salvation of the island, felt that the Democratic side appeared more enthusiastic for its construction, while the Republicans had demonstrated some hesitancy, some reluctance on the issue.*

Following the election, Governor Dennis J. Roberts announced his support of the plans.

Still, the Jamestown Protective Association would not concede. Under the leadership of Dr. William W. Miner, they instituted a series of legal actions. Only once in the two years of legal skirmishes that followed did the opposition actually receive a favorable judgment. In January 1959, U.S. District Court judge Edward W. Day found that "it is a matter of common knowledge that an oil refinery is a potential source of danger" and that the license issued by the Jamestown Town Council did not protect the public.

The town council acted quickly to overcome the deficiencies, and the decision was reversed in the court of appeals in January 1960. By that time, the situation in the world oil market had changed, and Gulf Oil announced that it would not build the refinery.

Gulf Oil's decision was not the end of the issue. Commerce Oil owned hundreds of acres in Jamestown. The zoning ordinance now allowed a refinery. A license to operate a refinery was still in effect. Perhaps most important, the rancor and mistrust that had built up between the groups supporting and opposing the refinery—often expressed in class and political terms as the difference between Republicans with money and Democrats who worked—remained.

A Jamestown Marina

Several marina complexes were proposed. The town planned to build a marina at the East Ferry. Commerce Oil came forward with a proposal for a $6 million condominium, motel, and apartment house complex, with a four-hundred-boat marina, gift shops, and a restaurant, on a 30.0-acre site at Eldred Avenue and East Shore Road. Grey Gull Enterprises Inc., a corporation representing Bohn-Mar Developers, signed an initial agreement to build a 244-unit condominium on a 25.6-acre tract of town-owned land at Taylor Point, a $5 million project.

The marina proposal that caused the most uproar was the suggestion, in 1959, to build a 160-boat marina on the Great Creek. The site, proposed by the town to the developer rather than vice versa, had two major advantages: it would be accessible, with proper dredging, from both the East and West Passages and would be sheltered in any storm. In that sense, the proposal harked back to three nineteenth-century proposals to put a canal through the center of the island.

The area under consideration, however, included 27.5 acres of salt marsh that had been deeded to the town by the Jamestown Garden Club in 1952. The deed stipulated:

> *This conveyance is on condition that the grantees and their successors shall use the premises for recreation purposes as a wildlife preserve and upon use of the premises for any other purpose, title to the premises shall forthwith revert to the grantors or their successors.*

This early instance of environmental protection in Jamestown prevented the proposal from going beyond the drawing board.

Postwar Adjustments

The Great Creek and saltwater marsh. *Photograph by Andrea von Hohenleiten.*

TRANSPORTATION: CROSSING THE EAST PASSAGE

Since 1925, the Town of Jamestown had owned all the stock in the Jamestown & Newport Ferry Company. The ferry company had made money between 1917 and 1932 but lost money every year after that, except in 1945 and 1947. By 1949, the ferry company, and by extension the town, was worried about the future.

JAMESTOWN & NEWPORT FERRY COMPANY FERRYBOATS
1873–1969

Jamestown	Built 1873; in service 1873–96; sold 1900; refit as barge 1904; retired 1907
Conanicut	Built 1886, in service 1886–1927, sold 1930; towed to Portland, Maine, as barge
Beaver Tail	Built 1896; in service 1896–1923 and occasionally until 1938; sold for salvage, 1938

J.A. Saunders	Built 1902; in service 1902–25; scuttled, 1927
Jamestown (II)	Built 1883; in service 1923–38; sold for scrap, 1938
Governor Carr	Built 1927; in service 1927–58; sold for scrap, 1960
Mohican	Built 1896; in service 1929–30; superstructure used for fuel; hull sold to shellfisher, 1934
Hammonton	Built 1906; in service 1930–58; sold for scrap, 1958
Jamestown (III)	Built 1926; in service 1950–51; sold at marshal's sale, 1951
Wildwood	Built 1911; in service 1951–58; sold for scrap, 1958
Newport	Built 1941; in service 1958–69; given to Pawtucket for $1.00 for youth center, 1969
Jamestown (IV)	Built 1941; in service 1958–69; sold to restaurant in Groton, Connecticut, 1969

The Hurricane of 1938 had left only two ferryboats, the *Governor Carr* and the *Hammonton*, to carry traffic across the East Passage. The *Governor Carr* made the round trip hourly throughout the year; the older *Hammonton* joined it during the summer months so that the ferry ran every half hour. Both ferryboats were coal fueled. The cost per day for sixteen trips—the ferries did not run at night—was $113.47 and $153.29, respectively. During the summer, any repair to either ferryboat meant a reduction in service. Even with both ferries running, travelers often had to wait an hour or more.

In addition, the ferries could not carry some vehicles. The clearance on the *Governor Carr* was only eleven feet, which meant that large trucks had to be turned away, and buses and some smaller trucks had to straddle two lanes.

Purchasing a new ferryboat during the war had been impossible. Now, having compared operating costs, the company wanted to buy a diesel ferryboat, which it estimated could be operated for $34.80 a day. The financing for the $125,000 boat would have to be approved by the town, and the town council asked the Planning Commission for a recommendation. While expressing doubts about its jurisdiction, the commission recommended the purchase and continued:

Postwar Adjustments

It should be apparent to everyone that the Town of Jamestown can no longer assume the sole responsibility for providing adequate transportation facilities across the Bay. To our knowledge, no other town in the country is placed in the position of having to provide such service for other communities and such service is generally recognized as a responsibility of the State.

In January 1950, the company purchased the diesel ferryboat *Gotham*. W. Foster Caswell, the ferry company manager, announced that he expected to have the boat, refurbished and renamed the *Jamestown*, on the Newport–Jamestown run in March. Later that month, the Rhode Island Senate passed without opposition a resolution creating a special commission to study the advisability of a state subsidy for the ferry company.

The *Gotham/Jamestown* turned out to be a disaster. The Coast Guard refused to license the vessel despite extensive repairs. In February 1951, it was seized by a U.S. marshal to secure payment of a $20,328 repair bill. It was finally sold that August for $26,500, having been used only seventy-six days.

The *Jamestown*, formerly the *Gotham*. The expenses incurred trying to bring the *Jamestown* online helped break the struggling town-owned ferry company. *Courtesy of the Jamestown Historical Society.*

JAMESTOWN

The winter of 1950–51 was a tough one in other ways for the hard-pressed ferry company. With the *Governor Carr* off-line for repairs, the *Hammonton* took over the winter run. In January, it cracked a boiler and, for a day, limped back and forth across the bay on a haphazard schedule. The following week, a 106-foot army craft FS-56, a passenger craft loaned by the army's Narragansett Bay Marine Repair Shops at Fort Adams, took over the run until the *Hammonton* could be repaired.

In face of the ferry company's insolvency, the state offered to take over the operation of the ferry but refused to assume the ferry company's outstanding obligations of $250,000. About 75 percent of Jamestowners eligible to vote turned out for a special financial town meeting on March 28, 1951. Despite rumors about all the awful things that would happen to Jamestown if the ferry operations were given over to the state, they voted 502 to 292 to lease

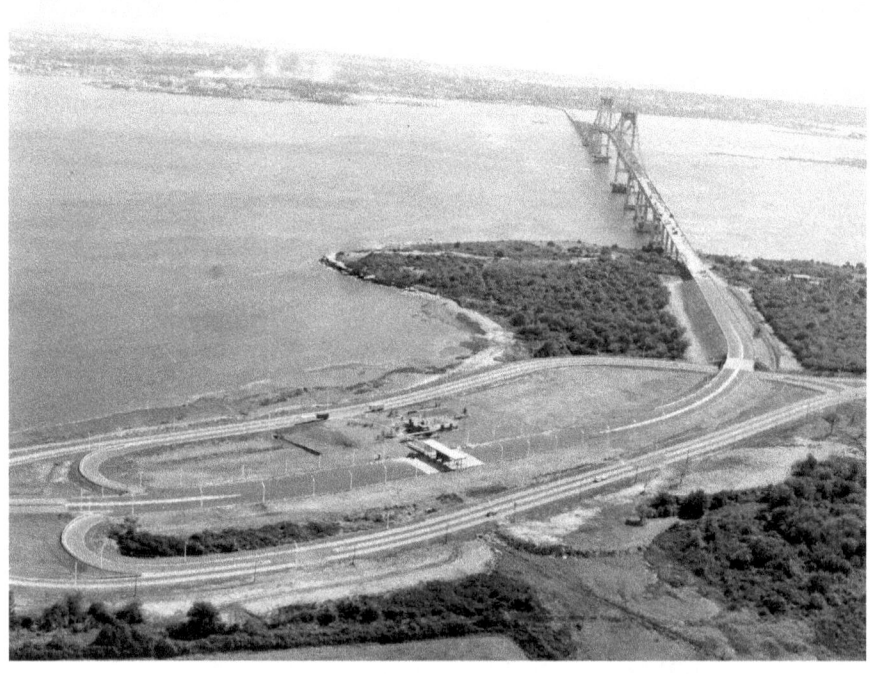

The Newport/Pell Bridge toll plaza and exit ramp at Taylor Point. The bridge, which opened in 1969, is 2.13 miles long and has a main span of sixteen hundred feet. Photograph by Jerry Taylor. *Courtesy of Rhode Island Turnpike and Bridge Authority.*

Postwar Adjustments

their seventy-seven-year-old ferry system to the State of Rhode Island for fifteen years at $1 a year.

The town signed the lease but continued to press for a more equitable arrangement. In 1956, the state bought the ferry system and all its assets for $270,000, payable over ten years at the rate of $27,000 a year. In December 1970, after the bridge to Newport had made the ferry obsolete, the courts ordered that $250,000 in severance pay be divided among more than fifty people who had worked on the ferryboats.

Talk of a bridge from Jamestown to Newport had begun even before the Jamestown Bridge was finished in 1940. The talk increased after the state took over the ferry. Many different routes were proposed. The early favorite was from the Dumplings to the Fort Adams area. In 1954, the state legislature created the Rhode Island Turnpike and Bridge Authority (RITBA) and gave it jurisdiction over the Mount Hope Bridge and planning for a Jamestown–Newport bridge. In 1963, the state decided that as soon as a bridge was

Last days of the Bay View Hotel. The tower that once dominated the waterfront was removed several years before the hotel was razed in 1985. *Courtesy of the Jamestown Historical Society.*

completed, the Rhode Island Department of Transportation would take control of the Jamestown Bridge and remove the toll.

A referendum on the new bridge in 1960 lost in Jamestown, 597 to 393, after a yearlong controversy, but at that point the bridge was a state rather than a local issue. Taylor Point was selected as the Jamestown terminus of the new bridge, and planning went forward. The Newport Bridge was completed in 1969 at a cost of $61,000,000.

The most immediate impact of the bridge was serious financial loss by East Ferry waterfront businesses because of the loss of the ferry traffic. The effect was not unexpected, and the Waterfront Authority applied for an $8,000 federal grant for an economic and engineering development study to remedy the hardship. The Jamestown Businessmen's Association placed a float at East Ferry to be used for boat landing. Plans for a town-owned marina bogged down when costs skyrocketed above the appropriation made by the voters. The area did not recover fully until the 1980s, when the renovation of the stores in the Hunt block and the building of the Bay View Condominiums brought a new, fresh look to the area.

AFTER THE BRIDGES

The impact on Conanicut Island of the opening of the Newport Bridge and the removal of the toll on the Jamestown Bridge can best be seen in numbers.

Jamestown's population doubled, rising from 2,911 in 1970, the year after the bridge opened, to 5,622 in 2000, to an estimated 6,200 in 2010.

In 1970, there were 1,554 housing units on the island, of which 450 were seasonal. In 2010, Jamestown had 2,696 residential properties, 85 condominium units, 7 apartment buildings, and over 100 mixed-use or commercial properties.

The median price asked for a house in 1970 was $13,100, or about $73,500 in 2010 dollars. The median assessed value for single-family residential property in 2010 was $414,100.

With a quicker way across the East Passage, traffic on the old Jamestown Bridge increased from 3,200 vehicles per day in 1969 to 20,400 per day in 1990. In 2006, with the new Jamestown–Verrazzano Bridge in place across the West Passage and the John Eldred Parkway connecting the two bridges, the number of vehicles topped 27,000.

The average family income rose between 1970 and 2000 from $9,500 to about $60,000. Taking inflation into account, a Jamestown family in 2000 earned almost twice as much as in 1970, and almost all the new residents worked off-island.

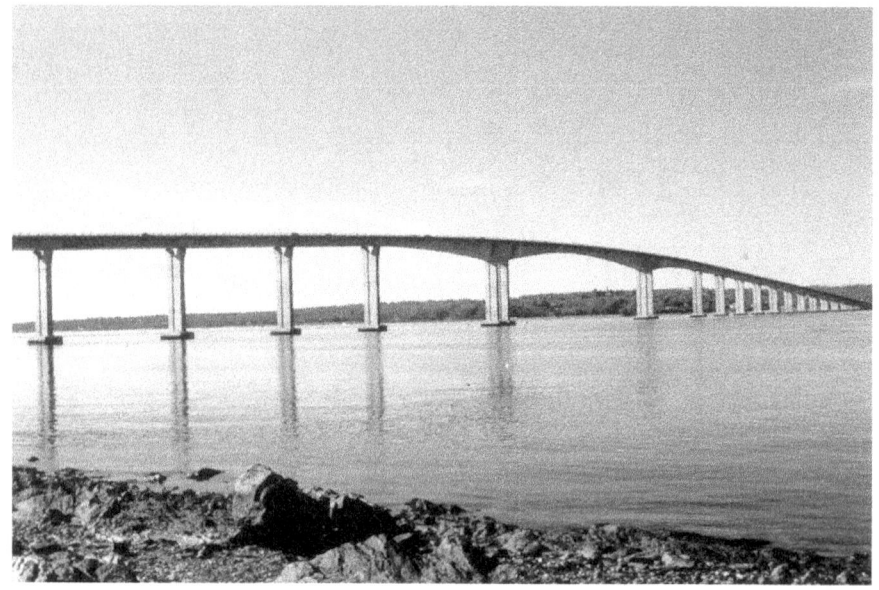

Jamestown–Verrazzano Bridge. The new bridge over the West Passage opened in October 1992. *Photograph by Nancy Logan.*

Although the growth experienced in the late twentieth century was anticipated, its extent was not. Jamestown's first *Comprehensive Community Plan* in 1966 projected and planned for a maximum population in 1990 of 3,700; in reality the figure was 4,999. On the other hand, the plan saw the overall future of the island clearly. Although it defined a manufacturing area at the North End, development of which would mean the extension of utilities to the area, it recognized that

> *Jamestown will be essentially a residential community, retaining a satellite relationship to Providence and Newport. Commercial development will be locally oriented and any industrial development will be a minor factor.*

The 1966 plan's objective "to preserve and enhance the unique character of Jamestown" had, by the fourth revision of the *Comprehensive Community Plan* in 2002, become "protect Jamestown's rural character," which the Planning Commission interpreted to mean "that which is unique to the Island of Jamestown and is infused with a rural feeling, an island spirit and a village identity."

After the Bridges

A Rural Feeling

Development of any kind affected the rural feeling of Jamestown, and some Jamestowners fought to keep the town exactly the way it was, balking at having a bridge to Newport, opposing a four-lane expressway between the two bridges, refusing to consider cluster housing or condominiums, and rejecting bed-and-breakfasts and accessory, or "in-law," apartments. The quip that every newcomer to the island wanted to keep the island exactly the way it was when he or she arrived was repeated often and with a certain amount of truth.

Nonetheless, more people came and more housing was needed. In 1978 alone, the Planning Commission considered four subdivisions, representing 151 new houses. Commerce Oil's plans for East Passage and West Reach Estates were the largest. Three interlocking tasks that occupied much of the energy of the town planners were the development of regulations for subdivisions that ensured that each new plat fit comfortably into the rural and village character of Jamestown, the creation of an open space corridor down the center of the island, and the building of a water system that could support the development.

The Planning Commission and the town council reviewed the zoning regulations regularly, tweaking them as necessary. In 1981, a major revision redefined minimum lot sizes in several parts of the island. In particular, the land within the watershed was zoned to five acres to protect the town water supply, and for the first time, the ordinance made provision for condominium development and cluster housing. Zoning ordinance changes in 1995 and 2009 were primarily concerned with strengthening review of proposed development in the village area.

Water, both its quantity and its quality, remained the major issue.

At first, the town tried to use the shortage of water as a way to limit, or at least slow down, growth. In 1980, the town council declared a one-year moratorium on water hookups. Four years later, it turned down a proposal for housing for the elderly because it would tax the water system. Sometimes, in exchange for project approval, developers contributed to the town infrastructure. For example, in 1984 the town council approved a request to extend sewer lines to a seventeen-house subdivision in exchange for $85,000 to upgrade not only the sewer line serving the area but other aging sewer lines as well.

Jamestown

The water problem reached crisis level in 1993. A diminishing water supply brought on an outdoor watering ban in August. With the reservoir level still dropping and no substantial rainfall, National Guard troops began trucking in eighty-five thousand gallons of water a day in September. A 3.5-mile conduit for transporting drinking water across the old Jamestown Bridge resolved the immediate problem, but it was a stopgap measure, and the financial impact was high. Residents received water bills three times the normal rate.

Over the next few years, town wells and a higher dam at the North Reservoir increased the water supply. Household water conservation was legislated. In 1999, all municipal water customers were required to convert to water-efficient washing machines, toilets, showerheads, and faucets. In-ground or underground irrigation systems without private wells were banned. Progressively restrictive bans on outdoor water use went into effect each summer.

In 2000, municipal water customers consumed an average of 250,000 gallons of water daily—more in the summer months—and 285,000 gallons usage was projected by 2020. Most of the municipal water supply came from the North Reservoir. As early as 1982, experts had determined that the watershed below the reservoir produced an average of 700,000 gallons a day. Unfortunately, the South Pond was not large enough to contain the runoff, and besides, suspended particulates in the water clogged the treatment plant filters. A report from consultants in 2000 recommended that the overflow from the South Pond be pumped to the main reservoir. This could increase the safe yield of the water supply from 283,000 gallons a day to 404,000 gallons a day. The system would cost $500,000.

The first year after the mixing of the two water sources began, 2002, there was a widespread drought, which meant that the proportion of South Pond water was higher than expected. The old water treatment plant could not handle the concentrated mixture, and the town had to buy water from North Kingstown again. The problem was short-lived. The state-of-the-art, high-tech water treatment plant that came online in May 2009 can produce 500,000 gallons of clean water daily. A second water tower and the implementation of a plan to replace all the water mains by 2045 increased the efficiency of water delivery.

The municipal water system serves only about 43 percent of the homes on Conanicut Island, and everyone living north of the Great Creek depends on

After the Bridges

individual wells. In an effort to protect the drinking water in that area, the North End Concerned Citizens asked the federal Environmental Protection Agency (EPA) to declare Conanicut Island a Sole Source Aquifer. The designation, assigned in August 2009, allows the EPA to become involved in the decision process if a large project, funded even partially by federal funds, is undertaken anywhere on the island.

Protecting the water supply and protecting open space are synergistic. The watershed zoning in 1981 was, after the Jamestown Garden Club's salt marsh project in 1951, the first in a series of efforts to protect open space from development. Faced with the possibility that the last golf course on the island would be replaced by McMansions, the voters at a special financial town meeting in December 1986 overwhelmingly approved the $2.1 million purchase of the 76-acre country club. That same year, the Conanicut Island Land Trust, formed in 1984, acquired its first open space. By 2009, the trust had legal responsibility, either by direct ownership, ownership of development rights, or conservation easement, for about 450 acres.

One of a series of Conanicut Island Land Trust signs asking for donations to purchase development rights of farmland on Windmill Hill in 2007. *Photograph by Joe Logan.*

Local, state, and national conservation organizations, such as the Audubon Society and the Nature Conservancy, as well as governmental agencies at all levels, continued efforts to shelter farmland from development. In September 2007, at another special financial town meeting, voters agreed to add $3 million to the funds already provided by other entities to purchase the development rights of two farms in the Windmill Hill Historic District. Bruce Keiser, the town administrator, explained that the town had determined that keeping the farms as open space was important to maintaining the character of the island, while the U.S. Department of Agriculture and Rhode Island Department of Environmental Management were invested in ensuring that the farms be maintained as working agricultural lands. By 2010, a total of about sixteen hundred acres on Jamestown were legally protected from development.

An Island Spirit

As stated in the 2002 *Comprehensive Community Plan*:

> *Jamestowners have maintained their traditional spirit of community involvement and volunteerism…which staff*[s] *the Fire Department, Ambulance Corps, and* [Jamestown's] *many boards, commissions, committees and civic organizations. This is crucial to our historically low tax rate and the cornerstone of our community spirit.*

With the influx of new islanders, the older volunteer organizations flourished, sometimes taking on new roles, and new ones were established. Annual events proliferated, many of them started in the 1970s: the Jamestown Rotary Club's Round the Island Bike race, a Christmas pageant on Shoreby Green, the New Year's Day Penguin Plunge at Mackerel Cove to benefit the Special Olympics, and the Fools' Rules Regatta, now sponsored by the Jamestown Yacht Club, which was founded in 1977.

One of the most important interests to profit from Jamestown's tradition of volunteerism was the arts. Jamestown had been a magnet for visual artists since the late nineteenth century. The Conanicut Island Art Association was

After the Bridges

Thirty-fourth annual Penguin Plunge, January 1, 2010. *Courtesy of the* Jamestown Press.

Thirty-second annual Fools' Rules Regatta, 2009. Participants have two hours before the race to build a sailing craft using nonmarine items. *Photograph by Joe Logan.*

organized by a coalition of businessmen and artists in 1975 to give island artists a venue while at the same time attracting tourists and other artists to the island. Its first annual arts and crafts show that August was a one-day show that included all forms of graphic expression. The group grew along with the town, and in January 2008, it took on the mission of decorating the newly completed town hall with rotating exhibits.

Theater came to the island in 1979, when the Jamestown Players bought and renovated the old Bomes Theater. This first venture failed, but in 1990, the Jamestown Substance Abuse Prevention Task Force gave $500 in start-up money to the Jamestown Community Theatre to stage a play with the youth of Jamestown. The group has staged one or two plays a year, starting with the musical *Peter Pan* in 1990.

An interest in music gave birth to several local organizations, among them the Jamestown Community Chorus, which celebrated its sixtieth anniversary in 2009, and the Jamestown Community Band, which made its debut at the Memorial Day parade in 1993. In 2001, Jamestowners got together to purchase the Jamestown Community Piano. The piano, a seven-foot Schimmel grand, may be used by anyone in the community, and each year the Jamestown Community Piano Association sponsors a concert series that features it.

In 2009, a group of artists intent on providing a common place for classes in dance, theater, music, writing, and the visual arts for people of all ages, abilities, and backgrounds formed the Jamestown Arts Center. The following year, they purchased a warehouse building on Valley Street near the library and began renovation Jamestowners interested in preserving Jamestown's history were also recruiting new enthusiasts. When the library on North Main Road opened in 1971, the Jamestown Historical Society leased the old library, originally a one-room schoolhouse, for a museum. The museum opened the following year with an exhibit of memorabilia from the ferryboat era. The historical society had been established in 1912 in order to maintain the old Jamestown windmill. As the town grew, the society assumed new responsibilities, becoming caretaker for the 1786 Quaker meetinghouse in 1990 and, with the Friends of the Conanicut Battery, the Revolutionary War earthworks battery in 2002. In 2007, it leased a vault in the basement of the town hall to house the artifacts it had collected over the years.

Other groups organized to protect the Beavertail Lighthouse, the Dutch Island Lighthouse, and the Harbor Entrance Control Post. In 1994, the

After the Bridges

Jamestown Fire Department, intent on honoring its history and its past members, rebuilt and expanded its fire department museum, which had opened in 1959. The rededication coincided with the 100th birthday of the museum's LaFrance steam fire engine.

Five Jamestown landmarks—the Fort Dumpling Site, Friends Meetinghouse, Conanicut Battery, Jamestown Windmill, and the Beavertail Light—and the Windmill Hill Historic District, which encompasses the area from the Great Creek north to the John Eldred Expressway, were placed on the National Register of Historic Places in the 1970s. In the next decade, the Conanicut Island Lighthouse at the North End and the Dutch Island Lighthouse, as well as three archaeological sites and other private homes, were added. In 2010, the town, at the request of a group of residents of Shoreby Hill, initiated the process to have Shoreby Hill placed on the register also.

Organizations to help animals also flourished. The Humane Society of Jamestown was founded in 1970 and, in 1972, following several incidents of cruelty to animals, began the humane education program at the Jamestown schools.

Demolition of the center span of the old Jamestown Bridge, April 18, 2006. The bridge, which opened in 1940, had been derelict since 1992. *Courtesy of the Jamestown Historical Society.*

Not all activities that reflected the islanders' independent spirit were so positive.

In 1977, the voters approved a new town hall by a slim ten-vote margin but failed to approve a bond issued for its construction. Planning continued, but it would be 2005 before both plans and funding were approved.

After rejecting earlier and less expensive proposals to renovate the existing police department office in the Recreation Center on Conanicus Avenue, voters agreed to a new $845,000 police station in 1989. The police moved to the new station across from the Jamestown Country Club on Conanicus Avenue in July 1991. More office space and a locker room were added in 2009.

The Public Works Department had pleaded for a highway barn to house equipment and to provide space for working on town vehicles since 1963, when the equipment had been moved to temporary quarters in a state-owned building at Fort Wetherill. In the mid-1980s, the state asked the town to vacate the building. From 1997 to 2007, the town council and several volunteer committees searched for a site. The recommended site next to the transfer station at the North End was strongly opposed by the North End Concerned Citizens because of the unknown effect on the water supply.

The new town hall. The renovated old town hall (right) contains the Rosamond A. Tefft Council Chambers. Town offices are in the new building. *Photograph by Peter Marcus.*

After several votes on both site and funding, the town built the barn next to the wastewater treatment plant on Taylor Point in 2009.

Jamestown's crime rate is usually low, less than one-tenth that of the state as a whole. Nevertheless, in 1977, the town figured prominently in two of the biggest drug raids conducted on the East Coast. In August, a neighbor notified police chief James G. Pemantell about "strange plastic-covered" bundles in a lot adjacent to a Jamestown home. The bundles were bales of marijuana that had been floated ashore. In November, the state police raided a rented home on East Shore Road and found another stash of marijuana valued at $3 million.

A Village Identity

The immediate effect of the bridges was a general deterioration of the village area. Throughout the 1970s, committees and associations were formed to arrest the decline. The town council created a Jamestown Beautification Committee in 1970, and the voters approved a budget for it of more than $1 million. In the mid-1970s, two hundred feet of pier were added at the East Ferry, and the Waterfront Authority, chaired by Dr. William W. Miner, who had led the opposition to Commerce Oil, proposed expansion of a small boat facility. In 1979, the town council named a twelve-member Revitalization Committee to study the downtown business area and to come up with recommendations to revitalize that area.

In the 1980s, the East Ferry took on a "new look," with several new businesses springing up and many of the old ones either moving to new and more attractive quarters or sprucing up the old buildings. The growth of Conanicut Marine Services, which had opened its doors in 1974, created a positive waterfront atmosphere. The Hunt block of stores received a second story and became a residential and commercial condominium complex. Toward the end of the decade, the Bay View Condominiums, designed to be reminiscent of the nineteenth-century Bay View Hotel, opened.

The *Jamestown Press* began publishing in April 1989, giving the town a voice of its own after years of depending on off-island sources for news about what was happening next door.

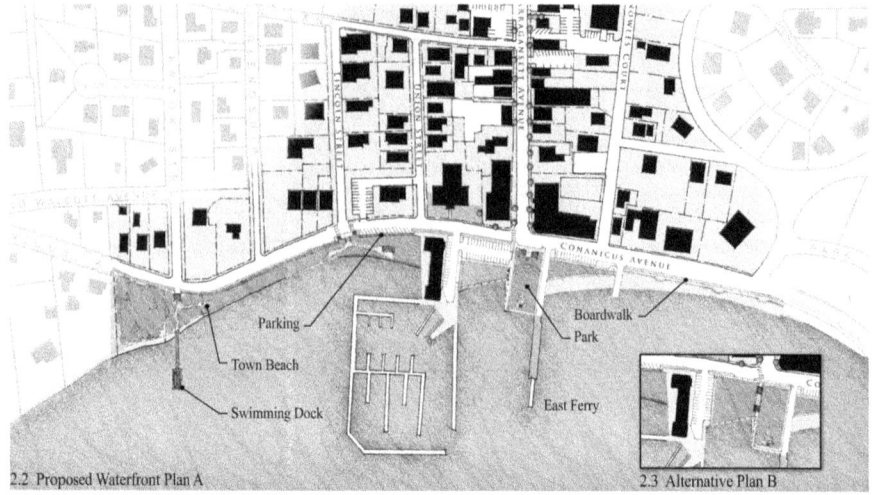

2.2 Proposed Waterfront Plan A 2.3 Alternative Plan B

A possible new design for the East Ferry waterfront from the 2007 *Jamestown Vision Charrette Report*. Proposed designs emphasized continuous pedestrian access to the water. *Courtesy of the Town of Jamestown.*

The revitalization of East Ferry and Narragansett Avenue raised concerns about how to ensure that the village center was neither a cutesy re-creation of its late nineteenth-century origins nor a mishmash of modern architectural styles. Two buildings in particular came under attack: the bank at the corner of Green Lane—a nondescript one-story brick building with a large parking lot in front—and the gas station/convenience store next to it. To limit the possibility of similar structures being built, the zoning ordinance in 1995 added a Development Plan Review article, which empowered the Planning Commission to review plans for all commercial development projects both for adherence to zoning provisions and for consideration of the historical and architectural character of the district.

In 2007, the Jamestown Planning Commission sponsored a charrette, a series of meetings between the residents of Jamestown and a team of town planning and design professionals. The specific goal of the charrette was to define ways for the town to manage future development and growth within the island's central village district. The zoning ordinance passed by the town council in October 2009 incorporated many of the recommendations from the team, including specific building design guidelines to ensure that new or redesigned buildings enhance the friendly, walkable character of the current village.

EPILOGUE

Many forces have shaped Jamestown's evolution as a town: national and global events that have brought the island a military presence out of proportion to its size, economic cycles of prosperity and depression, and the character of its inhabitants.

But above all, Jamestown's history has been shaped, both for good and ill, by its geography. Conanicut is an island with no mineral or industrial resources. As an exurban grassland for the thriving colonial city of Newport, Jamestown was part of a larger world using the common roadway of the surrounding bay. As the reliability and speed of transportation on land increased, that same bay isolated Jamestown and encouraged a self-sufficient rural farming community. The advent of reliable but relatively slow steam transport on the bay brought summer visitors and fostered the growth of a low-key summer resort. An affluent residential suburb grew up as soon as bridges spanned the surrounding water.

In the past, Jamestown's position at the mouth of Narragansett Bay gave it some strategic value, a value outdated now by new technologies. Its geography and the new technologies have made it valuable in a different way. The town is near the center of the East Coast megalopolis—less than two hours from Boston, about four hours from New York City, and fifteen minutes from Newport—making it easily accessible. The air of the island is freshened each day by ocean breezes. The bay is clean, thanks in large

measure to the forces that came together to fight Commerce Oil's attempt to build a refinery in Jamestown and realized that the refinery battle was only a skirmish in the ecology wars.

Jamestowners are divided over whether the changes are positive or negative. Some look back nostalgically at the ferries and the solitude they allowed. Some look forward to a vibrant village and waterfront and grand suburban homes. Still, whether one is reviewing Jamestown's past, considering its present, or anticipating its future, the imperatives of its geography remain unchanged.

BIBLIOGRAPHY

Bailey, Mary Ellen. "Social and Economic Influences on the Politics of Jamestown, Rhode Island, 1920–1940." Undergraduate thesis, Bates College, 1954.

Bates, W. Lincoln Bates. "Slavery Days in Rhode Island." *Bulletin of the Jamestown Historical Society*, no. 2 (November 1921).

Buttrick, James C. "Charles Lovatt Bevins, Jamestown's English Architect." *Newport History, Bulletin of the Newport Historical Society* 78, no. 260 (Spring 2009): 36–63.

Buttrick, James C., with the Jamestown Historical Society. *Images of America: Jamestown*. Charleston, SC: Arcadia Publishing, 2003.

Carr, Edson Irving. *The Carr Family Records, Embacing [sic] the Record of the First Families Who Settled in America and Their Descendants, with Many Branches Who Came to This Country at a Later Date*. Rockton, IL: Herald Printing House, 1894. Available online at ftp http://books.google.com/books.

Chapin, Anna August, and Charles V. Chapin. *A History of Rhode Island Ferries, 1640–1923*. Providence, RI: The Oxford Press, 1925.

Cole, J.R. "Town of Jamestown." In *History of Newport County Rhode Island From the Year 1638 to the Year 1887, Including the Settlement of Its Towns, and Their Subsequent Progress*. Edited by Richard M. Bayles. New York: L.E. Preston & Co., 1888.

Conanicut Island Land Trust. *Jamestown Farms Viability Report*. 2004.

Enright, Rosemary, and Sue Maden. "Keepers of the Dutch Island Light." Occasional Paper #5, Jamestown Historical Society, 2009.

Field, Edward, ed. *State of Rhode Island and Providence Plantations at the End of the Century: A History*. Boston: The Mason Publishing Company, 1902. Available online at ftp http://books.google.com/books.

Harding, Mary B., and Sue Maden, directors. *Oral History of the Jamestown Ferries*. Jamestown, RI: Jamestown Historical Society, 1986.

Historic and Architectural Resources of Jamestown, Rhode Island. Rhode Island Historical Preservation & Heritage Commission, 1995.

Howard, John H. *100 Years in Jamestown: From Destination Resort to Bedroom Town*. Jamestown, RI: Jamestown Historical Society, 2000.

Jamestown Planning Commission. *Comprehensive Community Plan*. Jamestown, RI, 1966, 1979, 1996, 2002.

———. *Jamestown Vision Charrette Report*. Jamestown, RI, 2007. Available online at http://www.jamestownri.net/plan/jamestownvisionreport.pdf.

Jefferys, C.P.B. *Newport: A Short History*. Newport, RI: Newport Historical Society, 1992.

Johnston, William D. *Slavery in Rhode Island, 1755–1776*. Providence, RI: Publications of the Rhode Island Historical Society, 1894.

Karentz, Varoujan. *Beavertail Light Station on Conanicut Island: Its Use, Development and History from 1749*. Charleston, SC: Book Surge Publishing, 2008.

Lippincott, Bertram. *Jamestown Sampler*. Flourtown, PA: GO Printing Corporation, 1980.

Lippincott, Bertram, III. "King James's Other Island." *Newport History, Bulletin of the Newport Historical Society* 54, part 4, no. 184 (Fall 1981): 100–12.

———. "The Wanton Farm of Jamestown, R.I." *Newport History, Bulletin of the Newport Historical Society* 58, part 3, no. 199 (Summer 1985): 72–78.

Maden, Sue. *Greetings from Jamestown, Rhode Island: Picture Post Card Views 1900–1950*. Jamestown, RI: West Ferry Press, 1988.

———. *The Jamestown Bridge, 1940–2007: Concept to Demolition*. Jamestown, RI: The Jamestown Press, 2007.

Maden, Sue, with images by Dick Allphin and Tom McCandless. *The Building Boom in Jamestown, Rhode Island, 1926–1931: Buildings, Builders, People Associated with the Buildings, A Glimpse of Life in this Era*. Jamestown, RI: West Ferry Press, 2004.

Maden, Sue, and Janet Cooper, comps. *The Electric Spark: A Monthly Chronicle of Jamestown Happenings, 1910–1935*. Jamestown, RI: West Ferry Press, 1996.

Maden, Sue, and Patrick Hodgkin. *Jamestown Affairs: A Miscellany of Historical Flashbacks*. Jamestown, RI: West Ferry Press, 1996.

Maden, Sue, and Rosemary Enright. "The Dr. Bates Sanitarium in Jamestown, 1900–1944." *Newport History, Bulletin of the Newport Historical Society* 78, no. 260 (Spring 2009): 1–35.

McGaughan, Mary Stearns, and Terrence F. McGaughan. *Dismissed with Prejudice*. Jamestown, RI, 1994.

Quattromani, Shirley Tiexiera. *Portuguese of Conanicut Island: History through Memories, History of the Portuguese of Conanicut Island, 1895–1980*. Edited by Catharine Morris Wright. Jamestown, RI: Jamestown Philomenian Library, 1980.

Rappleye, Charles. *Sons of Providence: The Brown Brothers, the Slave Trade, and the American Revolution*. New York: Simon & Schuster, 2006.

Schroder, Walter K. *Defenses of Narragansett Bay in World War II*. Providence, RI: Rhode Island Bicentennial Foundation, 1980.

———. *Images of America: Dutch Island and Fort Greble*. Dover, NH: Arcadia Publishing, 1998.

Simmons, William Scranton. *Cautantowwit's House: An Indian Burial Ground on the Island of Conanicut in Narragansett Bay*. Providence, RI: Brown University Press, 1970.

Society for the Preservation of New England Antiquities. "Guide to Watson Farm, Jamestown, Rhode Island." N.d.

Warren, Wilfred E. *The Jamestown Ferryboats, 1873–1969*. Jamestown, RI: Wilfred E. Warren, 1976.

Watson, Walter Leon. *History of Jamestown on Conanicut Island in the State of Rhode Island*. Providence, RI: John F. Greene Co., Inc., 1949.

———. *The House of Carr: A Historical Sketch of the Carr Family from 1450 to 1926*. Providence, RI, 1926.

Wood, Linda. *Rhode Island's Islands: An Oral History, Conanicut Island*. Rhode Island Historical Society and Jamestown Historical Society, 1985–86.

Youngken, Richard C. *African Americans in Newport*. Providence, RI: Rhode Island Historical Preservation & Heritage Commission and Rhode Island Black Heritage Society, 1995.

INDEX

A

accidents 29, 107, 129
Africa 11, 34, 37
agriculture 14, 16, 22, 25, 34, 41, 51, 52, 53, 56, 57–58, 88–90, 170
American Legion 119, 140, 146, 155
American Revolution 34, 37, 39, 41–49, 51, 53, 55, 58, 63, 66, 127
Anderson, Helena 142
Anthony, Elijah 72, 92
archaeology 13, 14, 15, 16, 173
architects 37, 69, 81, 82, 93, 94, 101, 102, 109, 110
Armbrust family 83, 92, 114
Arnold family 18, 28, 30, 36, 142
artifact, Native American 14
artillery green 25, 32, 60, 67, 120
artists 32, 52, 57, 80, 133, 170, 172

B

Bates, Dr. William Lincoln 89, 107
batteries (military) 47, 129, 131, 132, 136
Battey, William 48
Bay View Condominiums 164, 175
Bay View Hotel 72, 76, 77, 78, 82, 99, 100, 106, 120, 135, 163, 175
Bay Voyage Inn 78, 82, 120
beaches 11, 32, 60, 98, 118, 123, 151, 152
Beavertail (area) 11, 26, 32, 33, 36, 45, 56, 116, 150, 154
Beavertail Lighthouse 36, 37, 60, 127, 138, 144, 172, 173
Bevins, Charles L. 81, 101, 109, 110
Board of Trade 111, 119, 121
Boone, Albert 92
bridges 9, 32, 33, 34, 163, 165, 175. *See also* specific bridges
Brinley, Francis 25, 31
Brown, James A. 76
buildings moved 64, 76, 78, 109, 110, 115
burial grounds 13, 14, 15, 16, 25, 60, 151

INDEX

C

Camp Seaside 106
camps (military) 129
Carr family 28–31, 39, 55, 61, 65, 67, 72, 89, 95, 135
Carr, George C. 67, 72, 79, 92, 96, 104, 111
Carr, Governor Caleb 18, 28, 29, 31, 39, 55
Carr, Isaac 64, 69, 94
Carr, Nicholas 29, 30, 31, 48, 66
Carr School 94, 95, 151
Casino 83, 115
Caswell family 79, 80, 91, 161
cemeteries 65, 129
censuses 57, 85, 86, 87, 88, 165
Central Baptist Church 69, 109, 134
Chamber of Commerce, Jamestown 111, 153
Champlin House 76, 78, 89, 97, 120
Champlin, William A. 76
Chandler, Abbott 111
charrette 176
Chesebrough, David 34
churches and chapels 65–69, 71, 75, 109–111. *See also* specific churches
Civilian Conservation Corps 121
Civil War 92, 129–30, 131, 139
Clarke family 44, 62, 65, 95, 120, 135
Clarke School 96, 114, 151
Clothier, Isaac 81
cluster housing 149, 167
Coast Artillery 107, 133, 136, 138, 141
colonial settlement 25, 65
Commerce Oil 148, 149, 155–58, 167, 175

common pasture 16, 25
Community Center 135, 140, 151
Comprehensive Community Plan 166, 170
Conanicut Battery 47, 48, 49, 127, 132, 133, 172, 173
Conanicut Grange 112, 114, 140, 151
Conanicut Island Art Association 170
Conanicut Island Land Trust 169
Conanicut Island Lighthouse 173
Conanicut Land Company 73
Conanicut Light and Power Company 106
Conanicut Marine Services 175
Conanicut Park (development) 73–75, 76, 96, 98, 102, 106, 109, 151
Conanicut Park Hotel 74, 75, 98, 107
Conanicut Telegraph and Telephone Company 102, 103
Conanicut Yacht Club 83, 112, 115
condemnation of land 132, 133, 134, 138, 140
condominiums 158, 165, 167, 175
Cottrell family 56, 60, 79, 92, 132
Cranston, Governor Samuel 34, 38
crime 175
crusher (stone) 116, 117, 120, 121

D

Davis, Lucius J. 73
deaths 29, 39, 40, 44, 106, 120, 122, 129, 134, 142
Democratic Party 60, 91, 92, 157, 158
demolition of buildings 68, 75, 81, 120, 124, 128, 129, 133, 140, 163

INDEX

depression (economic) 91, 113, 118–122
Dr. Bates Sanitarium 76, 83, 87, 89, 107, 108, 120
Dumplings (area) 11, 48, 80, 81, 83, 111, 128, 150, 163
dump sites 98
Dutch Island 9, 10, 11, 16, 17, 22, 23, 25, 29, 30, 61, 107, 129, 131, 132, 133, 136, 150, 154, 172, 173
Dutch Island Lighthouse 129, 136, 172, 173

E

economy 38, 40, 51–58, 86–90, 118–22, 121, 130, 145, 154–58
education 61–62, 94–96, 139, 150–51, 173. *See also* schools
Eldred, John 43
elections 91, 92, 93, 147, 157
electricity and lighting 85, 93, 104–06, 151, 152
Ellery Ferry House 76

F

Farley, Hannah M. 61
farms and farmers 13, 15, 18, 23, 25, 29, 32, 33, 35, 41, 43, 45, 46, 49, 52, 53, 56, 57, 60, 63, 65, 69, 73, 79, 82, 83, 86, 87, 89, 97, 105, 115, 118, 127, 151, 154, 156, 169, 170
Federal Building and Development Corporation 148, 151, 152
Federal Emergency Relief Administration 121
ferryboats (named) 29, 31, 41, 55–56, 59-60, 65, 71–73, 74, 75, 76, 77, 80, 81, 88, 117, 118, 119, 122, 123, 124, 125, 136, 145, 159–63
Fillmore, Captain Harry M. 123
fires 37, 44, 45, 63, 93, 99, 100, 101, 102, 120, 141
Fisher, Joshua 25, 26, 31
Fools' Rules Regatta 170, 171
Fort Adams 128, 133, 136, 162, 163
Fort Burnside 138, 139, 143
Fort Dumpling 128, 129, 173
Fort Getty 132, 138, 139, 141, 143, 150
Fort Greble 101, 107, 131, 132, 133, 136
Fort Wetherill 101, 114, 132, 133, 138, 139, 141, 143, 150, 174
fossil, fern 11
Franklin, Abel 37, 44
Furtado, Frank 92

G

Gardner family 56, 69, 76
Gardner House 76, 78, 99, 102, 106, 108, 120, 135, 140
Geller, Harold M. 155
General Assembly. *See* Rhode Island General Assembly
geography and geology 9–12, 69
Germans 101, 139
Gill, John F. 93
Girard, Armand 152
Gobeille, Dr. Alfred B. 108, 157
Gould family 17, 18, 25, 28
Gould Island 9, 10, 11, 17, 30, 61, 134, 136–138, 143, 150, 154
Greble, Lieutenant John T. 131
gristmill. *See* windmill
growth 51, 73–83, 85–88, 145, 146, 149, 150, 165–66, 167. *See also* specific developments

INDEX

Guimarey family 122
Gulf Oil 155, 157, 158

H

Hammond, Mary H.C. 135
Harbor Entrance Control Post 138, 139, 143, 172
Head, Alton 117
Head, James G. 151, 152, 153
health 98, 106–08, 150, 151
highway barn 174
Holy Ghost Society and Hall 115
Hoof-and-Mouth Disease Laboratory 154–55
Horgan, Patrick H. 76, 79, 109
hospitals 49, 66, 92, 106, 107, 132
houses (named) 30, 46, 64, 65, 76, 81, 122, 138
Howland family 44, 45, 72, 79
Howland, James 40
Hull family 44, 57, 93, 105, 114, 115
Humane Society of Jamestown 173
Hurricane of 1938 113, 114, 122–25, 140, 160
Hutchinson, Governor Thomas 34, 44

I

illness 75, 98, 107, 129
immigrants 87, 88, 92
incorporation, act of 31

J

Jamestown Ambulance Association 108
Jamestown Arts Center 172
Jamestown Beautification Committee 175
Jamestown Brass Band 112
Jamestown Bridge 121, 122, 125–26, 127, 136, 143, 145, 151, 153, 154, 163, 164, 165, 168, 173
Jamestown Community Band 112, 172
Jamestown Community Chorus 172
Jamestown Community Piano Association 172
Jamestown Community Theatre 172
Jamestown Country Club 174
Jamestown Emergency Medical Service 108, 170
Jamestown Fire Department 99–102, 170, 173
Jamestown Forum 153
Jamestown Garden Club 112, 158, 169
Jamestown Golf and Country Club 112, 169
Jamestown Historical Society 55, 112, 172
Jamestown Improvement Society 111
Jamestown Light and Water Company 98, 106, 111
Jamestown Lions Club 112
Jamestown & Newport Ferry Company 72, 87, 91, 117, 118, 119, 124, 147, 154, 159, 161, 162
Jamestown Philomenian Library 14, 65, 172
Jamestown Press 175
Jamestown Protective Association 157
Jamestown Rotary Club 112, 170
Jamestown Shores Association 152, 156
Jamestown Shores (development) 148, 151–53, 155
Jamestown-Verrazzano Bridge 165, 166

INDEX

Jamestown Water Company 97, 149
Jamestown Yacht Club 170

K

King, Thomas 99
Knowles family 76, 77, 95, 99, 103, 123

L

Lawn Avenue School 151
laws 38, 39, 40, 41, 55, 62, 65, 91
lawsuits 148, 149, 157, 163
lighthouse keepers 37, 60, 129, 132, 136
Lippincott, Walter 115, 116
Littlefield, Nathaniel 99, 100
livestock 16, 31, 33, 34, 42, 44, 49, 52, 53, 57, 60, 89

M

Mackerel Cove Beach Pavilion 114, 115, 116, 122
Maplewood. *See* Dr. Bates Sanitarium
maps 10, 25, 26, 27, 28, 29, 31, 85, 86, 176
marinas 158, 164
marsh, saltwater 9, 32, 33, 43, 97, 158, 159, 169
Masterson, James 91
Melrose Avenue School 151
Meredith, LeRoy 114
millers 54, 60
Miner, Dr. William W. 157, 175
Mount Zion African Methodist Episcopal Church 109
Movable Chapel of the Transfiguration 109, 110
municipal building 93, 94, 102
museums 172, 173

N

Narragansett (town) 35, 41, 56
Narragansett (tribe) 13, 14–17, 18, 22, 23
National Register of Historic Places 173
Newlin, James H.M. 80, 96, 104, 105
Newport 9, 16, 18, 22, 28, 29, 30, 31, 34, 35, 36, 37, 38, 39, 41, 42, 43, 47, 48, 49, 51, 55, 56, 62, 66, 72, 76, 77, 90, 94, 97, 99, 100, 101, 106, 126, 127, 128, 130, 143, 166
Newport/Pell Bridge 32, 148, 150, 159–164, 165, 167
North End Concerned Citizens 169, 174
nursing home 107

O

occupation by British 46–49, 51
occupations 18, 51, 86, 87, 88, 133
Ocean Highlands (development) 79–81
ordinances 34, 91, 98, 147, 148, 149, 153, 157, 158, 167, 176
Oxx family 69, 99, 100

P

parades 111, 172
parks 47, 74, 136, 140, 143, 144, 152, 155
Pell, Senator Claiborne 143
Pemantel, Bill 122
Pemantell, James G. 175
Penguin Plunge 170, 171
pharmacy 108
physicians 106, 107, 108
Planning Commission 147, 148, 149, 152, 160, 166, 167, 176

Index

police 85, 94, 105, 117, 139, 140, 153, 174, 175
pollution 148, 150, 154
population 31, 38, 39, 41, 47, 52, 57, 59, 61, 62, 85, 87, 107, 129, 145, 150, 165, 166
Portuguese 87, 88, 92, 115
postal service 56, 64, 85, 104, 135
pound, animal 33, 34, 60
prepurchase agreement 17, 18, 19, 22, 28, 29
Preston, Reverend Charles E. 109
prisoners of war 45, 48, 139, 140
privateering and piracy 35, 42
Prospect Hill 48, 133, 138
Prudence Island 154, 155
Public Works Administration 121, 122, 125
purchase, 1657 17, 22–23, 25
purchasers, 1657 17, 18–21, 22, 25, 27, 28, 29, 30

Q

Quaker meetinghouse 66, 67, 111, 172
Quakers. *See* religions
Quononoquott Garden Club 112

R

Recreation Center 141, 174
Red Cross 108, 114, 140
refinery. *See* Commerce Oil
religions 47, 65, 66, 67, 69, 75, 111, 148. *See also* churches and chapels, specific churches
Rembijas, Major John C. 155
Remington family 32, 36, 44, 63, 64
Republican Party 91, 92, 157, 158
reservoirs 96, 97, 150, 155, 168
resort era 71–83, 104, 113, 120, 145

Rhode Island General Assembly 31, 33, 39, 42, 46, 53, 55, 72, 96, 147
Rhode Island National Guard 133, 138, 168
Rhode Island Turnpike and Bridge Authority 163
Richardson family 114, 134
Richards, William Trost 80, 133
Riverside House 99
Roll of Honor 141, 142
Royal Arcanum 93, 111

S

sachems 16, 17, 22, 23
St. Mark Church 110, 135, 140
St. Matthew's Episcopal Church 67, 68, 69, 109, 140
Saunders, Stillman 124, 136
Saunderstown 9, 49, 118, 123, 125, 126, 136, 140
schools 61, 62, 67, 93, 94, 135, 139, 145, 151
sewage and sewers 75, 81, 83, 85, 98, 148, 149, 150, 151, 153, 167, 175
sheep 31, 32, 34, 41, 42, 44, 57, 60
Sherman, Ebenezer 128
shipwrecks 118, 119
Shoreby Hill (development) 46, 81–83, 110, 173
Silvia, Manuel 92
Simmons, William S. 13
slavery 37–40, 40, 41
Smith family (Wickford) 18, 22, 23
Smith, Henry L. 99, 100
Smith, Samuel 89, 90, 92
Spanish-American War 133
Stiles, Reverend Ezra 44, 45
stores 44, 64, 69, 75, 90, 94, 102, 108, 120, 124, 164, 175
subdivisions 147, 148, 167

Index

submarines 133, 138
Sullivan, Reverend Patrick J. 135
summer visitors 67, 71–83, 85, 87, 88, 90, 92, 104, 105, 107, 109, 111, 112, 115, 116, 119, 133, 140, 142, 156. *See also* resort era
Sword, James B. 80

T

taxes 41, 59, 60, 91, 116, 120, 154
Taylor Point 150, 158, 162, 164, 175
Tefft family 99
Tefft, Rosamond 147, 148, 155, 174
telephone service 102–04
Temperance Society 111, 135
theaters 114, 172
Thorndike Hotel 76, 78, 101, 102, 106, 109, 120
toll plaza 32, 150, 162
tolls 55, 125, 164, 165
Torpedo Station 87, 122, 130, 133, 134, 143
torpedoes 134, 136, 137, 138, 139, 143
town clerks 31, 42, 58, 63, 64, 91, 93, 146, 147
town council 13, 31, 32, 34, 36, 42, 49, 58, 59, 91, 92, 93, 94, 98, 100, 103, 104, 106, 108, 119, 140, 141, 146, 147, 148, 150, 154, 155, 157, 160, 167, 174, 175, 176
town government 18, 28, 31–34, 42, 58–61, 72, 91–92, 116, 145–49, 153, 170
town hall 60, 92–94, 111, 172, 174
town revenue 33, 34, 36, 53, 59, 60, 98
Tucker, Pardon 96, 104

U

unemployment 118, 119, 154
United Services Organization (USO) 140, 141, 151
U.S. Army 92, 131, 133, 138, 139, 143, 162
U.S. Coast Guard 129, 136, 161
U. S. Navy 130
U.S. Navy 11, 101, 118, 122, 125, 130, 131, 136, 137, 138, 143, 154, 156, 157
USO 141

V

Vieira Coal Company 140
village life 32, 63–69, 73, 85, 92–112, 114, 115, 122, 156, 166, 170, 172, 175
votes at financial town meetings 32, 61, 72, 92, 96, 116, 125, 146, 147, 149, 150, 151, 157, 162, 169, 170, 174, 175

W

Wanton, Colonel Joseph 53
Washington, General George 49
waterfront improvement 122, 164, 175
water supply and distribution 75, 81, 93, 96–97, 104, 106, 129, 136, 145, 149, 151, 153, 167–69, 174
Watson family 52, 53, 63, 64, 72, 76, 91, 95, 102
Watson, John J. 64, 65, 92, 99
Weeden, Charles E. 76, 92, 99, 102
Weeden family 60, 64, 67
Westall, Mary 122
West Indies 34, 35, 37
Wetherill, Captain Alexander M. 133

INDEX

Wetherill, Herbert J. 93, 94, 102
Wharton family 80
windmill 53–55, 112, 172, 173
Windmill Hill Historic District 169, 170, 173
Wood, Rear Admiral Spencer S. 131
Work Projects Administration 121, 140
Works Progress Administration 121, 122, 124, 140
World War I 108, 113, 114, 120, 133–36
World War II 108, 136, 138–42
Wright, Sydney and Catharine Morris 13, 14

Y

YMCA/YWCA 106, 135

Z

zoning 147–49, 167, 169, 176. *See also* ordinances

ABOUT THE AUTHORS

Rosemary Enright holds a BA and an MA in English (Rosary Hill College, 1962; New York University, 1963) and has completed extensive graduate work in American civilization at New York University. Her professional careers include editorial work, teaching English at New York Institute of Technology, freelance writing, and work as a process engineer and computer systems requirement analyst for Northrop Grumman Corporation. She has been president of the Jamestown Historical Society board since 2005 and previously served as vice-president, a director, and editor of the biennial newsletter. She writes a monthly column for the *Jamestown Press* on historical society activities.

Sue Maden attended Carleton College (1952–54) and then went to school in New York City in nursing (BS in nursing, Cornell University–New York Hospital School of Nursing, 1957; MA in public health nursing,

Hunter College, 1963). After a variety of nursing positions in hospital and public health fields and the American Nurses Foundation, she earned a master's in library science at Pratt Institute (1974) and then worked at the Columbia University Health Science Library. Retiring to Jamestown in 1982, she has since focused on volunteer work and local history projects, which have resulted in articles, books, compilations, exhibits, and lectures. She contributes a weekly column of historical facts to the *Jamestown Press*. She has served several terms on the board of the Jamestown Historical Society, most recently from 2005 to present, and is chair of the society's collections committee. She is also on the publications committee of the Newport Historical Society.

www.ingramcontent.com/pod-product-compliance
Lightning Source LLC
Chambersburg PA
CBHW060758100426
42813CB00004B/872